still-life
drawing and painting

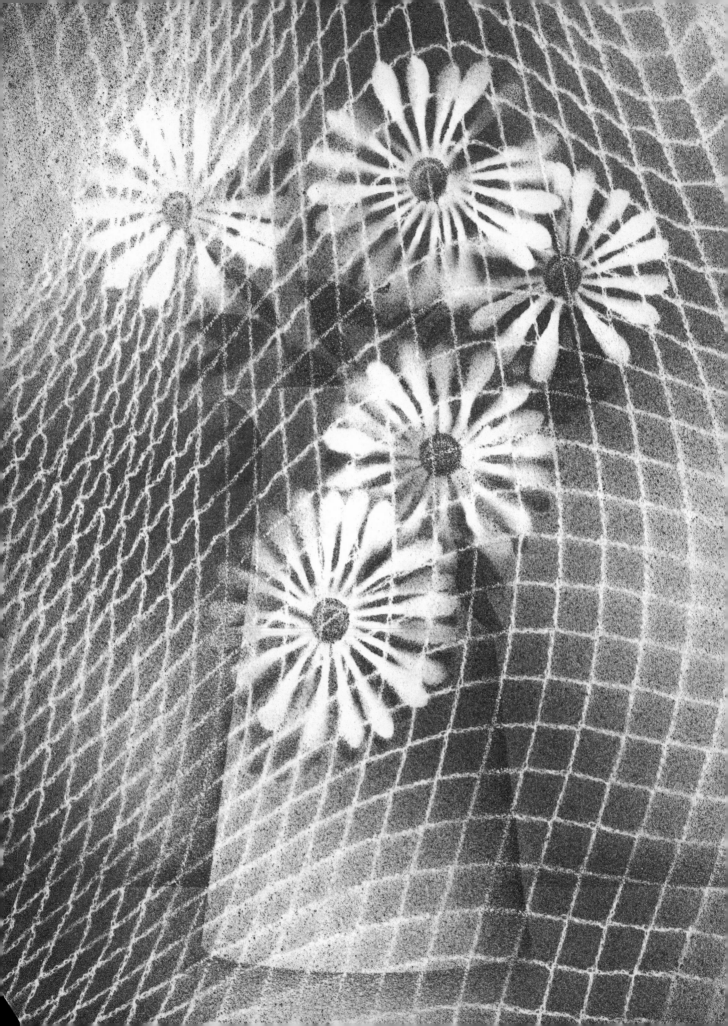

still-life
drawing and painting
by Jack Hamm

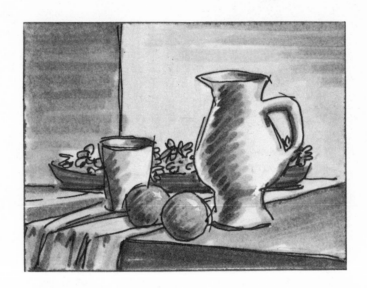

GROSSET & DUNLAP
A FILMWAYS COMPANY
Publishers • New York

To
Donna Lee and Milton Keith

Library of Congress catalog card number: 75-37308

ISBN 0-448-11526-3
First printing

PRINTED IN THE UNITED STATES OF AMERICA

PREFACE

Wherever you are *right now,* you are very likely within a very short distance, perhaps inches, of still-life material. Before reading further, look up and about. Doubtless you have surveyed the makings of a picture. Now there's the rather remote possibility that you, the reader, are in a boat drifting without oars (oars are still life) on a vast lake. You didn't bring any food along (food is still life); you didn't bring water (all water containers are still life); you left your billfold or purse on the dresser at home (these are and contain still life); you are stark naked (clothes, scarves, belts, shoes, etc., are still life); in fact, you purposely wanted to prove that you, the reader, could get away from all tangible still-life things. But you are still a reader, and you have a book in your hand, and that's still life!

To be sure, if you were in the above condition, a book might be the last thing you'd want in your hand. A manual on how to survive, however, might be appropriate. But there's no getting away from it; we live in a world of drawable, paintable still lifes. In the introductory pages of this book it will be further verified: still-life material is in abundance.

It's a shame, in a way, that many who profess interest in art never take up the challenge of still-life drawing and painting. This book is not a history of still-life work or of the men and women who produced this art. Some brief mention of great artists in this field may be found, but extensive lists or detailed descriptions of how they worked are not included here.

The chief concern of this book is to present the underlying principles and basic tenets that these successful still-life artists followed. All the while, the purpose is to simplify working methods and approaches, rather than to become involved in abstruse theories. These fundamentals are so interrelated that they will often lean on each other. That's all right, too, for they form an amiable family of practical rules. If a student familiarizes himself or herself with these ready helpers, and if a generous amount of resolute perseverance is called alongside, improved pictures are bound to result.

"Trial and error" are never to be ridiculed. No artist worth his salt did everything right. But errors can be reduced on the trial trail. There is no use harboring troublesome problems. It is hoped that these pages will solve problems and answer questions for the interested student as well as encourage the aspiring exhibitor. Still-life drawing and painting can be a most enjoyable experience.

JACK HAMM

CONTENTS

Introduction to
Still-Life Drawing and Painting

The Simple Freehand Line . 1
Still-life Material Is in Abundance 2
Placing the Subject Material . 3
The Five Essential Shapes . 4
The Practice Stroke Put to Work 5
The Wide Range of the Curvity 6
The Curvity with the Straight 6
Experimental Still-life Sketching 7
Thinking Inventively . 7
Simple Adventure Sketching 8
Opening the Creative Gates of the Mind 9

Significant Factors in the Early Stages

Edge Differentiation . 10
Front, Top and Side Planes . 11
Outlining the Middle Values 12
Linking the Middle Values . 12
Developing the Middle Values 12
Isolating the Middle Values . 13
Enclosing these Values . 13
Making the Values Your Servants 13
Dividing Space in a Pleasing Manner 14
Sectional Space Division . 16
Pure Dimensional Form . 18
Forms in Dark and Light . 20
Light and Shadow . 22

Fundamental Principles
in Still-Life Understanding

Values in Composition . 24
Visual Weights and Balance . 26
Line-up of Still-life Containers 28
Right and Wrong Ways of Container Arrangement . . 29
Lessons from the Apple . 32
Using Four Basic Values . 34
Small Fruit Compositions . 36
Parallel Sketch Lines . 37
Pears and Pen . 38
Cards in Still Life . 39
Step-by-step Chalk Drawing 40
Sectional Detail Study . 43
The Picture Plane and Pictorial Space 44
Spatial Step-backs in Still Life 46

Considerations Which Assist
in Executing a Still Life

Oil and Acrylic Painting . 48
Pen and Ink Still Life . 50
Rolling Action in Still Life . 52
The Pen: Tight Control and Loose Control 56
The Brush: Tight Control and Loose Control 57
Texture in Still Life . 58

Opaque Watercolor in Sequence
 (employing texture) . 60
Texture by Grain, Pointillism Texture,
 Felt Pen Texture . 63

Supporting Roles Drapery Can Play

The Drape in Still Life . 64
Focusing Attention on the Drape 65
Various Uses of Drapery . 66
Charcoal Drawing and Marker Painting
 (utilizing drapery) . 67
Folds Are Everywhere . 68
Passive and Active Drapery . 70
More on the Function of Drapery 72

Invading the Abstract World in Still Life

Introduction to Abstraction . 74
Departing from Reality . 76
Transparency and Interpenetration 78
Experiment in Abstraction . 80
Angular Lines and Segmented Planes 84
Abstract Expression in Still Life 86

Turning to the World of
Plants and Flowers

Flowers in Still Life . 88
Floral Still-life Beginnings . 89
Floral Form . 90
Still-life Mood Painting . 92
Squeeze-tip Painting . 93
Pen and Ink with Wash . 93
Drawing and Painting the Rose 94
The Rose Dissected and Analyzed 96
The Six Basic Shapes of Flowers with Examples 97

Using the Atomizer to Capture
Foliage Often Overlooked

Mist Painting Floral Still Lifes 98
Misting Combined with Painting and Drawing 105
Misting Enchanting Patterns 106
Wintry Images and Effects . 107
Creative Exploring with Misting 108
Positive and Negative Mist Painting 110
Unusual Effects . 111
Mist Painting Plant Roots . 113
Abstracts from Plant Life . 114

Combining Plastic Bristles
with Other Art Tools

Stamen Brush Painting . 116
Using the Stamen Brush . 118
Try the Untried! . 119

Index . 120

THE SIMPLE FREEHAND LINE

At the right are three objects very simply and loosely represented. The bowl, the jug and the glass might have been drawn by nearly anybody. And that "anybody" might have been a person anywhere between ages five to 105. Figs. a, b & c are as elementary as pencil will allow. If one can draw these or similar "still-life pieces," he can enter into the learning processes described in this book. It is true that the underlying basics to the best approaches in the study of art are refreshingly simple.

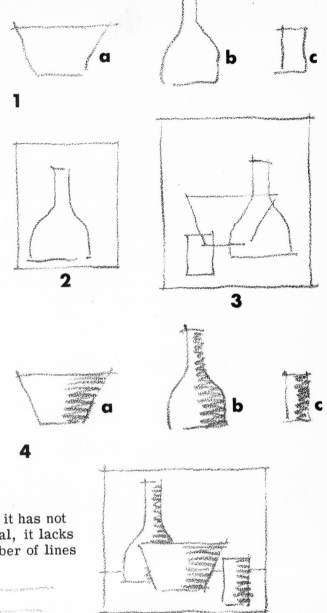

Not many things can be more simply drawn than the bowl, the jug and the glass. These could have been more exactly set down. They might have been done in straighter lines or possess more symmetry or made to look "more real."

One of the big hindrances to the beginner is his or her belief that the true subject requires photo-like reproduction. No greater misconception was ever perpetrated in all of art study. Because the beginner's fingers do not act like a machine, he is led to believe that he was never meant to enter into art training.

Let's draw two lines. One will be "freehand" and the other will be drawn along a straight-edge or ruler:

A ⎯⎯⎯⎯⎯⎯⎯⎯⎯⎯⎯⎯⎯⎯⎯⎯⎯⎯

B ⎯⎯⎯⎯⎯⎯⎯⎯⎯⎯⎯⎯⎯⎯⎯⎯⎯⎯

Line A attests to living, flexing fingers back of it, it has not leaned on a ruler; it's warm. Line B is mechanical, it lacks personality; it's cold. On the sketchpad draw a number of lines with pencil in an easy, freehand manner:

This type of line has more promise than the ruled line. As time goes by, the freehand line becomes the servant of the artist and is subject to his control. Using this kind of line we return to the illustrations above right. Now place one of the still-life pieces in a frame, as in fig. 2. The frame is as important as the subject, which in this case is the jug. Rather than center the jug, we've moved it slightly to the left. By so doing the spaces around the jug have variety and are more interesting. Some artists refer to the area around the subject as "negative space" and the area within the subject as "positive space." Later more will be said about proper spacing.

In fig. 3 the several items have been overlaid as though they were transparent. Here again the intention is to divide the total area in an interesting, informal way. Compare the simple space divisions: it is a fascinating assortment apart from the bowl-jug-glass identity.

In fig. 4 the several items have been given a feeling of dimension by placing their right halves in shadow. The pieces assume more roundness and appear solid. Further along we'll see that this modeling of form may be unwanted and unnecessary in abstract drawing and painting. In fig. 5 the forms are grouped with a table line running behind. Thus we come up with our first still-life drawing. In this elementary sketch we have not sought to round the tops or bottoms of these three pieces.

1

STILL-LIFE MATERIAL IS IN ABUNDANCE

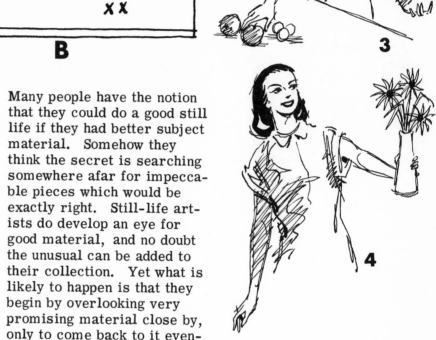

A

B

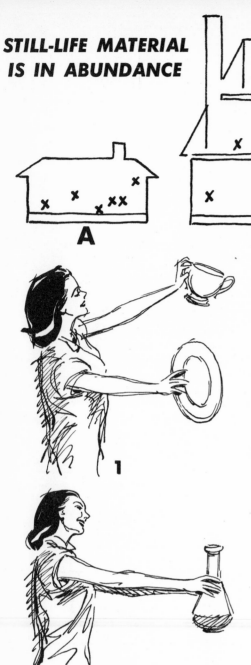

1

2

Many people have the notion that they could do a good still life if they had better subject material. Somehow they think the secret is searching somewhere afar for impeccable pieces which would be exactly right. Still-life artists do develop an eye for good material, and no doubt the unusual can be added to their collection. Yet what is likely to happen is that they begin by overlooking very promising material close by, only to come back to it eventually.

Let's take house A, a modest or even a poverty-stricken home. The x's in this cross section represent "good" material. In fact, the most **unpretentious of homes may have objects an** experienced still-lifer would consider to have first-rate possibilities. The big affluent house B would likely have things in many places (x's) which would be worthy of any artist's brush or pencil. Yet there is every probability that an investigation might find as many and maybe more pieces in the humble home. Really there's not much excuse for saying, "I just don't have anything to draw or paint." The portrait artist, the scenery artist, the commercial artist -- all may have less latent subject matter than the still-life artist.

3

4

1

2

3

PLACING THE SUBJECT MATERIAL

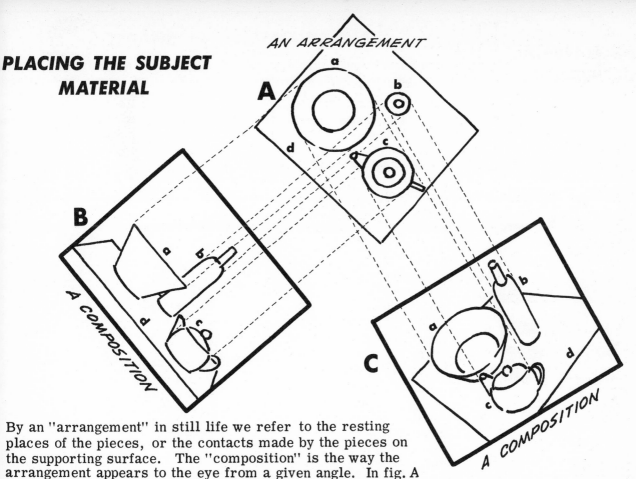

AN ARRANGEMENT

A

B — A COMPOSITION

C — A COMPOSITION

By an "arrangement" in still life we refer to the resting places of the pieces, or the contacts made by the pieces on the supporting surface. The "composition" is the way the arrangement appears to the eye from a given angle. In fig. A the three objects a, b & c are shown from above as they have been arranged on the rectangle "d" which could be a table, a card or the bottom of a shadow box. The composition in fig. B has the base somewhat below the eye level (or below the eye of the viewer). The fig. C composition is from another angle, the eye level being raised considerably. As one moves around the formation he may decide to move any or all the pieces to improve the composition.

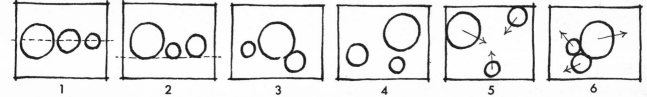

1 2 3 4 5 6

Figs. 1 & 2 above pose risky overhead arrangements, unless from some angle the group, because of varying heights and shapes, becomes an interesting composition. The artist alone decides on his own guidelines. He may insist on a fairly "tight" arrangement with little air around the objects such as in fig. 3, or he may want a more open feeling with the pieces separated, fig. 4. Experimentally place the pieces as far apart as the base will allow, fig. 5, and notice the natural inclination to bring them into a more cooperative relationship. Again, abut them as in fig. 6 and sense the need to relieve the pressure by moving at least one of the pieces into the open.

4

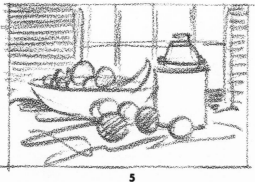

5

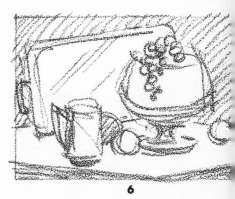

6

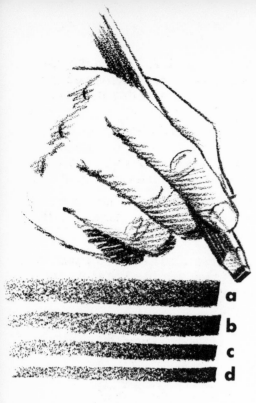

THE FIVE ESSENTIAL SHAPES

Very early in still-life drawing and painting it is well to learn the basic shapes and forms with which one has to be concerned. Every still-life concept employs several or all of these in its make-up.

A big, flat-leaded pencil of the ultra-soft variety (4B, 6B or 8B) is useful in our experimentation. At left is a sketch showing the pencil's shape. It must be sharpened with a blade of some kind (a single-edge razor blade is suggested). The point should not be too long for some pressure is needed and a long point will break too easily. Two pencils of different lead widths will serve the student well. Sample strokes are a, b, c & d.

Fig. A diagrams the five essential shapes or forms which we will keep in mind. They are: 1. The curvity, 2. The sphere (and the circular), 3. The straight, 4. The truncone and 5. The drape. Some of these may come in combination. Other forms of geometric nature or surfaces of varying gradations are not ruled out, but in general even they may be classified in these five catagories.

Let's examine each of these more specifically:

Fig.❶, the "curvity," has thousands of variations and includes nearly every vase, pottery or porcelain container in existence. Indeed, every curved object in the world which is not a circle can be admitted here. Fig. 1 is but one in the vast uncounted.

Fig.❷, the "sphere," is often modified in still life and takes in most fruit and many vegetable forms. A globe in the absolute sense is seldom wanted. The outer limits of a sphere is a circle and so is a round plate. In this respect the plate and the sphere

(cont'd next page)

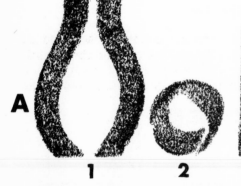

A **1** **2** **3** **4** **5**

Below are bold pencil strokes on the sketchpad. Fig. B represents 3 & 5 of A above; i.e., hard straights like a window frame or colonnade along with soft drapes clumped in front. Fig. C is a quick concept featuring a curvity, a truncone with a tall neck, fruit (spheres) on a drape with more fruit on a ledge (straights). Economy of line is demonstrated here: a dozen or so strokes.

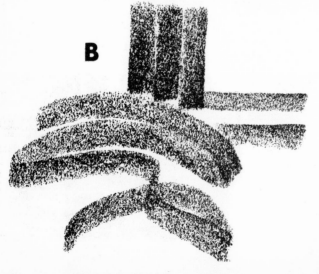

B

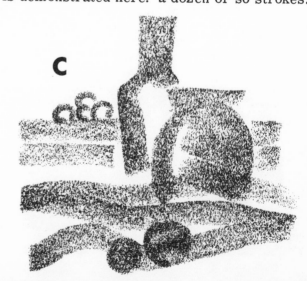

C

fall into the same classification two-dimensionally. Viewed from the top figs. 1, 2, 3 & 4 on the opposite page may be true circles. Viewed above or below the eye-level these same circles become elliptic (the sphere being the exception). Abstract or impressionistic treatments at this time are not being considered.

Fig. **3**, the "straight," is more broadly anything defined by a straight line in a still-life composition. It includes boxes, books, square or rectangular tables, window edges, etc. It can be the top of a round plate exactly at eye-level. In short it can be any line or edge which is not curved. Often such a line furnishes relief in an abundance of curves. Its importance cannot be overestimated.

Fig. **4**, the "truncone," is a term here employed as an abbreviated form of truncated cone. A truncated cone or pyramid is that part which is left after the vertex has been cut off by a plane. In still life it is mostly inverted and very likely has a base or a stand beneath:

Fig. **5**, the "drape," includes loosely arranged table cloths, curtains, tapestries, etc. Any textile or fabric which may take on folds would qualify here. Most still-life pieces are fixed in their construction. The drape is pliant and highly adaptable when used in the composition.

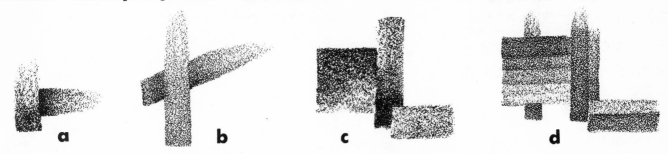

a b c d

THE PRACTICE STROKE PUT TO WORK

Above are practice strokes with the wide pencil. Learn to **make one stroke go behind the other by** using varying pressures abutting the last stroke made with the pencil point. Below are thumbnail sketches of imaginary still-life possibilities. Observe the simplicity of the strokes. As time goes by one can with little effort set down a number of sketches utilizing the principles discussed in the forthcoming pages.

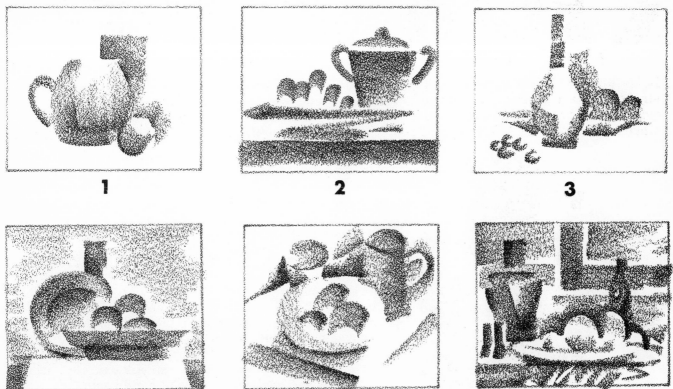

1 2 3

4 5 6

THE WIDE RANGE OF THE CURVITY

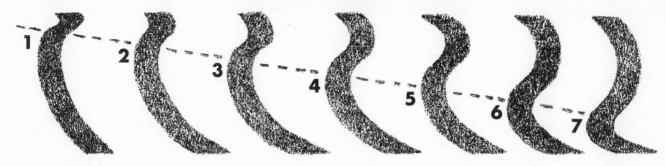

On page 4 diagrams of the five essential shapes or forms were given. Surely the "curvity" on that page is one of the most useful. Pottery, porcelain and various other kinds of rounded holders, at their inception, are all the products of the imagination. The bulge or belly of a given holder can occur anywhere from top to bottom. The still-life artist should feel <u>certain</u> <u>liberties</u> in responding to objects in front of him or when engaged in pure creative sketching. Above are wide-track lines suggesting the range.

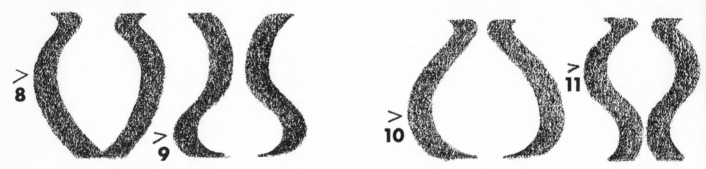

Beauty of form is not hard to come by. Interest found in the flow of a contour may be due to positioning of the girth of the bowl, length and circumference of the neck and/or the base. This is not to overemphasize these features; it is merely coming to grips with the necessity for following some definite pattern.

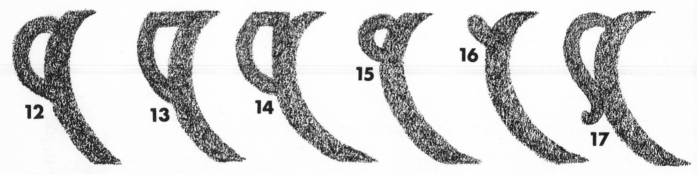

The handle may be a highly decorative part of the rounded holder, if indeed there is to be a handle at all. Often the handle is optional. It was originally applied to be functional. In a still life it is more ornamental and is more for the eye to get hold of than the hand.

THE CURVITY WITH THE STRAIGHT

There is no end to shapes and forms of vases, urns and other rounded containers. At left the "curvity" (fig. 1, p.4) is combined with a "straight" (fig. 3, p.4). Here there is a "lip" or "rim" to the neck, and the base flows evenly off of the bowl. There needs to be a certain sameness to some forms, such as specific kinds of fruit at least some identity characteristics are mandatory. So it may be with other parts of a picture. But all receptacles and containers may be highly variable.

EXPERIMENTAL STILL-LIFE SKETCHING

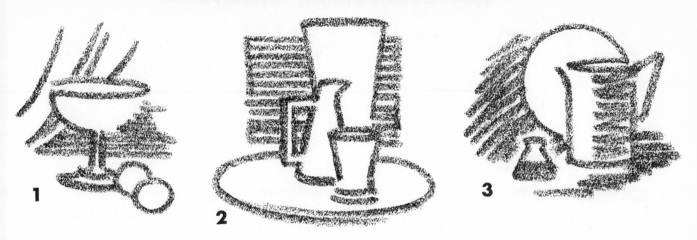

1 **2** **3**

Here are some experimental sketches set down without working from actual subject material. These are simple forms called forth from the imagination. What do they have in common? They are made with a fairly heavy though uniform line. The pencil is an 8B 1/8" lead. The paper is an ordinary sketch pad. Each sketch has a gray value achieved by multiple lines drawn in a parallel fashion.

4

5

THINKING INVENTIVELY

Though all of these compositions are simple, each one has a sense of completeness. There are pleasant combinations of form using one or the other of the essentials mentioned on p.4. The curved and straight lines complement each other. These figures were not drawn blindly, but each one was planned quickly in thin, light lines. The purpose was to think inventively. Such an approach should exclude the complex. Let there be an overlapping of line which results in one object being placed in front of the other. In forthcoming pages this overlapping will be thoroughly discussed.

Observe the elliptical base and the rectangular backdrop in fig. 2 and the indefinite edging of the gray areas in figs. 1 and 3 which have been used to tie together and reinforce the various parts. This kind of elementary exploring can prove most profitable. It relieves the pent-up desires one has to give birth to new ideas.

6

SIMPLE ADVENTURE SKETCHING

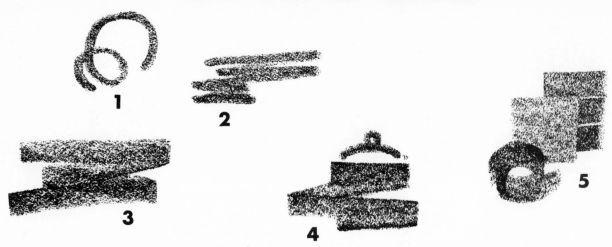

Two pencils, both of a very soft lead (6B or 8B), the one a large flat, the other a smaller round, can be put to good use in "adventure" sketching. Figs. 1 and 2 are contact applications of the small. Figs. 3 and 5 are contact applications of the large flat. In fig. 4 the two are combined. Already there emerges the intended aim of our thinking: something in still life, here the lid of a pot. As we progress these lines take on suggestibility. Thus we begin our "adventure" sketching.

In fig. 6 there is further evidence of still life in our penciled musings. We're thinking in terms of receptacles, pots, pans, vases and the like. In fig. 7 the sphere (p. 4, fig. 2) is brought into play along with the straight line. Bowls and fruit at once come to mind. Fig. 8 possesses the suggestion of a pot handle and a pouring spout.

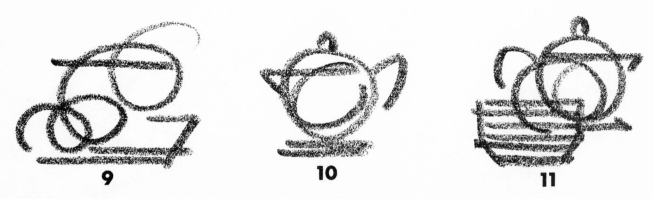

In fig. 9 the rolling lines press toward the fruit-and-container concept and call for relief afforded by some straight lines. Fig. 10 becomes a teapot and fig. 11 suggests a similar pot with possibly a basket container in front of it. All along these loose sketches lean toward still-life expression.

12

13

14

Here before us the simple lines introduced on the opposite page take on greater meaning. Fig. 12 sees a pitcher emerge with fruit and a few shadows. In the sequence we begin to reveal one of the major purposes of the experiment: that of sensing mass and bulk. Tangible weight is suggested in fig. 13 by the use of a few lines. Defining the objects exactly is not as important as feeling a grouping of still-life materials. Fig. 14 is more explicit. Here we hastily, yet deliberately, begin to improvise known objects, keeping in mind all the while principles of good composition.

OPENING THE CREATIVE GATES OF THE MIND

Since "feeler" sketches such as these can be done rather quickly, one thing very often leads to another. The artist can use these probings to select some elements and eliminate others; or he can combine elements from several sketches. In figs. 15 and 16 there is greater involvement. Some of the line work may actually be reduced in the final phases of the enlarged picture. Any set of lines may assume importance, may become thought-provoking to the creator. This fact is demonstrated: it helps to get something on paper. Good intentions never make good pictures unless they are set in motion. Pencil probing often swings open the gates of the mind. "Adventure" sketching can be both a stimulator and a relaxer. It can stimulate ideas and at the same time become a relaxing way of browsing and casually inspecting these ideas.

15

16

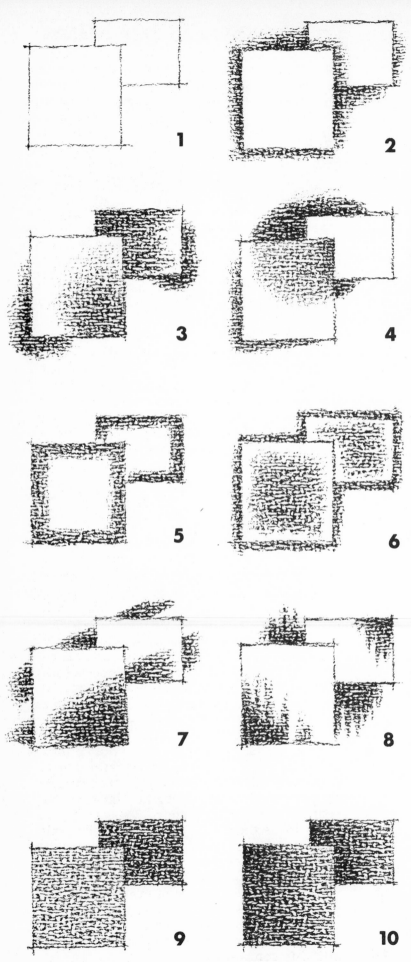

EDGE DIFFERENTIATION

Of what value are these two pages before us? How do they relate to our still-life study? Actually, the exercises presented relate to all of art, so they are of more than passing worth. They may be used only for referral purposes.

This page deals with flats or two dimensions: height and breadth without depth or thickness. The opposite page deals with the extra dimension of depth. In all instances herewith the problem becomes one of edge differentiation. This problem must be met head-on by the artist in all compositions.

First he outlines his subject or treats it lineally; that is, with lines (see fig. 1 on both pages). He may stop there, but usually a dark and light pattern is desired whether or not it is to be in color. It would be a bland exhibit if the art was all line without values or coloration.

Next the artist asks himself how he is going to distinguish one area from another. Simple as it may seem, and simple as it really is, the way it is done may make or break a composition.

Fig. 2 finds the planes assuming greater importance by a feathered support of darks at the outer edges. The front plane is lifted off the second by the same method provided the illusion of space is wanted.

Fig. 3 has graduated values on the planes met by contrasting values either on the planes themselves or under the planes. Observe the dark and light scheme.

Fig. 4 has an oval shape running through, under and around the planes. This sort of thing is good in still-life abstractions.

Fig. 5 carries an interior border treatment that could be widened or narrowed. These borders could be of differing widths.

Fig. 6 has an exterior border treatment with floating value areas inside.

Fig. 7 has acquired diagonal layers of value behind and on top of the rectangles.

Fig. 8 has jagged, vertical streaks on and behind the planes.

Fig. 9 is simply two planes of flat values differing from each other. This is obvious but dependable.

Fig. 10 has graduating values applied so that there is vivid contrast where the planes overlap.

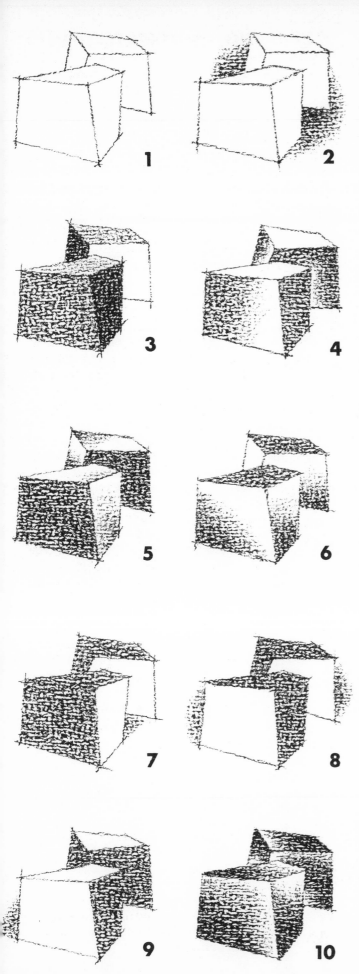

1

2

3

4

5

6

7

8

9

10

FRONT, TOP AND SIDE PLANES

On this page we'll deal with the extra dimension of depth. On the preceding page we had but two planes. And, although these could be separated spatially, and though they could be treated with value gradations, they still held to their two-dimensional state. Most still-life subjects possess side planes and/or top planes. In the case of rounded objects, there are turning surfaces to consider.

In each of these instances we have three exposed surfaces of two uneven quadrilateral forms. They could be called lop-sided cubes or irregular boxes. These shapes are more interesting than two "perfect" cubes with monotonous parallelism. This is why many still-life painters interpret what they see in ways other than with mathematical accuracies.

The total of six planes seen in each of the examples from 1 to 10 are fascinating in their variations.

Fig. 2 is backed up by a feathered value though the two forms remain in outline.

Fig. 3 has darks on opposite sides, left and right, of the two forms. The top planes are treated similarly; however, the front planes are different.

Fig. 4 has one plane of even value, three others go from dark to light and the two top ones are plain.

When there is a change of plane in fig. 5 the edges are met with dark or light. The two front planes are dark overall.

Fig. 6 has the two top planes dark instead of the two front planes as in 5. The remaining surfaces change from dark to light about midway.

Fig. 7 begins a mono-value chain which occurs in figs. 8 & 9 as well, yet on different surfaces. Observe the location of the whites which cut into these adjacent and connecting middle-tones. Value-wise the two forms run into each other, yet they remain apart by reason of the several white surfaces.

Isolate the darkened sides in figs. 7, 8 & 9 so that they are by themselves. Notice the interesting pattern. Form can be defined and flat areas will turn into position even though they are identically valued, provided they are handled in the right manner.

In these three figures the remaining white sides are backed up by incidental spots of gray. A dominating color or value may thus run through a composition by attachment.

Fig. 10 is an example of every visible side going from dark to light leaving decided changes of plane along the way. Try some of these variations on these two pages in your still-life compositions.

OUTLINING THE MIDDLE VALUES

1

The page before this one (figs. 7, 8 & 9) brings up the matter of chains of value running through a composition. If the student will look at his still-life arrangement and mentally comprehend the sequences of these darks and lights, then he will be in a better position to manage them on paper or canvas. The diagrams at the left are not meant as routine approaches to drawing, but are presented to illustrate a point. Fig. 1 is a simplified sketch of our subject consisting of, not so much outlines of the actual items involved, but outlines enclosing the median value as it runs through the whole. We're looking at what is before us and blocking in these areas which will be mono-toned in fig. 2.

LINKING THE MIDDLE VALUES

2

In fig. 2 these areas have been roughed in with little thought given to three-dimensional form. Surely good space division enters into this breakdown of light and gray. We are thinking in terms of pattern and design. The surfaces on the preceding page are flat planes. Here we have mostly rounded surfaces. This roundness is not being expressed in fig. 2. A merging of values into a middle-tone absorbs any detailing or gradation of values. Despite the fact that we have limited our concept to one lone gray, it is still inviting and interesting. From this we know we have wisely chosen a good linkage of shade to be contrasted with the tones above the midway point on our value chart --the range being from light to dark or white to black.

DEVELOPING THE MIDDLE VALUES

Fig. 3 is the completed sketch of the round bowl, the round vase and round fruit stand. Round fruit and rounded drape folds are further defined yet simply done. There are no intense darks or blacks -- there could be, but, in this instance, we have stopped short of any extreme darks. A lone black or "stark dark" would call undue attention to itself. If one were used, then similar value representation should be expressed elsewhere in the composition.

3

ISOLATING THE MIDDLE VALUES

1

In this exercise both flat and rounded surfaces are to be found in the still-life arrangement. Actually, all works of art should have an appeal totally apart from any intended identities. In a very real sense the question What is it? is not as important as How is it presented? Granted, some artists seem ashamed if anyone can detect nameable things in their work. It is just as possible for one artist to be hooked on this notion as for another to be controlled by things as they really are, or ultra-realism. Fig. 1 has the important median values isolated from the rest of the picture. Observe how they cooperatively work together.

ENCLOSING THESE VALUES

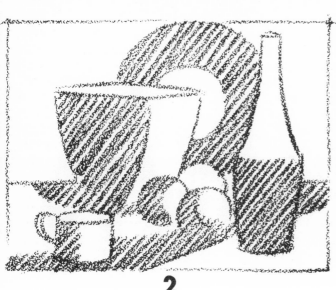

2

Fig. 2 encloses these median values with the outlines with which we ordinarily begin. It is well to experiment with values in their relation to each other before getting caught up in detail. This is not to suggest that this be done in every case as is done in fig. 1, but it is important to have an awareness of the darks and lights in the initial survey of the subject to be portrayed. When the artist moves his still-life items into place, it is smart to be doing this in terms of darks and lights. Being the master of the situation, he can change the value or color of a particular item in the early stages of his planning -- that is, first in his mind, then in the execution of his work.

MAKING THE VALUES
YOUR SERVANTS

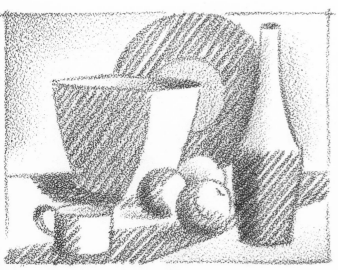

3

Fig. 3 has added values: some lighter, some darker than the roughed-in middle-tone of fig. 2. Attention is called to the fact that, in this sketch, we have deliberately used our components rather than having our components using us. We have used shadow as design rather than law. The bottle is casting no shadow at all on the table, yet the bottle has shadow on its left side. The value streak on the table might be said to partially serve as shadow. True, most of the darks have swung left. Even this is not necessary. The light which makes the shadow should remain your **servant**.

DIVIDING SPACE IN A PLEASING MANNER

In developing a still-life composition, where to stop in the number of pieces to be used is, quite naturally, up to the creator. The old Dutch masters went through a period when they considered many pieces a challenge, and one of their objectives was to make several dozen or more items appear so real that the viewer could reach out and pluck them right off the canvas. Admittedly, some of these pictures look "overstocked."

In preventing a composition from resembling clutter, it is important to train one's discretionary senses so that another article can be added with the result appearing pleasingly complete. There has to be a limit somewhere, and knowing where to stop is part of the problem.

On these two pages is an exercise done with blocks of wood. As we progress, we have several concerns in mind. One is to have each addition look right, as if we could stop there. Another concern is to divide space in a pleasing manner. Regardless of what is used as subject material, space is always divided by lines defining the various elements involved. Still another concern is to keep in mind a pleasing dark and light pattern. Of course, all of these concerns are related.

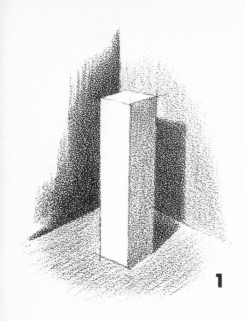

1

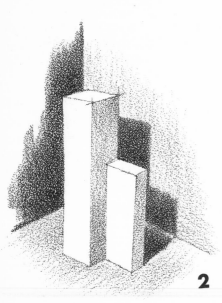

2

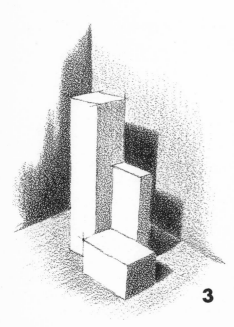

3

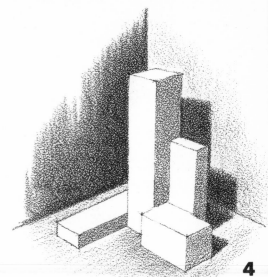

4

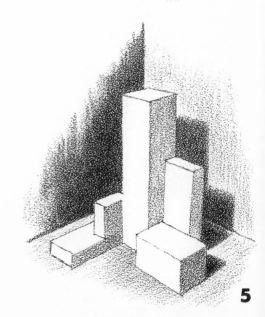

5

We begin in fig. 1 with what we call an anchor piece. We're going to build onto it or around it. Though it stands alone in one sense, it was not placed thoughtlessly. The corner of the room, or shadow box, or (in this case) three pieces of stiff cardboard forming a corner resting on top of a table, become a vital part of the experiment. Notice where the three lines converging on the corner intercept the lone block. None of these lines divide the block edges in center. The single block is lonesome, however, just as a single piece in any still life is lonesome.

In fig. 2 we add a second block, and our interest is more than doubled. This block is not half as tall as the first but is more than half. It could be less, but never half. Already we have something of a completed feeling. At least the two blocks seem to belong -- the lonesomeness is gone.

In fig. 3 a third block is added. It is welcome. It doesn't hurt; it helps. Don't ignore the shadow pattern.

The shadows in fig. 3 are interesting in their own right. But the three blocks would stand alone, as a group, without shadows, walls or floor. Mentally isolate the blocks from their setting and observe how they complement each other.

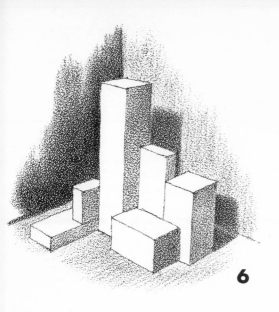

Fig. 4 takes on a fourth block -- and to advantage. It is well placed. This is not to say this is the only place where it could have gone. The new block is cooperative. Spaces and pattern continue to be pleasing.

Fig. 5 sees a fifth and this block seems to say, "I'll join in, for I can be a party to what's going on." This is the smallest of all blocks so far. Often a smaller item in a still life can go in more places than a larger. This is true in this instance. There are numerous positions where it may have been effectively added.

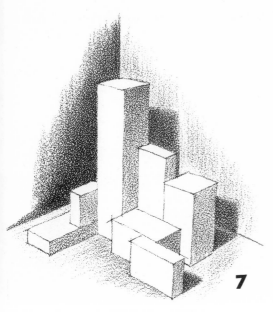

Fig. 6 has a bold intruder. As this block becomes a flanker on the right, it seems to observe all the rules and is accepted by its fellows.

Fig. 7 sees an up-front addition. It becomes a new lead-in and does it well. It is not mandatory at all, but it becomes a part of the whole. With it comes the extra bonus of two dark, interesting, triangular shapes: one a cast shadow and the other the visible portion of the shadowed side of the adjacent block.

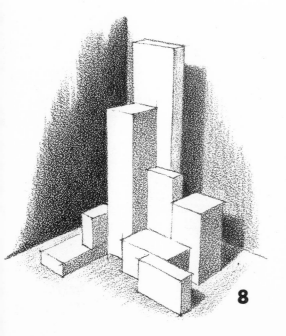

Fig. 8 has a new king block in the background. One might think it would compete with the anchor block of fig. 1, but it doesn't. Why? Because of judicious placement. However, with this there is a feeling that the overall arrangement may be terminated. Some artists could take a hundred or more blocks and incorporate them into a grand abstract design. This could be drawn from the imagination without necessarily constructing a real-life setup. Somewhere enroute the classification would be changed. No longer would "still life" apply in terms of our projected understanding of the expression. Attention is called here to the interesting "running outline" which encompasses the entire eight-block arrangement.

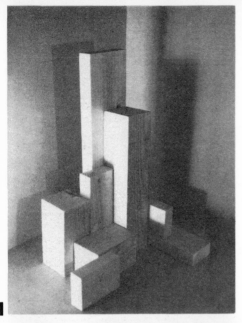

1

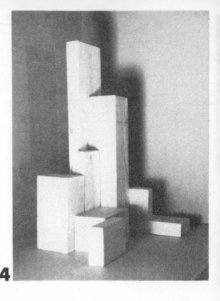

A

4

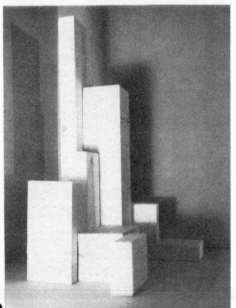

2

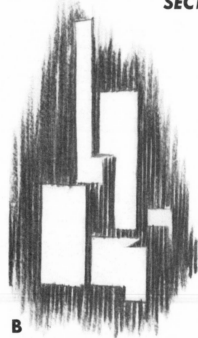

B

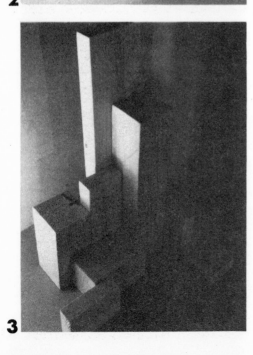

3

SECTIONAL SPACE DIVISION

On these two pages are photographs of the block composition which was assembled piece by piece on pages 14 and 15. If an arrangement is thoughtfully put together, it lends itself to multiple compositions for the artist. When space is properly divided sectionally, it makes little difference what the subject matter is. Consequently, the still life A, being fashioned after the plan in fig. 1, is sound in its composition.

To be sure, good still lifes are not ordinarily built upon such tight volumetric space division. As one can see from these 10 photos, well-ordered volumetric space division looks good from many angles with many lightings. That's why in a school class on still life three or four people usually can work from the same arrangement at the same time. Fig. B is a breakdown of the lights in fig. 2. Again the interest is held high because of the sound composition. If the darks were isolated the same would be true.

Planes that step in, step down, step up and step around can be most fascinating. Light and shadow on these planes can produce striking effects. The still-life student should not be afraid to carry the plane motif into many of his compositions of rounded subjects. In fact, if he would spend a week or two translating everything he sees into planes, he would someday look back on that period as one of the most profitable times of his life.

An awareness of planes in any kind of art pays off handsomely. On these pages the planes are openly obvious. The forms used here about each other so that the floor plan produces only 90°angles: ⌐_⌐_⌐ However, the

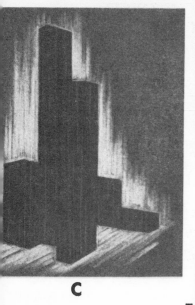

C

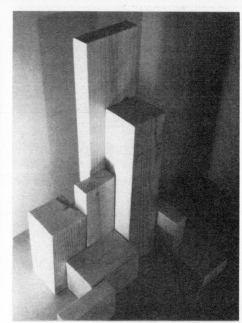

5

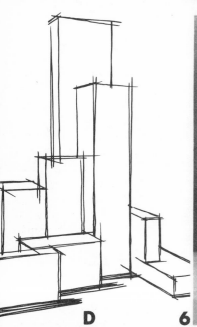

D

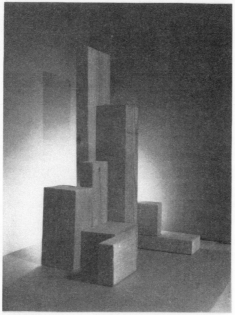

6

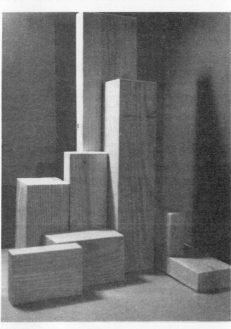

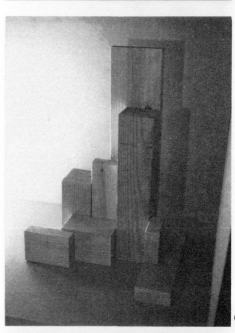

9

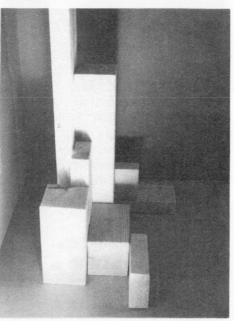

7

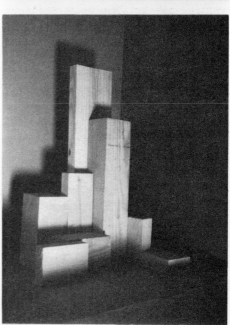

10

eye of the beholder sees
every kind of angle imag-
inable depending upon his
position in relation to the
forms in front of him:

 etc.
(see sketch D above).

 At the top of the page
fig. C is the overall sil-
houette of fig. 5. The in-
terest still obtains even
in the surrounding contour.
Learn to check out the
outer confines of the inner
components. This is a very
good still-life practice. It
can be done in the mind's
eye in a matter of seconds.

PURE DIMENSIONAL FORM

At this stage of our study we could engage in a long discussion on solid geometry. After we finished we would be little better off as still-life artists. However, there are some related matters that can be of considerable help.

In fig. A there are six shapes. These are expressed in their purest structural forms. On pages 4 & 5 we talked of the "five essential shapes" that take in all the various aspects of still life. Here we will refer to the solid particulars and the "inanimate children" spawned by them.

● Fig. 1 is the pure sphere. Of course, there always can be a size difference: it could be the earth or a pea. As it is pictured here, the surface is continually curving convexly and smoothly in all directions. Strictly speaking, neither the earth nor a pea is a pure sphere; nor is an orange, a grape or an apple. And that fact is important to the still-life student. The great master artists turned their fruit in layers of value and color— not necessarily layers on top of each other, but layers next to each other. Few of them tried to reproduce a "pure sphere surface." Indeed, close examination will reveal a feeling of planes on round fruit and round vases. Hence great emphasis is placed on planes in this book (refer to page 16 and especially pages 32 and 33 at this point).

● Fig. 2 is the pure cube. Under conventional lighting it has three values in evidence: highlight, half-light or half-shade, and shade —this being if three sides are showing. On occasion only two sides may show; seldom just one. But here again, many master artists don't want pure, flat values. A flat plane may possess more character if it has variable layers of value or color (in this connection refer to pages 10 & 11 and elsewhere in this book). A variation or extension of the cube shape would be the rectangular box.

● Fig. 3 is the pure cone. The smooth, nonvertical surface of the cone converges upwards toward the apex.

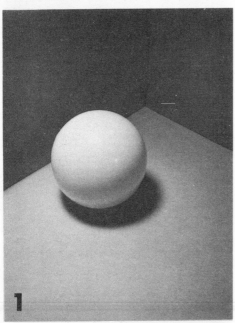

1

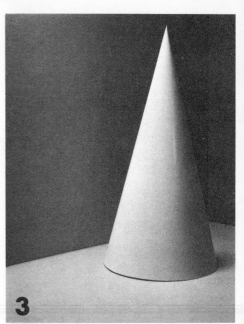

3

2

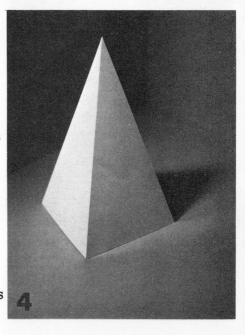

4

What has been said concerning the sphere and the cube still obtains with the cone (fig. 3); i.e., still-life treatments invite layers or breaks in value and/or color as subtle yet detectable planes in defining the surface.

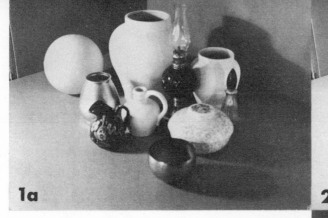

1a

2a

● Fig. 4 is the pure pyramid. It may have as its base a triangle, a square, a rectangle or polygon. The sides always converge at the apex. Both the cone and the pyramid are usually turned over and truncated (sliced off) in still-life pieces (see p. 5; para. marked Fig. 4).

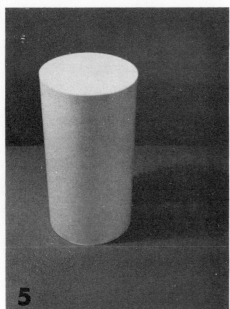

5

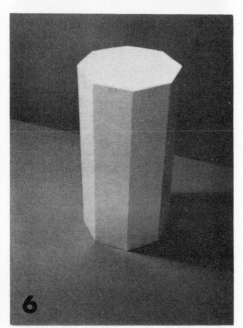

6

● Fig. 5 is the pure cylinder. Still-life objects built on this form are many. A wide range of value gradations may appear on its rounded surface depending on the light source and intensity. As we consider the cylinder we do well to go to the next figure (6).

● Fig. 6 is the pure prism. In this case it is an octagonal or eight-sided prism. Most prism forms in still life are hexagonal or six-sided. A prism is a solid whose bases or ends are similar, equal and parallel polygons, the faces being parallelograms. The reason for choosing the eight-sided prism here is that we see a good value "walk-around." The top is in full light, the left side is quarter-light, then half-light, then half-shade then shade as the four visible surfaces move around. Now, if these four up-and-down values were transferred informally (not mechanically) to the cylinder and the cylinder's top and bottom were shaped as informal ellipses, we would come up with a wonderful still-life piece (refer also to pages 34 & 35).

3a (4a)

5a

6a

● Figs. 1a through 6a show typical still-life subjects based upon these pure forms. Only a few are needed for fine composition.

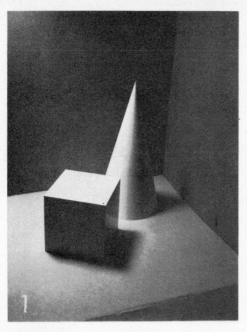

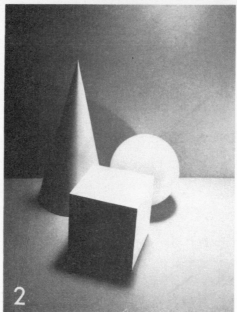

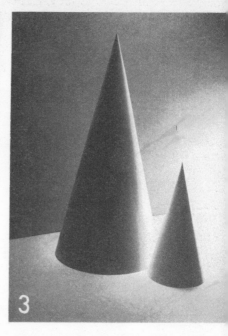

FORMS IN DARK AND LIGHT

On the previous page the argument is made for informality, for looseness of execution, for a break from pure form's exactitudes. A linear preciseness and an uninvolved surface, or we might phrase it, a mechanical outline with a smooth exterior -- these are opposed to linear variance and an involved surface. Fig. A at the right is an example of the latter. It is a painting sketch of the fig. 2 composition. The outward aspect is layered. The surfaces move in steps. The cone has subtle gradations like the octagonal prism (p. 19). The sphere is layered. What

the artist must do is represent and interpret what he sees before him or envisions.

The problem of dark and light enters the picture early. Some of the pure forms spoken of on pages 18 & 19 are grouped in figs. 1, 2, 3, 4, 6 & 7. Intense light is used for vivid contrast. The questions the student should ask are: "Where are the darkest darks and the lightest lights?" and "Where are the middle values in the range bounded by these extremes?" Fig. B across is a crayon

drawing of three apples and a vase. It is done on a middle-toned paper. The highlight on the vase was applied first, then the low dark on the apple. From there the values between were ascertained. Unlike fig. A, fig. B was developed with a marked degree of preciseness. The source of light is from the right so that section of the picture is treated lightly. The background darkens as it meets the vase's white side.

The vase was turned so that the three visible sides are depicted in varying widths and values. Two apples overlap; one is set apart. The apples cast long shadows as does the fruit in fig. 5.

The pure forms of pages 18-21 were made from heavy paper and scotch tape, the sphere is a 98¢ plastic ball, the shadow box is cardboard, the lights are 100-watt bulbs with reflector shades.

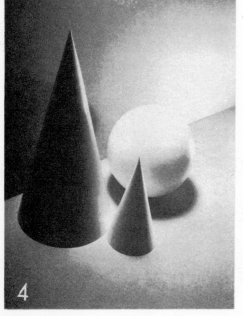

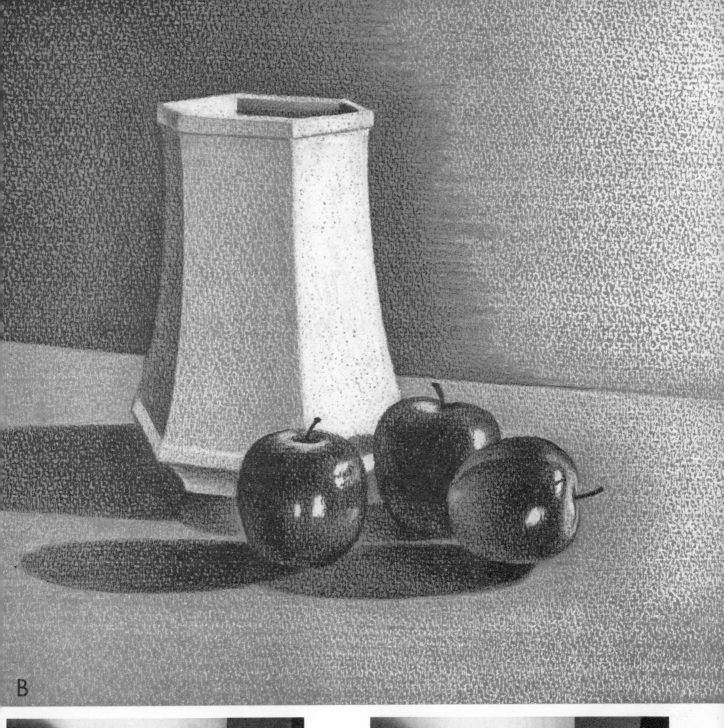

B

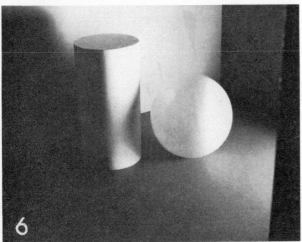

6

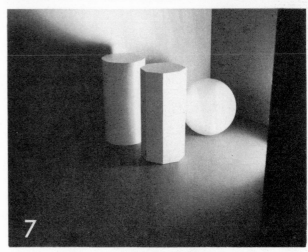

7



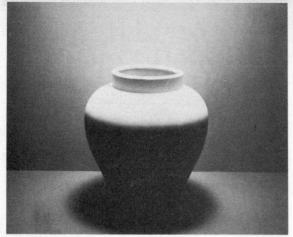

1

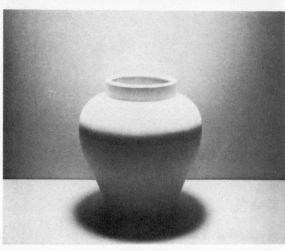

3

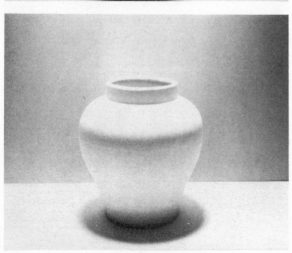

4

LIGHT AND SHADOW

There is no question that the still-life artist cannot draw or paint long without confronting shadow. He need not feel bound to obey all its rules, but he should know that shadows can serve many purposes. They can define an edge, explain a surface, inform of space, capture attention or conceal an area.

Here we have a record of experimentation dealing with shadow and reflected light. It is nearly impossible to set up a still-life display without dealing with light and shade in some way. The originating light source in figs. 1 through 5 is exactly the same. A 100-watt bulb is placed directly over the vase and never moved. The background card also remains constant. The only varying factor is the card on which the vase rests.

The floor surface of your shadow box or table top may seriously affect the appearance of the items on it owing to the amount of light it reflects. This holds true with artificial light or daylight.

The floor in fig. 1 is a dark-colored card with a **coarse-grained** surface. Observe there is no reflected light below the shoulder of the vase. The base of the vase is swallowed in shadow.

Fig. 2 has the same colored floor card as fig. 1, but it has

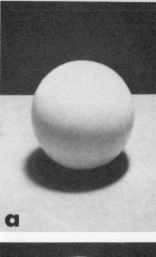

a

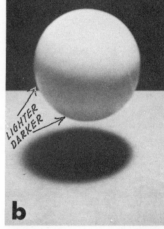

b

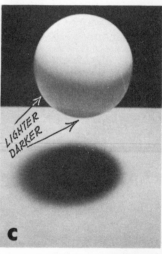

c

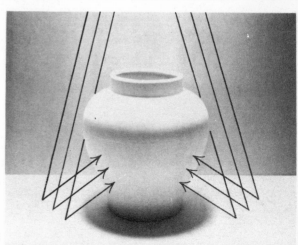

5

22

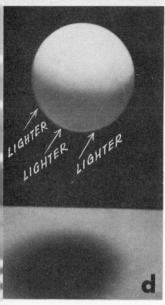

d

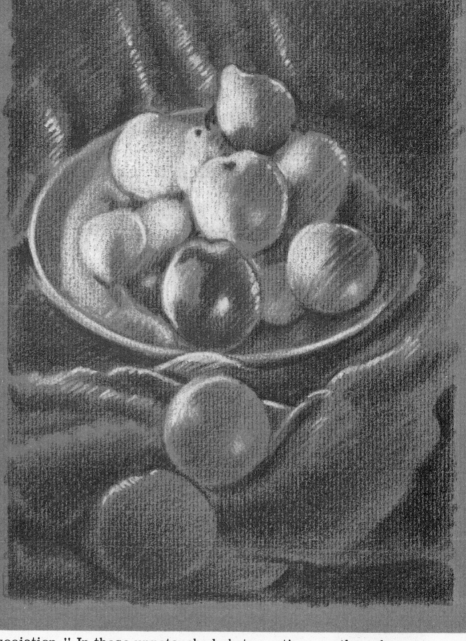

A

a smooth surface. Notice how the lower sides of the vase have acquired partial definition.

Fig. 3 has a white card with a coarse-grained surface. The lower sides of the vase have picked up more reflected light.

Fig. 4 has a white card with a smooth reflective surface.

Fig. 5 is the same picture as 4 showing what has happened. Light rays have been reflected up on the vase's sides. In figs. 1 and 4 we have the same light source, same background card, same vase, but different floor cards.

In fig. 6 the circumstances of fig. 1 are repeated except a white card is placed at the right. Fig. 7 shows how the reflected rays have influenced the vase's right side.

Figs. "a" through "d" illustrate what is called "tendency through association." In these unretouched photos notice, as the sphere lifts, its bottom not only takes on reflected light, but has a tendency to look lighter because of its association with the dark background. Fig. A is a still-life sketch employing these principles. The light source originates from the left. Left lights are direct lights; right lights are reflected lights. Some of the rimmed light is partly due to association and comparison with darks. Instead of cards we have used drapes. Most fabrics are not as reflective as hard surfaces.

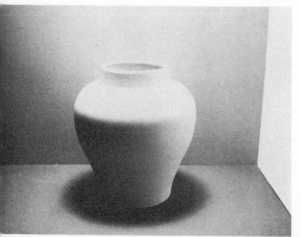

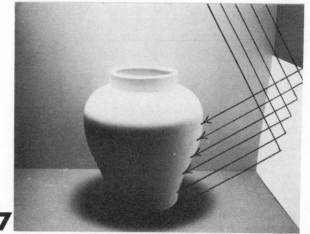

7

VALUES IN COMPOSITION

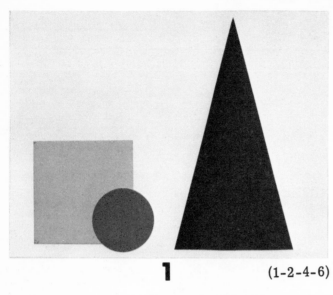

1 (1-2-4-6)

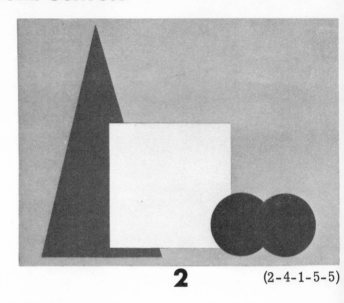

2 (2-4-1-5-5)

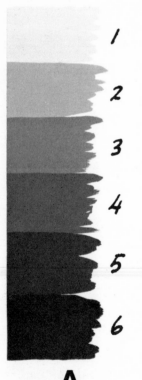

A

On pages 18 to 20 pure form in a dimensional state was set before us. For the most part composition was hardly mentioned. Our concentration was upon solidity as expressed by turning values. In fig. A are six swatches of gouache water paint. Each of these values is only a step away from the one next to it. Had an intermediate step between adjacent values been inserted, it would have appeared to be an undetectable mergence rather than an obvious change. As it is, values A-5 and A-6 are so close as to be a mergence. A value lighter than A-1 might hold optically but would run the risk of fading in reproduction.

To the right of each composition number are the value numbers of fig. A in the order of their appearance. The first number in each case is the overall background value. Each composition (1-6) has a different value background. In this experiment we're limiting ourselves to these flat shapes: squares, circles and triangles (isosceles triangles having two equal sides).

We have two objectives in mind. They are (1) to arrange these simple shapes into interesting compositions, and (2) to utilize four or more of the six values so that they will be pleasingly placed. All the shapes in figs. 1 to 7 are assorted cutouts so that they may be moved about before being mounted. Absolute accuracy in cutting is unnecessary; that is, the mechanical symmetry of each piece. Of course, one can draw the several items in their places, then paint them afterwards rather than using movable pieces.

What have been the considerations in making these compositions?

1. Avoid dividing any existing space in half when laying a piece upon it.

2. Do not allow any edge to flow directly onto another edge when overlapping the pieces. This assures each overlapping piece of looking definitely in front of the piece behind it.

3. Be sure value demarcations produce sufficient contrast between the pieces.

4. Seek to obtain a feeling of balance both with the pieces themselves and the values. Sometimes an isolated shape will counterbalance a group of shapes. A small dark may counterbalance two larger middle values. A small light may do the same thing depending on its location and prominence.

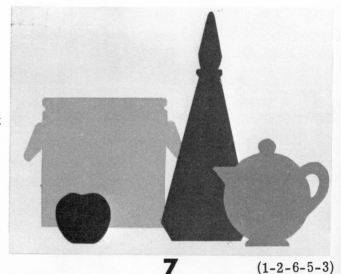

7 (1-2-6-5-3)

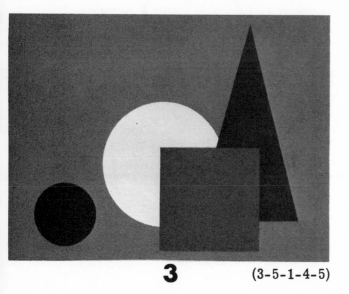

3 (3-5-1-4-5)

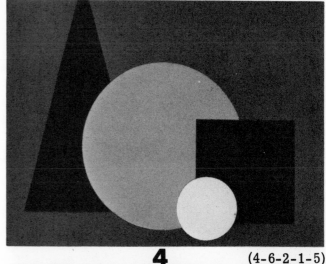

4 (4-6-2-1-5)

5. After your selection is made, test it by checking the negative spaces (those around the shapes) as well as the positive spaces (those within the shapes). Is there fresh variety?

 Though every still-life piece will not fit into a neat geometrical outline, many will. Fig. 7 on the previous page contains two circles, a square and a triangle. They have been changed into identifiable objects. The composition problem in fig. 7 is little different from that in any one of the figs. 1 to 6 including the matter of darks and lights.

B

C

 Fig. B at the left is made up of three geometrical shapes within a vertical frame. Each of fig. C's objects fits into B's plan. The items corresponding to little "a" & "b" are fully contained in the circle and rectangle (except for the small base of "a"). The item corresponding to "c," though fitting into the triangle, has handles and base outside the outline. Small or slender protrusions such as some handles, knobs, lips of vases, pouring spouts, etc., do not mater-

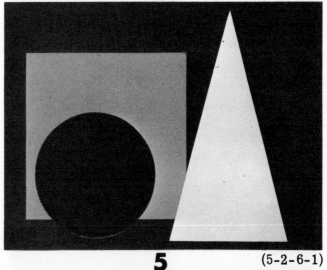

5 (5-2-6-1)

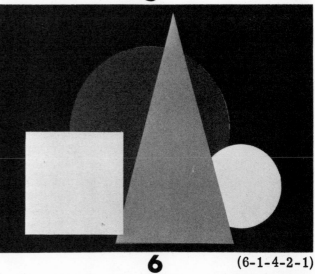

6 (6-1-4-2-1)

ially affect the general shape. The exercise presented here can be helpful in developing a sense of "what to do" when confronted with still-life arrangement and composition. Though a chief concern here has been dark and light value placement, the same exercise can be done with color (keeping the values of the various colors in mind).

VISUAL WEIGHTS AND BALANCE

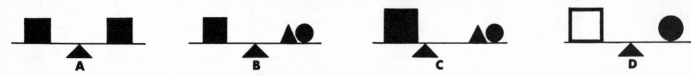

On these two pages we will amplify consideration No. 4 at the bottom of page 24. The matter of balance is very important to the still-life artist. There are several kinds of balance. First, there is that which is called symmetrical balance. This means that identical forms appear equidistant from the balance point (see fig. A above). Sometimes this is referred to as formal or passive balance. Second, there is asymmetrical balance. This means that nonidentical forms appear on either side of the balance point (see fig. B above). They may be equidistant from the balance point (as in B) or they may be unequal distances from the balance point (as in C). The "visual weight" of the big square in C counterbalances the visual weight of the smaller triangle and circle -- in this case the balance point appears at the left of center. Sometimes asymmetrical bal-

ance is referred to as informal or active balance. Fig. D is an example of dissimilar forms having approximately the same "visual weight." These may or may not be equidistant from the balance point -- this would be a "judgment call" on the part of the viewer.

Not only do things and objects have discernible weight but areas of value and color also have weight and are subject to balance. If fig. 1 were divided in four equal parts with the same values in either half, we would have perfect symmetrical balance (as demonstrated in fig. A). Instead we have achieved asymmetrical or active (as opposed to passive) balance with these three unequal perpen-

dicular sections. The darker strip at the right counterbalances the two larger areas of middle value. The visual weight is balanced at the point of the small triangle.

The visual weight is always determined by the degree of attention prompted by contrasting value or color or by any unusual activity in-

herent in the composition. Fig. 2 has more activity than does fig. 1 owing to the severe contrast to the left of center. Notice how this has influenced the balance point. In fig. 3 the diagonal is introduced which is always more stimulating than the more peaceful perpendicular. Though there is more visual weight at the left, it is modulated. The intense contrast at the right is more active

and counterbalances the darker area. Fig. 4 is the most active composition of them all. It contains counter diagonals which slash against each other. The eye is propelled through the painting at a furious rate. The balance point has been omitted purposely to ask

a

b

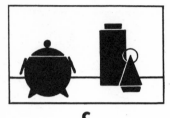

c

d

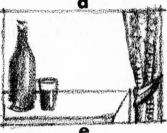

e

f

g

the reader where he would place it. Whereas fig. 5 moves in straight lines, fig. 6 progresses in a circular motion. Again, where would you place the balance point beneath each composition? Look at each in terms of visual weight.

Returning to identifiable material, we would do well to keep in mind that anything in a picture may be a factor in determining its balance. Large expanses in the background, divided spaces, lines and edges -- all can be an influence. If the student sees objects as mass and bulk minus individuality, the problem becomes easier.

The parts of fig. "a" at upper left are the objects in "c" weighed out, calculated in "b" and positioned in "c." Step "a" may be simply a mental process.

The fact that a picture has balance does not necessarily make it a good picture. Sketch "d" at the right has perfect symmetrical balance but is a terrible composition. Sketch "e" has asymmetrical balance and is as bad as "d." Sketch "f" is obviously out-of-balance being lefthand heavy. There is a semblance of balance in "g," but it lacks unity.

What then are the rules for applying balance to advantage? Balance in one sense comes as a result of good composition. Yet when the artist places something here or there, he is working for the two simultaneously, composition and balance.

Whether we incorporate three items (fruit bowl, pot and cup) in fig. 8 or six or more items in fig. 9, we are planning a well-balanced composition. In fig. 7 we have isolated the darks of fig. 8 (this may be done mentally) and considered the effect of their visual weight. Fig. 8 is a closely related group that is in no sense an abstract expression. Fig. 9 is semi-abstract. Isolate the darks in "9" as we have done in "7." Now isolate the lights. Lastly, isolate the middle values. See how they relate to each other. The total composition is in good balance. We speak of balanced meals, rooms, programs and PICTURES.

7

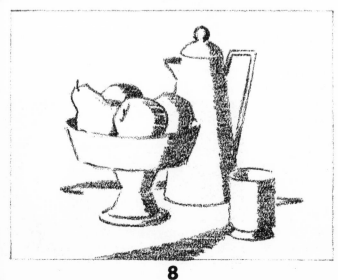

8

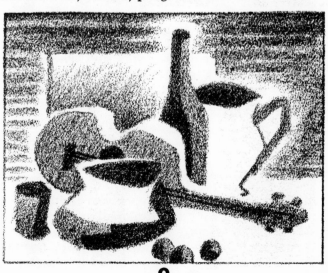

9

LINE-UP OF STILL-LIFE CONTAINERS

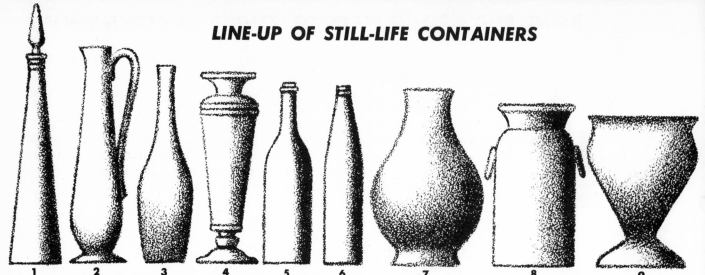

1 2 3 4 5 6 7 8 9

After a while of collecting various articles of still-life material, the artist sometimes refers to the acquisition as the "line-up." These entries do not have to be kept on a storage shelf, for indeed they may be in use about the house or studio. But there needs to be a systematic awareness of their existence as well as their description. Some of the items may be castoffs from a dumpground or a salvage store. Others may be highly regarded pieces from the decor of important rooms.

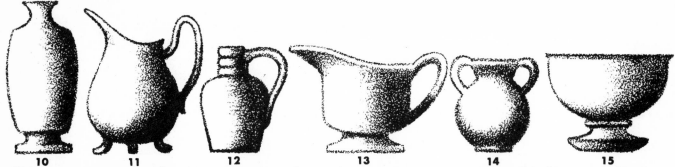

10 11 12 13 14 15

This page contains table pieces or types of containers. By no means does this line-up indicate that other subject material comes second. Fruit, flowers, lamps, clocks, musical instruments, books, etc., are all possible subjects to be used apart from containers or along with them. However some consider the container groups to be nearly indispensable. True, in any still-life exhibit, you don't go far without coming onto containers either empty or holding something. For our purpose on

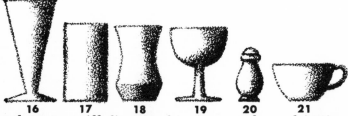

16 17 18 19 20 21

this and the next several pages we'll disregard texture, value coloration and eye-level perspective. Everything here has a straight-on top and a straight-on bottom. The reason for this is that we want to move the identical cutouts around. The succession of the articles from top to bottom (1-24) moves

22 23 24

according to height. To properly arrange subjects in a composition calls for a height and width assessment relating one to the other. On the first row top are the tall items often used as anchor pieces. If the arrangement is close to the picture frame, the tall pieces may serve to divide over-all space to advantage. Likewise a long, flat piece may serve to divide space horizontally.

RIGHT AND WRONG WAYS OF CONTAINER ARRANGEMENT

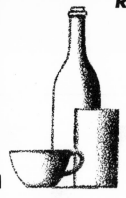

Following are some suggestions which may help the beginning still-life student. Like most "rules" of art, there is nothing so hard-and-fast as never to be broken. But when one observes hundreds of instances where certain procedures are followed, then he can safely conclude that it is wise to learn from the masters.

Fig. 1 is a simple but well-ordered arrangement. The shapes of the objects themselves complement each other. The areas of the visible parts are different and interesting. The darks are well distributed. There is a good balance of curves and straight lines. The running outline encompassing the group is interesting. All of this means it would look well within a frame.

1

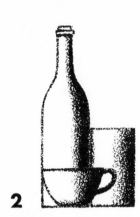
2

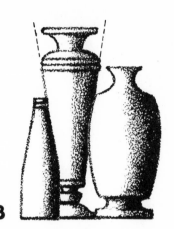
3

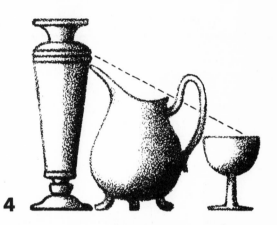
4

Fig. 2 is the same subject matter as fig. 1. The left edges of the cup and glass are positioned to stop right on the bottle's sides. This is considered unpardonable, and some might say it is so obviously in error that we're wasting time and space even mentioning it. Yet it can happen. For one thing, a feeling of dimension is sacrificed: one article is not so likely to **look as if it is <u>behind</u>** another. There is a lack of naturalness in the placement. The running outline binding the group is deficient in interest. Fig. 3 shows some similar mistakes. The sides of the taller vase are in direct line with the sides of the other two articles (dotted line). Fig. 4 has the edges of each item barely touching the next one. The arrangement looks straight across from left to right rather than each piece being placed informally in a pleasing cluster. The large, medium and small, in that order, make for a ski-slide (dotted line) which shouldn't be allowed to happen. When every piece is fully exposed, they each vie for equal attention and refuse cooperative composition.

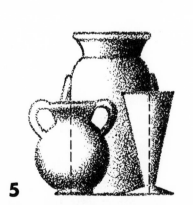
5

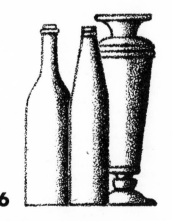
6

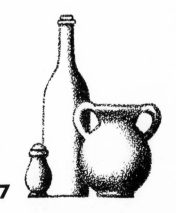
7

Fig. 5 has two articles placed in front of the milk can so that the sides of the can (dotted lines) divide the articles in half. This sort of thing may be a danger sign, especially if it occurs twice in the same picture. The small, round vase had better be moved more to the left. Fig. 6 has two counts against it. One, the pieces are too nearly the same height, and two, the spaces through center are too repetitious and monotonous. Anything which is wearisomely uniform should be avoided. Fig. 7 has variety, is pleasing, and steers clear of the above-mentioned errors.

1 2 3

Continuing the discussion from the previous page, we take up several other points for the beginner's consideration. Arranging small groups of three's is still our assignment, our subjects being taken from the available "line-up." However, each of the three examples (figs. 1 to 3) is poorly chosen. Why? Fig. 1 is made up exclusively of straight lines with no curved-line relief. Granted, above eye-level perspective would introduce the ellipse, but each item is still straight-sided. Fig. 2 is the reverse with all items curve-sided. And, in truer perspective, the tops and bottoms would be defined in more curves. Fig. 3 is suppressed vertically and is overdone horizontally. Now, there are some good aspects about the foregoing. The relative height mark-offs are interesting in each case. One might argue that a theme is followed through. An abstract interpretation might prove a delight. Frames and drapes could help solve problems. Using the same items let's be more selective:

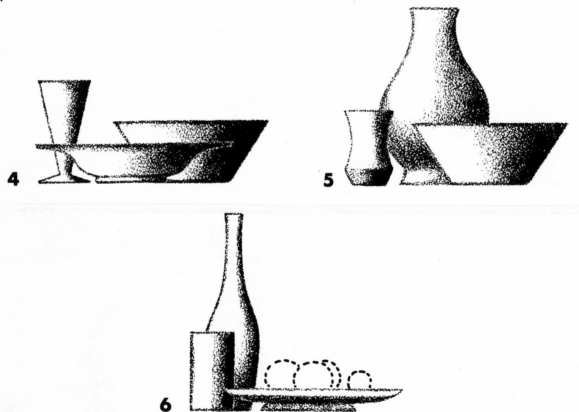

4 5 6

In fig. 4 the two bowls which are strongly horizontal in fig. 3 are brought together with the taller tumbler. The lower bowl has rounded sides which give relief to the straight lines and angles of the other two pieces. The negative space around all the pieces is interesting. Fig. 5 features two curved items with the straight-sided bowl. The straights and the curves give improved variety to the composition. Fig. 6 utilizes the plate, the straight glass and the curved pin-bottle. The dotted lines represent fruit which would enhance the picture. Indeed, any still life will appear more purposeful if at least one of the containers has something in it.

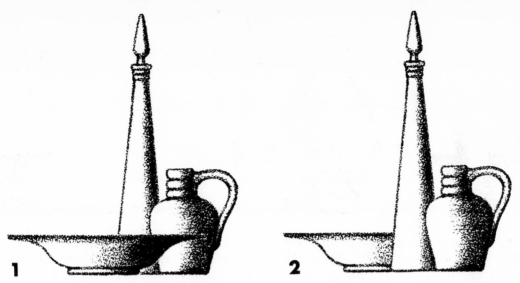

1

2

Above are two compositions that may be described as a "right" and a "wrong." This is not to say that these are the only ways to arrange the articles to be either right or wrong. Fig. 1 is more pleasing than fig. 2. The charm of the little jug is in no way diminished by having the bowl in front of it; whereas the bowl is halved and its symmetry is lost in fig. 2. The beauty of all three pieces is shown in fig. 1 both individually and collectively. Additionally, the line of the bowl leads into the composition, and the simple shadows on the right form an interesting pattern. In fig. 2 the blands of the unshadowed sides are in too close a proximity. Make this observation: if one were to look down from above on fig. 1, the bases of each article would form a triangle. A similar view over fig. 2 would find the bases in more or less a straight line.

3

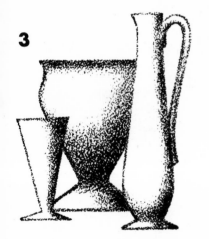

4

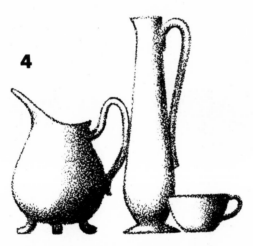

5

The objects in figs. 3, 4 & 5 are not as well chosen as they might be. By way of warning they are assembled. The bottoms of the threesome in fig. 3 are too much the same. In selecting still-life material keep variety in mind. Of course, changes can be made in a drawing or painting to alter shapes and sizes. Do not feel bound to accept every piece exactly as it is. Fig. 4 has items each of which has a round handle. Avoid repetitious characteristics such as this. In this case the tall center piece could have been turned so that the handle would be out of sight. Also the grouping could be improved. Fig. 5 has shapes too akin. These three rounded bodies together are monotonous.

6

Fig. 6 is an example of a lone piece set out by itself (the cup). This is often done. To have all three of the objects separated, however, would be ill-advised. If such a drawing were thus arranged, and the upper and bottom extremities of the items were drawn straight across (as they are here), an abstract or impressionistic interpretation of the entire picture might be best. If realistic forms are desired, then eye-level perspective would better be followed.

LESSONS FROM THE APPLE

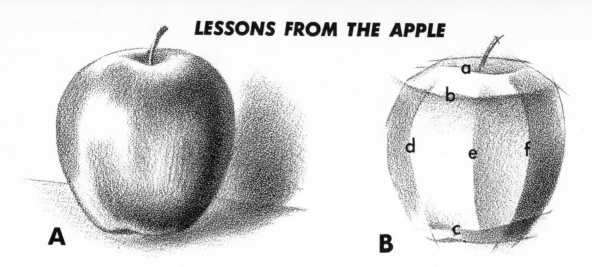

A

B

More apples are chosen for still-life pictures than any other fruit. Two reasons are their diversity and availability. There are some 10,000 varieties of apples grown in scores of countries around the world. Apples are growing somewhere in the U. S. all the time, and they possess more of the legendary and poetic than all other still-life edibles, except for bread. They outlast most other fruits in a still-life arrangement. They come in more colors, shades and sizes than other fruit. This diversity makes them good subject material.

An apple can teach us a lot about form. Fig. A is a realistically drawn example. The student would do well to set an apple before him and draw it as it is before moving on to interpretations. Don't get into a realism rut however. One thing for sure, the apple is not perfectly round like a ball. It has five nodules at its base which give rise to as many or more planes coming up the sides.

Fig. B divides the surface into a turning of planes. Look for these planes when you examine an apple. Of course, their changes of direction do not have to be knife-edge sharp, but they are pronounced enough to catch light and take on shadow. There is a latitudinal change, a, b & c, as well as a longitudinal, d, e & f, change of plane. Different values (degrees of light and dark) can be seen on these planes. They give a feeling of solidity to the object. The apple's glossy surface registers reflections beautifully. Note the highlight (lightest area) and the lowlight (darkest area) in fig. A. Some apples have interesting up-and-down streaks or complete color changes on their surfaces.

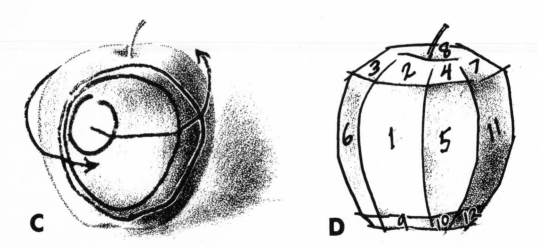

C

D

In fig. C the sensation of turning is illustrated. The small circle is the highlight which is usually somewhere within the second circle. This second circle encloses the area nearest the viewer. From this area the illusion of turning is achieved as the apple's surface "goes around" with the help of value gradations. The far side being out of view takes up at the left as the spatial circuit is completed. Pure, quantitative form needs to be pondered by every artist.

Fig. D suggests a dozen or so changes of plane in the order of their appearance on the value scale. The breakdown is up to the artist. Everything he draws or paints will have the aspect of flatness or thickness, will stay in two dimensions or want to come out in a third dimension.

 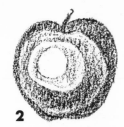

1 **2** **3** **4**

Fig. 1 is purely linear. It would appear flat except for the stem's recession. Most still lifes do not stop with outline alone. Fig. 2 is an interpretation suggesting both the external and internal. Almost anything can be presented in layered step-downs. Fig. 3 is a departure from the circular calling on an angular build-up of planes. Fig. 4 is a thing done by many still-life masters: bold outline with a three-quarter overlay of value or color_ a treatment sometimes claiming "spiritual intonation."

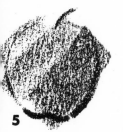 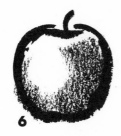 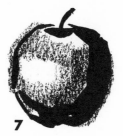 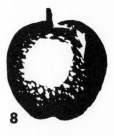

5 **6** **7** **8**

Fig. 5 consists of several values brushed on or sketched on with the apple being defined on top. Of course, the apple could be set down first with the splash-over of values following. Despite this informality, there is still the assurance of form. Figs. 6, 7 & 8 are exceptionally bold, the shadow side at the right going very dark. Fig. 6 has a rim of highlight on top as well as the main highlight. Fig. 8 is first done with wide darks then a stipple applied around the highlight's edge.

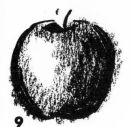

9 **10** **11** **12**

Fig. 9 is somewhat traditional, but notice the splash-over of shading that goes beyond the actual contour. This is one way of keeping the art style loose and the results fresh. Fig. 10 pushes this concept still further. If this were one of many fruits, the others should be drawn or painted after the same manner. Fig. 11 has an opening in the outline at lower left. Breaks like this can tie a subject into its setting. The relaxed edges of fig. 12 hold up provided other edges in the picture are treated in a similar manner. Normally an apple skin is slick, so treat neighboring objects similarly.

 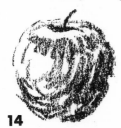 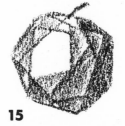 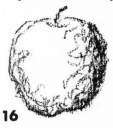

13 **14** **15** **16**

Dry brush is used in fig. 13. Excess ink is removed from the brush's soft sable bristles by stroking scrap paper. Again, the entire composition should be fashioned in the same way. Fig. 14 suggests still another "pencil painting" technique. In 15 the apple form is expressed in facets or crystal-like planes. Elsewhere in this book complete **still-life works** are built on a sectional-theme plan. The modeling in fig. 16 is different from the others on this page. Diverse ways of working often start from sparks of originality such as is demonstrated in the foregoing. Become adventurously experimental!

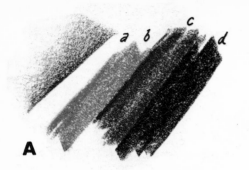

A

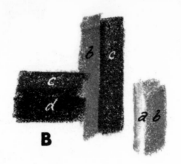

B

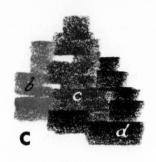

C

1

2

3

USING FOUR BASIC VALUES

Many successful artists tell us how they began by squirting dozens of different pigments of every variety on their palette. Then, as they became more experienced, they narrowed their selection down to a very limited number. With this restricted palette they were able to produce thousands of completely different pictures.

On this page are simple five - or ten - minute sketches using but four values. These are firm pastel or chalk renderings on layout paper. Figs. A, B & C are swatches laid side by side. In fig. A, small "a" is a white backed up by a left-hand shadow to show it's there. Value strokes b, c & d along with "a" complete the quartet. White in this foursome may be the pastel "a" or the paper itself. Figs. B and C are tryout strokes which will be employed in the illustrations on these two pages.

Figs. 1 & 2 are solid forms fashioned by our tetrad of colors or values. If colors are used rather than **grays**, be **sure** that they are few, and more especially, be sure the colors are of correct value. Place sample strokes on scrap paper, then squint the eyes until color identity is lost and only **grays** remain. For this particular experiment, it is best that the student begin with the **grays** at the outset.

Notice how the comprehensible planes in fig. 1 are distinct; whereas the conjectural planes in fig. 2 are indistinct, but still there.

4

We think of a round vase and a round ball or sphere in fig. 3 because they're defined by round edges left and right. But we think of a flat-sided container beside these because it has straight boundaries. The pouring

pot in fig. 4 appears round despite the same values as are used in fig. 1. So then, it depends on how the medium is applied. Project this principle into a larger and more expansive picture, and we have an invaluable help.

Another factor in determining the form is the "d" value (top of opposite page) being set against the "b" value in nearly every case. It sounds very simple to say, "light, medium and dark -- light, medium and dark" and it is! And yet, the next time you go to the art museum, observe how many times in the first 20 pictures along the wall you can find this sequence: light, medium and dark. There may be an intermission of light or there may be an intermission of dark occasionally, then here it will come again, "light, medium and dark." The reverse may be true provided the light source is from the right rather than the left. At times the succession will be from top to bottom. Hardly ever will it be from bottom to top.

In figs. 5 and 6 the simple tints and shades are obtained by "chopping" one into the other. This technique employed in miniature here can be carried over into larger portrayals.

For example, in fig. 7 there is no question about the curved surfaces of the big vessel. In modeling the outward aspect there has been a minimum of "blending." The applied strokes are clean and separate. Refer to fig. A on page 34. In the big vase the white "a" of fig. A is backed up by a lefthand shadow or shading to show that it's there. Then "b" is lightly applied in strokes from

5

6

left to right following the contour of the surface. Though there appear to be many values -- and there are -- they are obtained by crossing the few basics held in our hand. Finally the darkest shade is applied in an arc describing the shape of the subject. Just before the reflected light at the far right there is a quick change of pastel back into the middle value "c." Then the white of the paper serves as the reflected light (in this connection remember the reflected light discussed on pages 22 & 23). Throughout the process of applying the medium, observe that the paper is permitted to show through in places, just as underpainting in watercolor or oil.

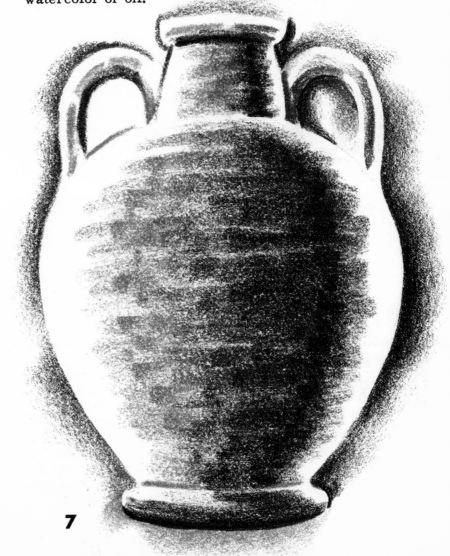

7

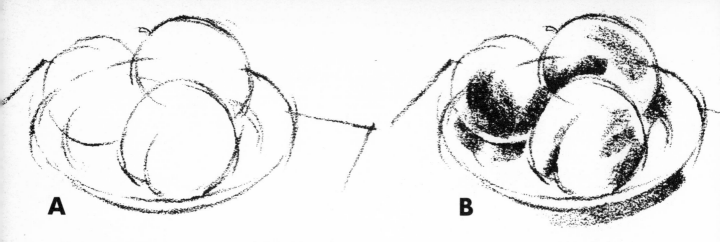

A

B

SMALL FRUIT COMPOSITIONS

Small fruit compositions can be significantly helpful. To launch out on a colossal canvas or a huge picture of any kind can be discouraging. To place several pieces of fruit on the project stand, then lightly sketch their outline, keeping the underdrawing pliable, is to take a step forward. Fig. A above sees the dish running through and behind the apples. Fig. B does not find any one piece finished, but shows a cooperative "building" of values in eight or nine places. Fig. C is the follow-up completion of the sketch. Some darks have been intensified; some lines have been strengthened. Observe where light meets dark and grays bind it all together.

C

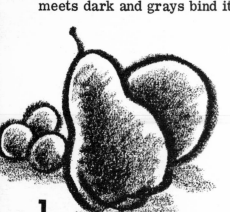

1

2

3

Figs. 1, 2 & 3 are examples of heavily outlined fruit. Begin as in fig. A, then bear down on the contours. Shade interiors to reveal strong relief. Fig. 4 is a more complicated composition with a modified outline. The line work is not so severe, yet is stronger than fig. 6 across the page. There are two clusters of fruit each of which could stand by itself. The bowl, drape and shadow are the unifiers.

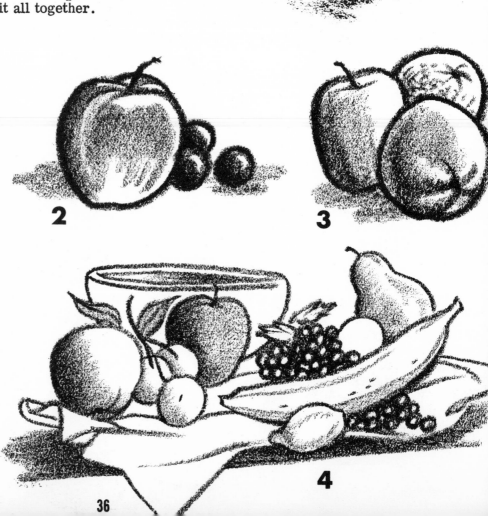

4

Most of the fruit in the still life at the right is seen through the large transparent goblet. The fruit is modeled with strokes conforming with the curvature of the individual pieces. The partial halo over the subject lends a subtle aura of light and adds interest to an otherwise plain background.

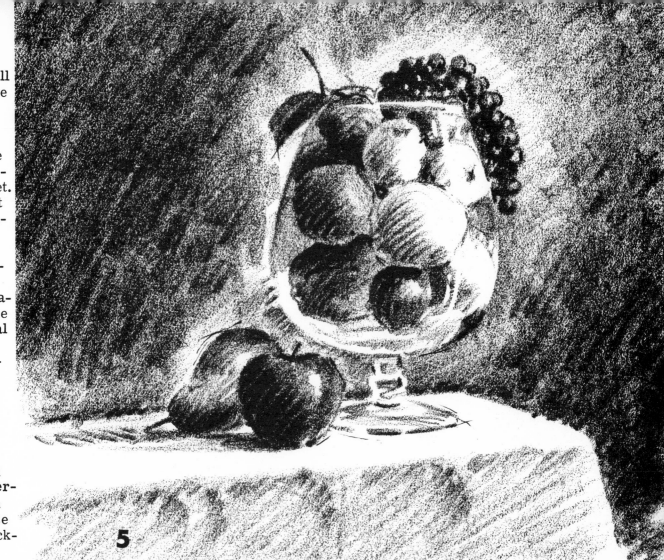

5

PARALLEL SKETCH LINES

In fig. 6 the many articles of fruit act in company with no compositional discord. The fruit, the tipped bowl and the flower vase serve as a threesome. Notice the parallel sketch lines -- always a safe procedure.

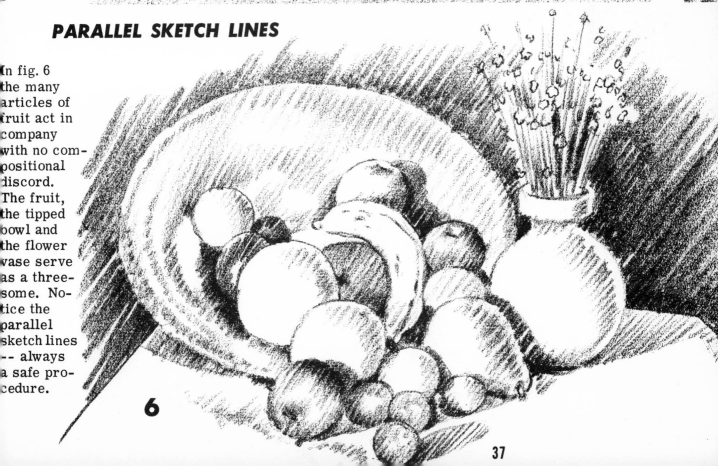

6

PEARS AND PEN

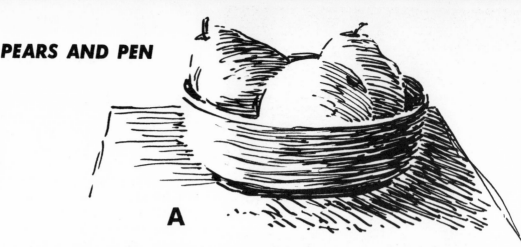

A

2

After the student has familiarized himself with pencil experimentation, he or she is ready to try pen and ink still life. Most of us will agree there is no emphatically patented way to make headway in learning. There may be a slightly different or an altogether different route in the process with various artists. Even so, it never hurts to come back to the elementary basics which are the building blocks in the learning structure. The foundational blocks may be shifted first left then right before the upper floors are built on.

On pages 32 and 33 we stepped to one side to consider the apple in a more analytical way. Like the fine jeweler who has fashioned a crown and picks up a single stone to admire its beauty, so we pick up a pear or a single grape with more appreciation than before. Later we will discuss pen and ink still life in broader terms, but for now we record the pear.

There is the big and little of this regal fruit. Like a banana, it can be a directional piece and "point" as other fruit cannot do. On occasion this is very important (see the pear in fig. 4, page 36). The unique depressions in the surface of many pears make for shadow pockets which we do not find in the apples. These appear as light is played upon them.

In figs. 1 to 5 are simple pen sketches of a single pear. Don't overlook the planes of a pear as shown in fig. 5. In fig. A three pears happily take their place in a plain receptacle on a small table top. Observe how the pen lines follow the curvatures. They're rounded on the pears and the dish; they're flattened on the table top.

Fig. B is a very simple and informal still life in pen and ink. The dark shadows from the pears are as important as the pears themselves in the composition. The last pear in the back says, "Let's go left, fellows, and take a look at the grapes."

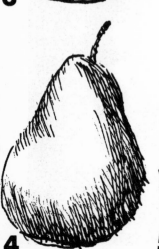

3

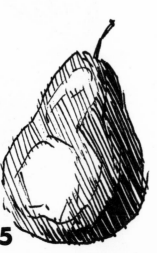

4

5

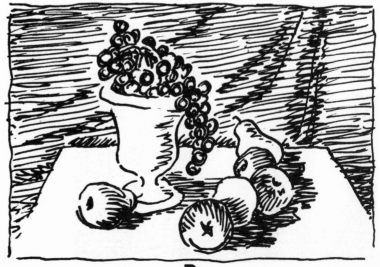

B

CARDS IN STILL LIFE

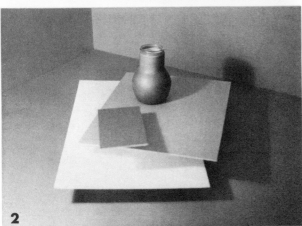

1

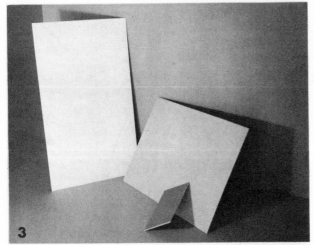

2

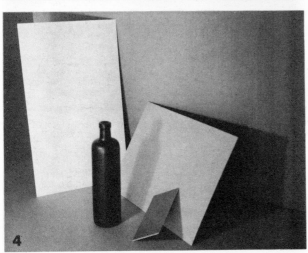

3

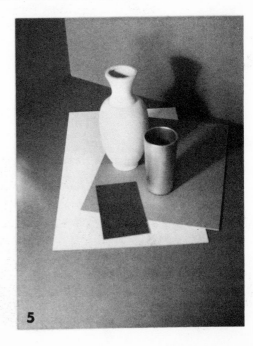

4

Before we get to page 40 and actually begin a large chalk still life, let's consider what cards can do in a still-life setup. Some still lifers never use cards, but they use table tops, ledges, shelves, window sills, etc. These "floor bases" are as much a part of the picture-whole as anything else. They're flat and usually unobtrusive, and that is as it should be. To do them justice and pay them deserved homage, let's lift them up in fig. 1. By their separation we create shadows. So the cards and shadows become "things" in a still life of their own.

In fig. 2 we add a small vase which promptly steals the attention and the cards become supportive in the picture. All the while, the bottom, side and back of the shadow box have escaped our attention completely, but they're there too and have an active role in what's happening. Give all these planes proper credit. They accent the chief focal point, the little round vase.

In fig. 3 the three cards are given new powers. With the help of the shadow box, they beget beautiful shadows which become active participants in a pleasurable composition.

In fig. 4 a bottle is introduced. Like the vase in fig. 2, it easily dominates the scene. The cards gladly yield as they always do when harmoniously arranged.

For the first time in fig. 5 we flatten the cards where they still play a dramatic role in an artistic composition. The small dark card becomes one of a triad with the vase and the tumbler. The entire picture contains well-divided spaces. Should the student wish to engage in such an experiment, a fairly stiff-bodied posterboard should be used.

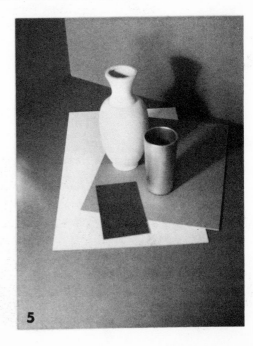

5

1

At the left we're looking at a 21 1/2 inch by 16 1/2 inch (outer frame) picture reduced to this size. We've set up a still life with but two cards and a small cream pitcher. These are positioned in our shadow box. With light-colored chalk (or large pastel) on a heavy middle-gray paper, we have outlined our cards and the back corners of the box. At the very outset, our spaces are well ordered. In one sense, the picture is linearly complete -- it stands on its own at this point.

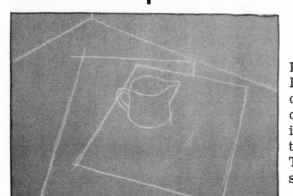

2

In fig. 2 the pitcher is placed in relation with the established lines. Though it appears not far from the center of the outer frame, it is off-center on its base card. The overlapping handle ties it to the second card. Before going further, may it be pointed out that the spaces around the pitcher on the top card are interestingly diversified. The same is true with the second card. The same is also true with the base of the shadow box.

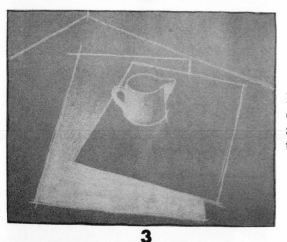

3

In fig. 3 we begin with the lightest of the colors. With chalk or pastel this is a must. Thus the light priorities are established. Strokes of light will be added later, but they are incidental compared with the broad light areas.

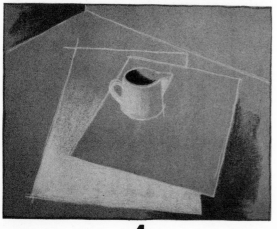

4

In fig. 4 we begin to establish our darks for balance (remember pages 26 & 27). By determining the extremes in light and dark, it is easier to later regulate the values in between. The outer darks as applied in fig. 4 help to stabilize the composition.

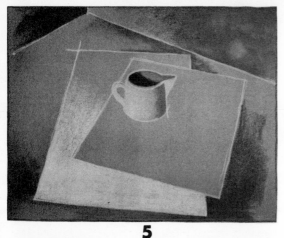

5

Fig. 5 has the first of the middle **grays added in strate-**gic places: in the upper right and lower left, on and in the pitcher, above and below the cards.

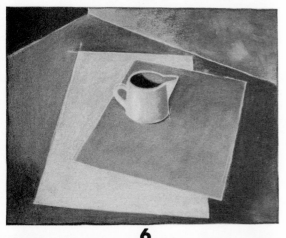

6

Fig. 6 sees an extension of the light on the bottom card and a beginning of shade on the top card. The balance darks (of fig. 4) are also extended. We begin to study the picture for gradation patches of value and/or color.

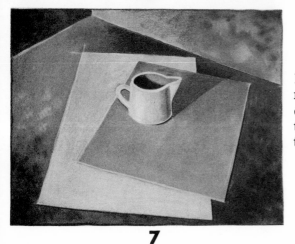

7

Fig. 7 has the gradation patches added, not in a hit-or-miss fashion, but a careful building of texture. The pitcher handle is partly outlined and a strip of half-shade on the right of the pitcher helps to round it out. A shadow that is cast from the pitcher is recorded on the top card.

Fig. 8 is the completed still life with final touches and accents. It should be emphasized that the variously treated shapes defined by the lines and edges are vital parts to the whole of the composition. On the next two pages, enlargements in detail will assist in clarifying these eight steps.

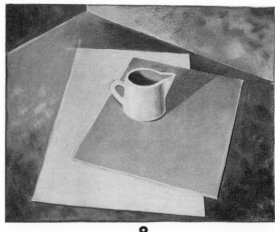

8

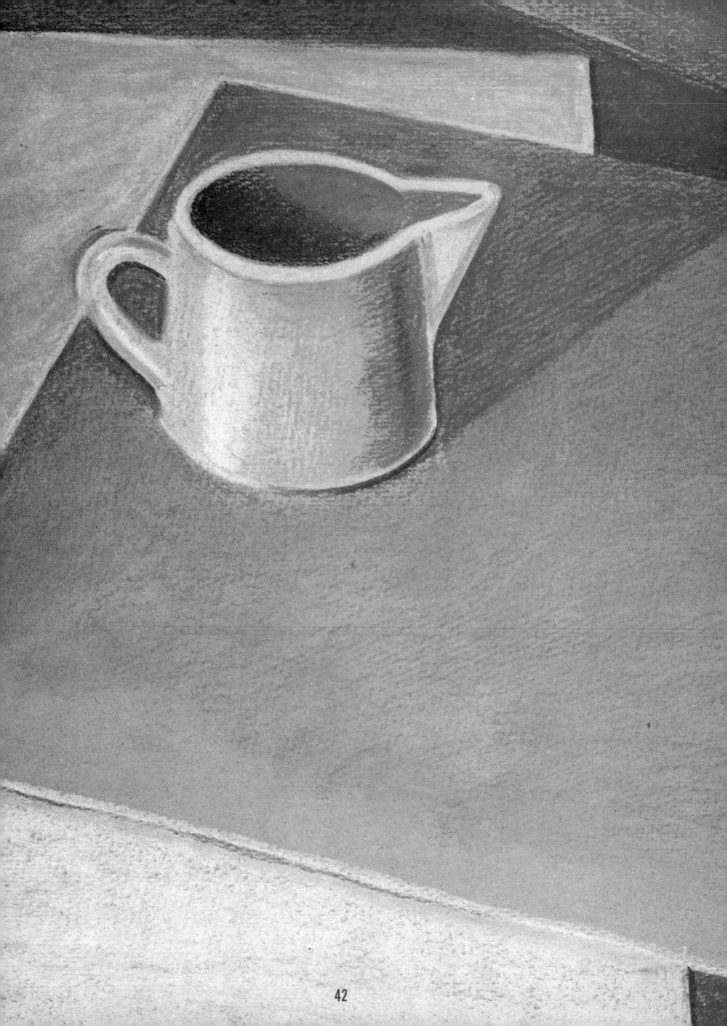

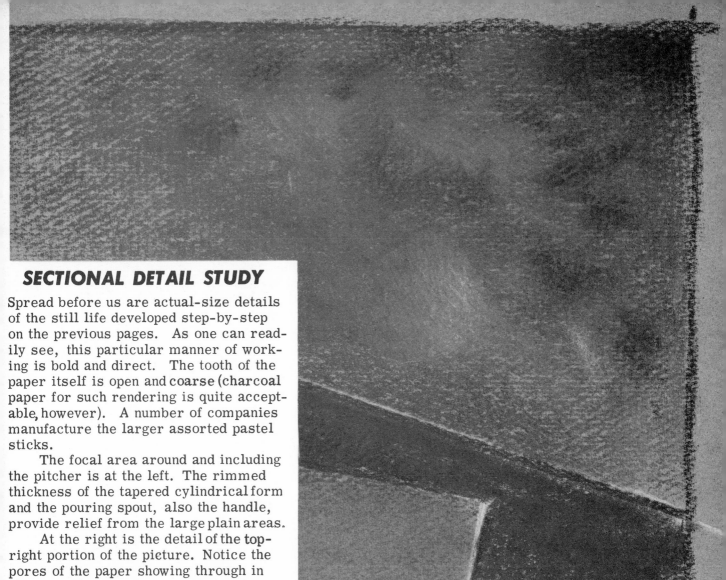

SECTIONAL DETAIL STUDY

Spread before us are actual-size details of the still life developed step-by-step on the previous pages. As one can readily see, this particular manner of working is bold and direct. The tooth of the paper itself is open and coarse (charcoal paper for such rendering is quite acceptable, however). A number of companies manufacture the larger assorted pastel sticks.

The focal area around and including the pitcher is at the left. The rimmed thickness of the tapered cylindrical form and the pouring spout, also the handle, provide relief from the large plain areas.

At the right is the detail of the top-right portion of the picture. Notice the pores of the paper showing through in places. The varishade background patches are in contrast to the smoother treatment of the big cards beneath the pitcher.

Below is the top-left portion further revealing its simplicity. There are many possibilities when using this fascinating medium. To be sure, one may choose more complex subject material, but it is good practice to reduce the elements to their simplest.

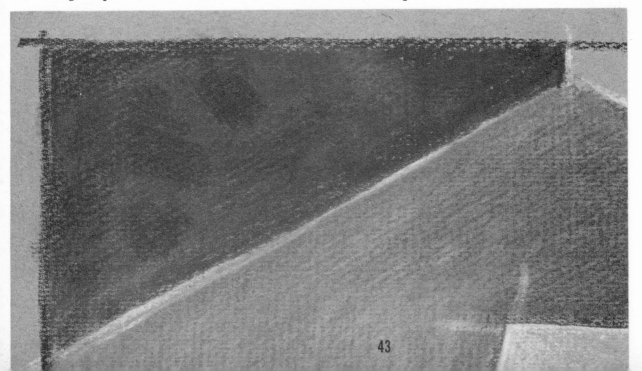

B

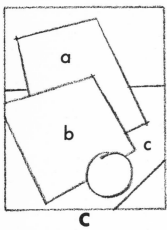

C

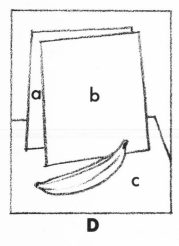

D

THE PICTURE PLANE AND PICTORIAL SPACE

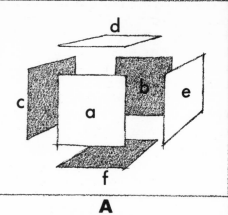

A

Prior to the discussion forthcoming, a still life was presented using only one object and several planes in different positions. That this approach has no limit is illustrated by the three sketches at the left.

Some elemental though useful terms employed by the artist are "picture plane" and "pictorial space." Very simply the picture plane is the plane marked out by the actual frame line of the picture itself. If a sheet of glass were put within the frame line, everything happening in the picture would be happening behind the plane of glass. By illusion sometimes a protruding object can be made to look as though part of it were in front of the picture plane. This will be illustrated later. In two-dimensional art recession into space is made <u>behind</u> the picture plane.

<u>Pictorial</u> <u>space</u> is the space created backward as well as up and down and across. This can be demonstrated by the "exploding cube" in fig. A. There is a feeling of space in and about the suspended sides of what was a cube. This is occurring behind the picture plane. Though picture concepts are put down on two dimensions, there can be a back-and-forth play in depth. **This seemingly extra-dimensional room is our** pictorial space.

All pictures are supposed to cause the viewer to either <u>watch</u> or have an experience of some kind. In the best pictures the viewer <u>enters into</u> and <u>takes part</u> in what the artist has done. If the work is of sufficient merit, the beholder will want to relive the pictorial activity over and over again. These are the pictures we like to have on our wall.

In still life the depth range is usually limited. A scene, on the other hand, may appear to go back a hundred miles. A still life is more intimate and on occasion may have more warmth.

There are three kinds of planes: One, a static plane which parallels the picture plane ;two, a tilted plane which may be thought of as "slightly dynamic" ; and, three, a thrusting plane which pushes into or out of the picture this, then, is a "dynamic" (or active) plane.

Planes "a" and "b" in fig. A are <u>static</u>; "c" through "f" are <u>dynamic</u>.

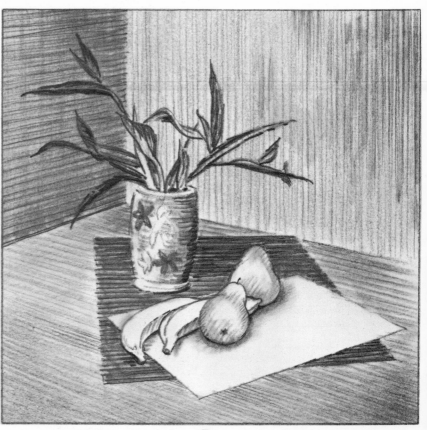

1

Using the definitions at the bottom of page 44, let's label the planes in figs. B to D. In fig. B, plane "a" is tilted, "b" is thrusting into the picture, and "c" (the table top) is an undefined supporting plane.

In fig. C, all three planes "a, b & c) are dynamic. Plane "c" in this case) becomes dynamic in that the diagonal at the lower right defines it.

In fig. D, planes "a" and "b" are borderline, nearly static but slightly dynamic (or active). Had they been straight-on and parallel to the picture plane, they would be static. The "c" plane here is thrusting back like the "c" of fig. C.

The two cards beneath the bananas, pears and vase in fig. 1 are dynamic planes thrusting into the composition. These combined with the diagonals of the shadow box furnish an active setting for the main subjects of the picture. There are five planes in fig. 1, two perpendicular and three level one with the other.

Leaving the more simple examples, let's go to fig. 2 and examine the pictorial space in this still-life composition. Here the soft drape is added which counteracts the severity of the flat planes. We have several step-backs into our pictorial space beginning at the front rim of the

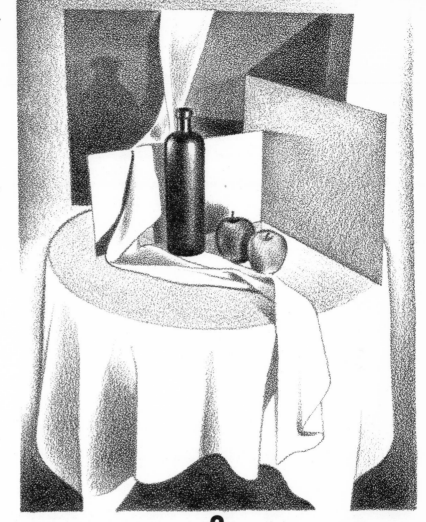

2

round table top. Actually, this forward table edge is in front of the picture plane, because the lower corners of the table cloth appear to be on the picture plane both left and right. This positions the table's leading edge and the center folds of the table cloth in front of the picture plane. In fig. 3 below, the flowers in "a" are behind the picture plane, but the forward flowers in "b" are in front of the picture plane as illustrated in "c" when that plane is turned sideways. When the base of the vase is on the picture plane (b), the flowers above it naturally protrude. The other way a part of the picture may appear to be in front of the picture plane is by violent perspective such as the fist of the man in "d."

The three planes on top of the table in fig. 2 help "bring into being" pictorial space. The receding drape on the table becomes an "eye track" as it goes up and over the planes -- this further develops a feeling

a b c d **3**

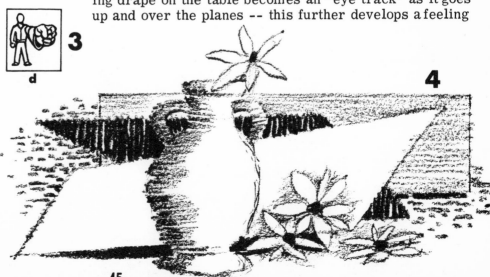

4

of pictorial space. The various shadows also promote spatial feeling.

Fig. 4 at the right is a more stylized, decorative handling of planes. The back card is static by our definition. The two front cards are dynamic by shape (being trapezoidal) more than by thrust (see fig. 1 at the left).

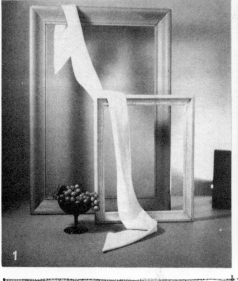

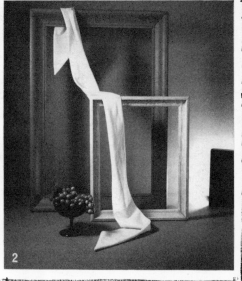

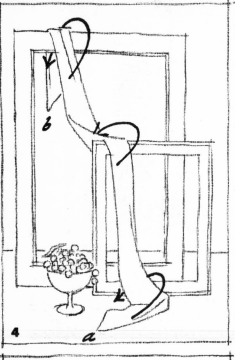

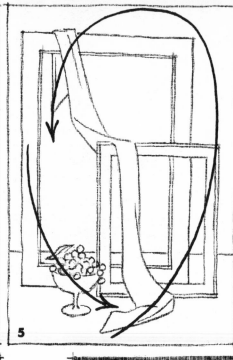

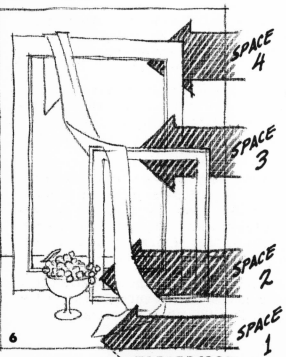

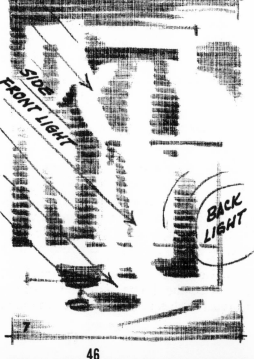

SPATIAL STEP-BACKS IN STILL LIFE

In still life the depth range, or the distance from the picture plane (described on page 44) to the backdrop, must be predetermined by the artist. There is no point in feeling required to take the viewer more than a few feet into pictorial space (see again on page 44). Some fine still lifes have far-away scenes behind them, sometimes seen through a window and sometimes by virtue of their being placed outdoors at the start. Since the engaging drama in a still life can be altogether satisfying when told in close quarters, it does not need far-flung additives. Indeed, anything portrayed very far behind still-life subjects had better be quiet and completely submissive to the upfront happening.

Just because we are going to limit our total pictorial space, however, does not mean we

cannot have a number of pleasing step-backs. In fig. 3 there are four planes; that is, counting the picture plane itself. They are static but distinctly separated by overlap and value change. They represent the planes bounded by the two inner-rectangular frames in fig. 8 and the wall plane behind them.

Experimental physics has it that there is nothing to distinguish one part of space from another except its relation to the place of material bodies. Our interest here lies not in technicalities but in friendly facts -- something we can use in everyday art. Yet this contribution from physics holds true.

Figs. 1 & 2 are photos of our subject. Each has different lighting. We'll not be bound by either, but will take parts from both. In this particular still-life experiment we will follow rather closely the realism before us. Our attention is first called to the drape which helpfully acts to explain the picture's recession into space (see fig. 4). Should the two inner frames, the drape, and the fruit dish be removed, there would be nothing left to tell us whether the remaining horizon line was that of a two-inch shelf or a thousand-mile desert.

Notice the arrows in fig. 4 which mark off space as the drape progressively recedes. Later in this book the topic of drapery will

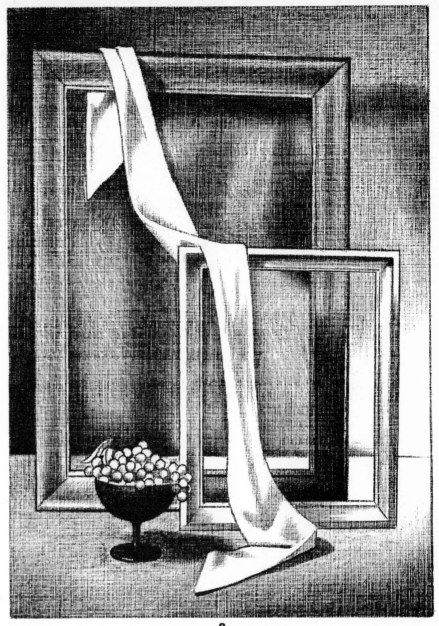

8

be more thoroughly discussed. The foremost thing (a) is the drape and also the backmost thing (b).

In fig. 5 the general follow-through for the entire picture is indicated by the sweeping arrows. Inasmuch as the righthand stagger of the two inner frames cooperates with the directional lines of the drape, there is little or no tension in the travel experience taken by the eye.

Fig. 6 registers the spatial divisions felt in the composition. Space 1 is just behind the picture plane, and space 4 is just in front of the plain backdrop. It would have been a mistake to have used a busily patterned backdrop. The shadows from the side-front light (diagrammed in fig. 7) throw enough pattern on the wall as it is. These subtle shadows serve to aerate the background portion of the picture and become a part of the composition's overall simplicity.

All we have done in fig. 7 is to indicate the influence of the two lights and their resultant shadows. The back light source is in evidence in figs. 1 & 2. This is only a 100-watt bulb in a metal shade placed behind a book. It furnishes the contrast wanted for the second frame dark in the lower right portion of the picture. Inner frames can be used in many dramatic ways, and they're not hard to secure. They can be employed in surrealism in extreme ways as if marking off segments of time in a dream world. Here we simply lay claim to close-quarter space division.

In fig. 8 attention is called to the supporting darks and lights on and behind the hard straight edges of the frames as well as the darks and lights used on and behind the soft curved edges of the drape. The dark of the fruit dish and the lights in the grapes further this study in contrasts.

A

B **C** **D**

OIL AND ACRYLIC PAINTING

There are many similarities between oil painting and acrylic painting. There are advantages to each. Acrylics dry faster (to some an advantage), but an easily mixed retarding medium can slow the drying time. Above is a piece of fruit painted with a palette knife. "A" is the middle base color. "B" is the first overspread. "C" is the second overspread and "D" the third. Colors ma

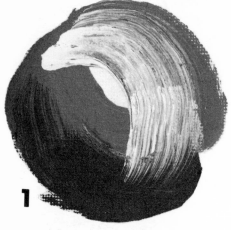

1

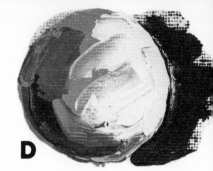

2

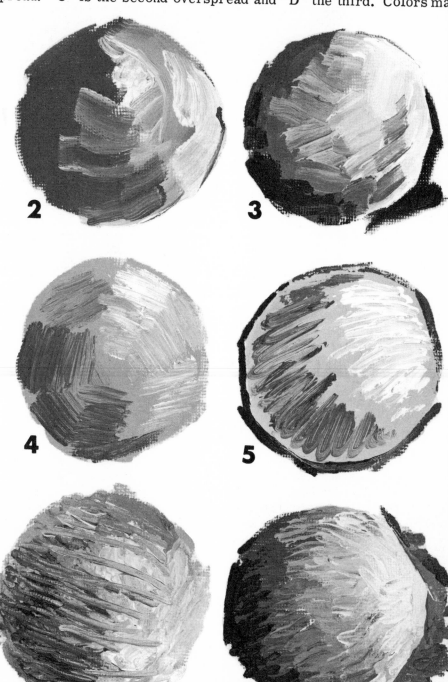

3

be mixed or blended with the flexible palette knife blade. Acrylics may be used directly from the tube or thinned with water. Brushes should be wet from the start and kept wet throughout. They should be washed with soap and water immediately at the end of every painting session.

Before the student paints a still life, it is well to experiment with the new medium. Fig. 1 demonstrates the possibilities with wide flat brush strokes; fig. 2 with a more narrow flat brush. Fig. 3 has more modeling, but is kept fresh, is not overworked. Fig. 4 rounds the form in straight strokes. Fig. 5 has the paint stroke riding on top of the thinner wet paint beneath, then an outline confining the whole. Fig. 6 is textured with the paint left in a semi-mixed state. Fig. 7 has several pure colors laid over each other with just enough blending to crisply round the form.

4

5

6

7

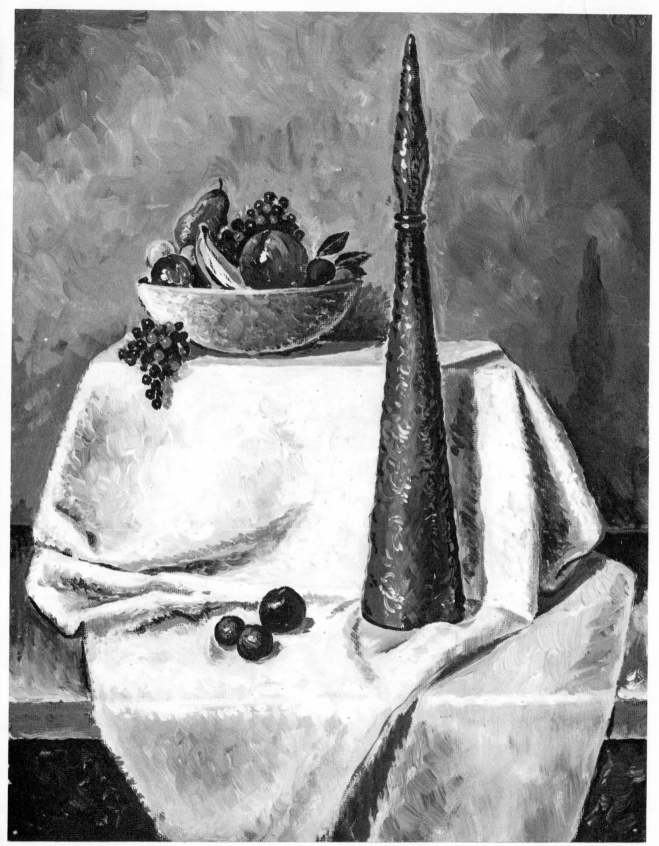

Here is a still life utilizing the principles presented in this book. Of course, there are as many different ways of painting as there are people in the world. The student should not seek to become somebody else. But it is soundly advisable to invite the works of the masters to become personally instructive. To closely study the labors of recognized artists is wise self-teaching. As we proceed with our investigation, make a list of things you wish to look for during your next library or museum visit. Ask yourself: how did Van Gogh and Gauguin do it? How did Cézanne and Manet do it? How did Braque and Gris do it? Pick a point from each picture before you.

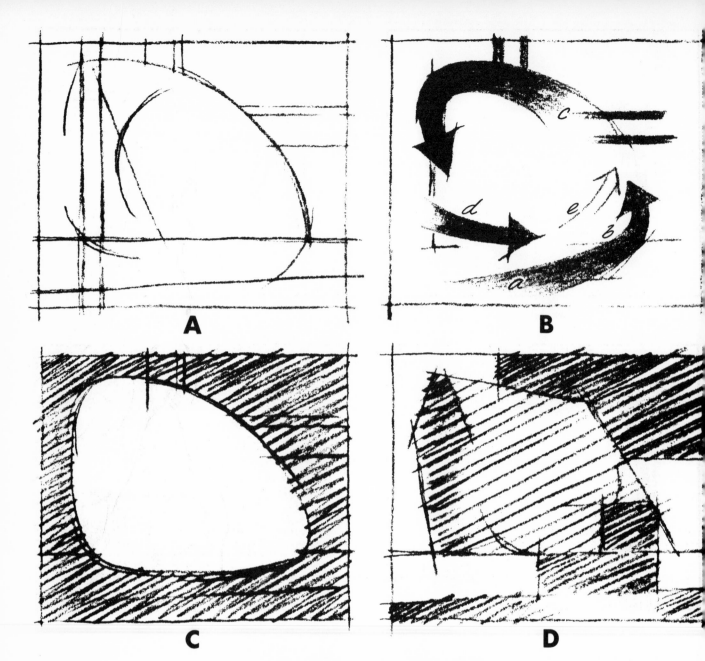

A	B
C	D

PEN AND INK STILL LIFE

Looking forward to the finished pen and ink still life across the page (fig. 4), we review the prelim
inary steps in the planning. Immediately, this question presents itself: which comes first, the
real-life setup or the two-dimensional paper work? The toy knight, the round brass plate, the
wooden chest and the miniature skull had to be initially arranged by the hand for the eye's provi-
sional approval. A thoughtful shifting about of the items is unavoidable. In most good composition
a few sweeping lines can contain the various components besides provide the directional feelings
in the picture.

In fig. A above we're testing our composition within the allotted rectangular frame. We see
that our grouping is sound and that the major space divisions are shaping up. In fig. B we con-
template the follow-through for the eye. There is the entering point "a," the link-lines of direc-
tion "b" and "c," and the return "d" for the renewal movement "e." Our aim: to keep the viewer
as long as possible; if he must leave our picture, let him go on his own, never send him away
(with poor follow-through).

Fig. C represents the two general areas of concern: the focal area (in white) where the ac-
tivity is to take place, and the outlying area (shaded) where the passive support will appear. The
to-the-right-rear frame which only partially shows behind the brass plate is static except for som
subdued line work contained within it. Fig. D is a breakdown of the dark and light pattern. Be-
cause the toy knight attracts so much attention, we will darken the end of the chest and its reflec-

1

2

3

4

tion as a counterbalancing measure.

Fig. 1 above is the light penciling which we keep pliable until it faithfully outlines what we want to ink later. At this stage notice where the knight's shield, the forehead of the small skull, and the chest cut in front of the round plate. The plate serves as a binding agent for the picture. Not only that, it ties onto the wall frame behind it.

Fig. 2 sees our first pen and ink application. At no place do we attempt to finish a part completely. We build the entire composition as we go along. What is happening does become more detailed, but only in outline form.

In fig. 3 the final touches commence to appear. Even so, observe that we "go about" over the picture, all the while honoring the dark and light scheme decided upon in fig. D on the opposite page.

As one can see in fig. 4, crosshatch pen work is sparingly used. Most of the shading is done in a parallel-line treatment. The crosshatch on the knight and at the end of the chest is kept open so there are no clogged areas. The strip reflections on the toy knight help retain the metal look -- the same with the swirl reflections on the brass plate.

The reflections in the highly varnished table top are used to advantage in becoming a sustaining base for the pieces above them. The glossy surface, though actually horizontal, has its shadows reflectively described by perpendicular lines done with the pen. These subtle shadows are vital to the overall design despite the fact that they are not tangible "things." The pen point used for this still-life study was the Gillott 170. The paper was a smooth two-ply bristol.

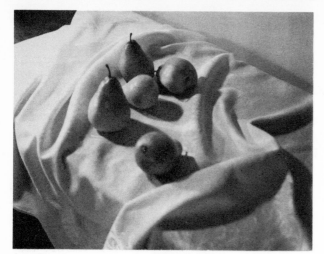

A

ROLLING ACTION IN A STILL LIFE

Why try to achieve "action" in a still life? Or, is it possible to reach a stage in a still-life development where there is as much action as in a marine painting where restless waves roll into the shore line? Maybe not entirely. And yet, when there is a certain departure from subject matter in favor of pure graphic encounter, there is good argument for the end effect being equally as moving. In this case, we're not going to go abstract, though we could easily enough, but we're going to stay with drapes and pears as we know them. Later, in other experiments, we'll veer completely away from conscious identity.

In order to more clearly illustrate what's going on, we'll devote the entire space on pages 54 and 55 to enlargements of the pictures on these two pages before us now. We'll talk about the methods involved while referring to figure numbers which match both sets of pictures. Once again we are aware of the difficulty of saving exact sections of the book for segregated aspects of still-life study. In other words, it is necessary to touch on related phases frequently even when discussing particulars. One cannot always have just drapes or just fruit or just this or the other. So, we borrow on drapes and fruit in this instance

1

Above: the general action.
Below: the picture outline.

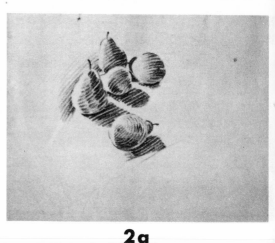

2a

Above: fruit detail isolated.
Below: major darks isolated.

2

2b

for a commentary on <u>action</u>. As we move along, we believe our approach in the advancing study is relevant, for we must never lose sight of the whole, the ultimate goal.

Actually, some kind of action in still life has been blended into our discussions almost from the start. In one sense of the word, action takes place as soon as the simplest line is put on a receiving surface, for as the reader knows by now, the eye follows line; also the eye moves from one mass to another when they are properly arranged. So we have linear direction and areal (from one mass to another) movement. The action feeling may be of different tempo: fast or slow, smooth and rhythmic or uneven and intermittent. It may be considered to be good action or poor action. The dynamic planes mentioned on pages 39, 40, 41, 44 and as early as page 11 deal with degrees of "thrust" -- a definite kind of action. Drapes invite more curves than planes, and hence may incite more <u>rolling</u> action. In fig. 5 the entire composition is roughly set out in straight lines which is quite unlike the true nature of drapery. We feel as much action, but it takes on the disposition of repeated thrusts as opposed to the rhythmic swirls of the subject before us.

Now, back to the drapes which constitute the greater portion of this composition. Before the pears are positioned, we lay the pliant cloth flat on the table top. Next the cloth is bunched slightly from left and right. Then both hands are placed palm down where the pears will be, and a swirling motion is enacted influencing the existing folds. A few touch-up pushes here and there produce the desired effect. All the while, the aim is to make the fold arrangement look natural. Also, we keep in mind that it eventually is to be seen behind a rectangular picture plane. Because the drape is supple and adaptable, it reveals three edges of the table top beneath: top right and left, also lower left. For a better delineation turn the page to fig. 4.

3

5

Above: preliminary plotting
 of values.
Below: final technique for
 either paint or pencil.

Above: the subject interpreted in straight lines.

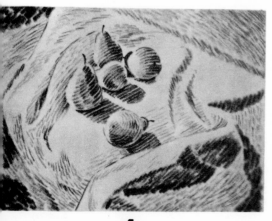

4

In the large fig. 4 (p. 55) notice the stroking technique used. Except for the flat on which the pears rest, the strokes have gone directionally with the sweep of the action shown in fig. 1. This treatment can be applied in many mediums. Related remarks under the heading of "texture" can be found on pages 62 and 63. On the pears themselves the strokes have followed the contour, and the strokes of the shadows from the fruit lie on their respective surfaces. Despite the fact that a limp table cloth and five docile pears constitute the sum total of our subject materials, the finished picture possesses vigorous action. There is a balancing pendulum effect produced by the darks in the bottom portion of the picture. In all, the circular pattern, the pursuing strokes, the persistent **counterclockwise drive**, we have an exhilarating still-life experience.

1

2

3

4

(see comments on pages 52 & 53)

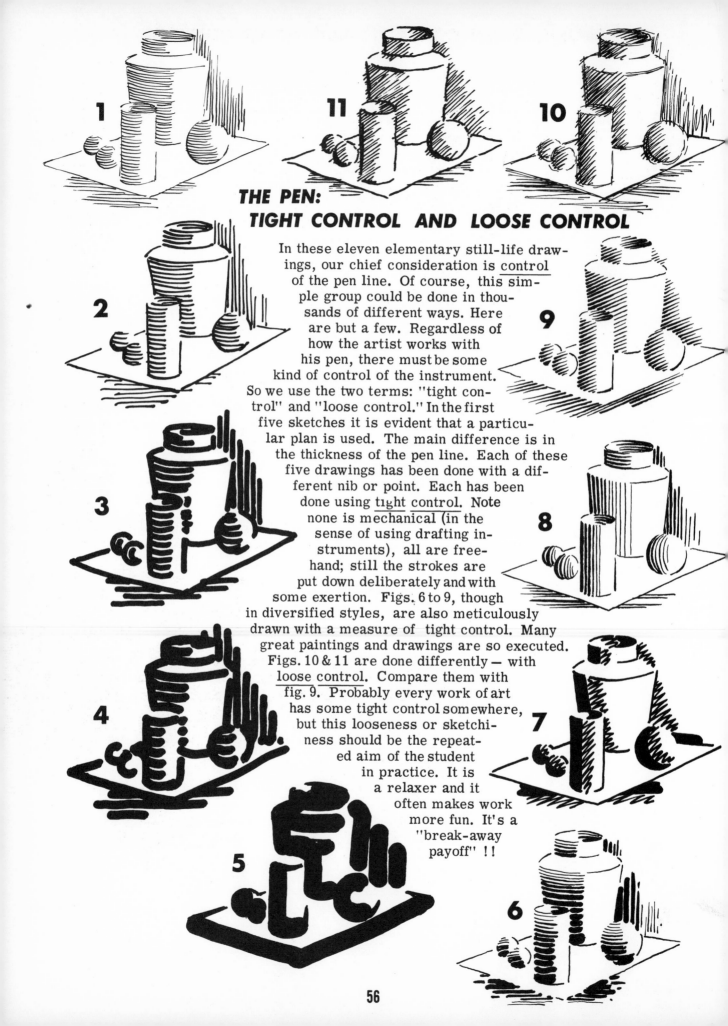

THE PEN:
TIGHT CONTROL AND LOOSE CONTROL

In these eleven elementary still-life draw-
ings, our chief consideration is <u>control</u>
of the pen line. Of course, this sim-
ple group could be done in thou-
sands of different ways. Here
are but a few. Regardless of
how the artist works with
his pen, there must be some
kind of control of the instrument.
So we use the two terms: "tight con-
trol" and "loose control." In the first
five sketches it is evident that a particu-
lar plan is used. The main difference is in
the thickness of the pen line. Each of these
five drawings has been done with a dif-
ferent nib or point. Each has been
done using <u>tight</u> control. Note
none is mechanical (in the
sense of using drafting in-
struments), all are free-
hand; still the strokes are
put down deliberately and with
some exertion. Figs. 6 to 9, though
in diversified styles, are also meticulously
drawn with a measure of tight control. Many
great paintings and drawings are so executed.
Figs. 10 & 11 are done differently — with
<u>loose control</u>. Compare them with
fig. 9. Probably every work of art
has some tight control somewhere,
but this looseness or sketchi-
ness should be the repeat-
ed aim of the student
in practice. It is
a relaxer and it
often makes work
more fun. It's a
"break-away
payoff" !!

56

THE BRUSH: TIGHT CONTROL AND LOOSE CONTROL

1 **2** **3** **4**

Concentrating on a single subject and using acrylics instead of ink, we'll carry over this matter of controlling the applied medium. This page is a continuation of the thought expressed on page 56. We are mindful of the fact that we're taking an item out of context, but it is done to further explain tight and loose control. It is impossible for one to be a painter without employing some kind of approach to the canvas. The beginner should minimize his frustrations. The more he understands, the more confidence he will possess. It is true that an ambitious student may "fall into" a style of his own with little outside help. Alas! Some fall into listless indifference and put away their brushes.

5 **6** **7** **8**

By now, the student may have overcome the "beginner quits." Even so, he may not have analyzed or thought of tight and loose control. Fig. 1 is a reasonably tight blend of modeling. Fig. 2 defines the shape we wish to portray when we apply the fairly loose blend of paint in fig. 3. Fig. 4 accomplishes the same thing with perpendicularly applied strokes -- still following the general shape. Fig. 4 is loose control. Fig. 5 is a studied treatment following rather loosely the fig. 2 perspective. Fig. 6 is looser impasto (thick application of pigment) than fig. 4. Yet both strokes move up and down. Figs. 7 & 8 are moderately loose with 8 taking less effort -- again an impasto build-up. Fig. 9's

9 **10** **11**

dull-finished surface is done under tight control. Fig. 10, on the other hand, is a highly reflective surface tightly done. Fig. 11 is also reflective and deliberately tight. If any of these vases were to be put back into context, the entire picture should be related in style. If you are hung up on tight control, try a looser approach. Excessive carelessness may need tightening up a little.

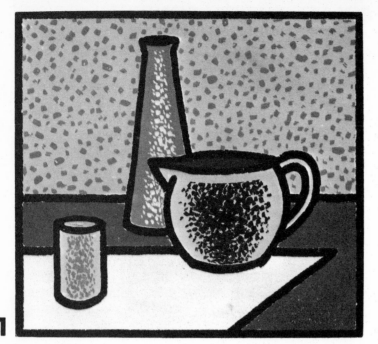

1

This is not the first leaf in the book to make use of gouache painting. The medium first appeared on pages 24, 25 & 26. There we discussed composition and balance utilizing flat colors exclusively. Here our purpose is to take a look at <u>texture</u> at its simplest.

First of all, "gouache" is made up of opaque colors which have been ground in water and mingled with a preparation of gum. It is water-soluble and can be secured in tubes or cakes. The six values appearing at the right (not counting white) are quite sufficient to tell any story in gouache.

In brief, "texture" refers to the degree of smoothness or roughness of surface areas either <u>tactually</u> and/or <u>visually</u>. If a surface has tactile qualities, it is perceptible to the touch. If a surface has visual texture only, the effect has been produced two-dimensionally. There is a second aspect, and that is softness or hardness. This is another tactile quality but may become visually convincing by association. For example, the same visual treatment may appear on an orange or a rock. From experience we know one is soft and the other is hard. Likewise, a piece of polished marble may have grain in it which demands that we show mottling or streaking in a drawing or painting. This kind of portrayal then will depend on smooth edges and brilliant reflections, besides the possible associative use of the marble.

It goes without saying that, regardless of how texture is handled, there is a subsequent sensory experience. The sense response is either to the touch or to the sight or both. As still-life artists we are concerned about the matter of sight primarily.

On these and the next several pages, we will face the problem of texture. In drawing and painting the answer may be found in the use of spots, flecks or stipples; dashes, strokes or traces of line; or any method which alters surface appearance.

There may be a foundational value or color upon which texture is built. Underpainting in watercolor, oil or acrylic may play an important part in arriving at the desired

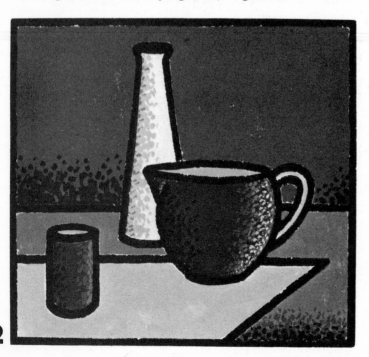

2

texture. The flattening of a plane, the rounding of a form, or the changing of the atmosphere may be accomplished with textural expressions. Texture may be used for value or color emphasis.

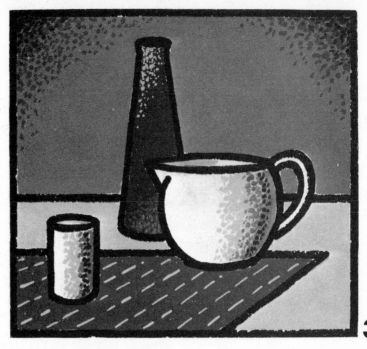
3

The still-life exercises 1 through 4 are designed to be of help in illustrating the foregoing points. There are three simple containers, two horizontal planes level with each other and a backdrop plane which could be atmosphere alone. These elemental objects are conveyed clearly in wide, bold line.

In fig. 1 a concentration of flecks centerways on the three receptacles assists in defining the form. The vase has flecks lighter than its base color, and the pitcher and glass have flecks darker than their base color. Each fleck grouping is of a different value: the vase has white, the glass has tint and the pitcher has shade (remember that "tint" is above middle on the value chart and "shade" is below). Wherever there is to be visual texture, there must be a visual difference in the values or colors. Tactile expression does not require this difference. The background in fig. 1 has widely spaced markings which, if they were opened up more, might draw attention to themselves. Textural "particles" may simply darken or lighten an area, or they may add interest to what would otherwise be a too-plain surface. There have been some great paintings which have had every square inch textured. The old rule "if it looks right" takes precedence, yet there is argument for <u>relief</u> from texture. Some textured works become awfully busy to the point of being disturbing. Others possess a feeling of unity when there is texture throughout. In the fig. 1 exercise the horizontal planes are plain.

Fig. 2 has darker dappling at the left, as opposed to light on the right, of the objects. Both the extreme foreground and the background contain graduated texture. It then becomes possible to change the value or color of flat surfaces without producing curves in them.

Though we have not stressed the original dark and light pattern apart from the adding of texture, notice that in each instance 1 through 4 the value pattern by predetermination is trustworthy.

In fig. 3 reflected light is shown in the **left of the glass and pitcher.** The front plane has

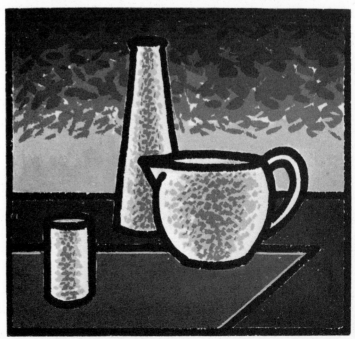
4

traces of line which honor the rules of perspective. In an abstraction this would not be necessary. Traces of line may be brush or pencil strokes set down side-by-side. They may be so close together as to cause the area to look untextured. Hundreds of paintings have had the corners darkened, though not necessarily by texture as in fig. 3 -- this helps the eye in its rounded travel experience within the frame.

In fig. 4 there is rugged texture in the background. If it were not for its regularity, the grouping could be taken as tree leaves. Now, this heavy spotting could be worked over again with smaller light tint spots cooperating with the trend from light to dark. The three containers here are all treated the same, in a light key, while being contrasted with the very dark base planes. The student is encouraged to try similar exercises of his own making.

1

OPAQUE WATERCOLOR IN SEQUENCE
(Employing texture)

The training picture presented
on these two pages is another example
of opaque watercolor painting
or gouache painting. None of the colors are
washed on; that is, there is no smooth,
soluble mergence in blend. Each application
is opaque rather than transparent so that
it covers whatever is beneath it. As we move
along, texture will be added.

Fig. 1 shows the beginning with three separately
valued planes in a shadow box. These do
not need to be actual; they may be imaginary.
The top-left plane was purposely made
lighter so it would better carry the shadow
of the flowers. After planes were established,
the flower vase and apple were outlined
in place. Though we'll cover the vase
with paint in the next frame, the three bits
of background value still showing within
the outline let us know that compositionally the
vase is well placed.

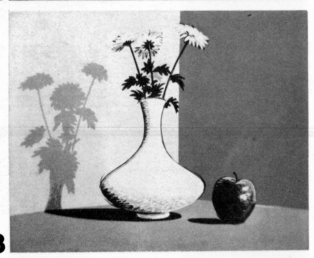

2

Fig. 2 diagrams our next step. We have
painted our lightest lights (the vase and
flowers) and the darkest darks (the
apple, the flower leaves and vase
shadow) before we start texturing. The
plain middle-tone of the flowers' shadow
is then added on the left wall.

Fig. 3 shows a beginning of detailed
definition which includes
texturing on the vase and apple.
The vase does not have a highly re-
flective surface, so it will not
register the several highlights
to be found on the apple.
The deep shadows below the objects
let us know that the light source is
strong enough to be caught on the
slick exterior of the apple.

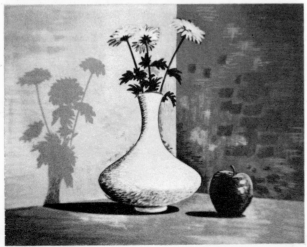

3

Fig. 4 is the finished painting which is
reproduced larger across the page.
There is more expanse in fig. 5 so that

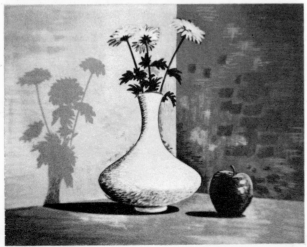

4

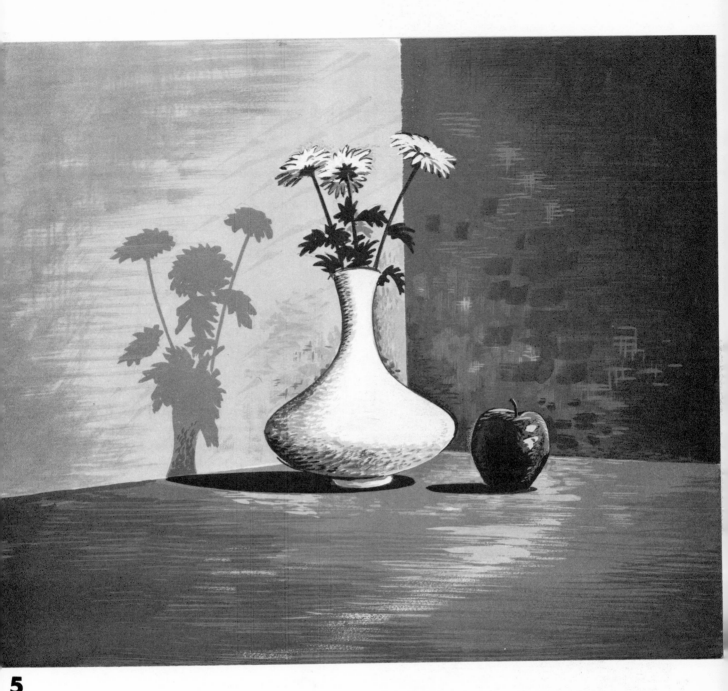

5

the student may examine more carefully the individual brush strokes. Some of the "after strokes" are feathered on. That is, the brush is not overly saturated with paint, but is stroked-out on a scrap before being applied to the picture. There are some instances of smaller single strokes of darker texture on the left of the white vase as it rounds in form, as well as single strokes of lighter texture on the right of the dark-skinned apple. There is a lead-in path of lighter paint going to the apple. Despite the fact that the right wall is still considered to be a single-valued plane, it has enough texture added to keep it from blanking out. The condensed boundary around fig. 4 may be a better circumscription than that of fig. 5. All the still-life story is told within this limitation.

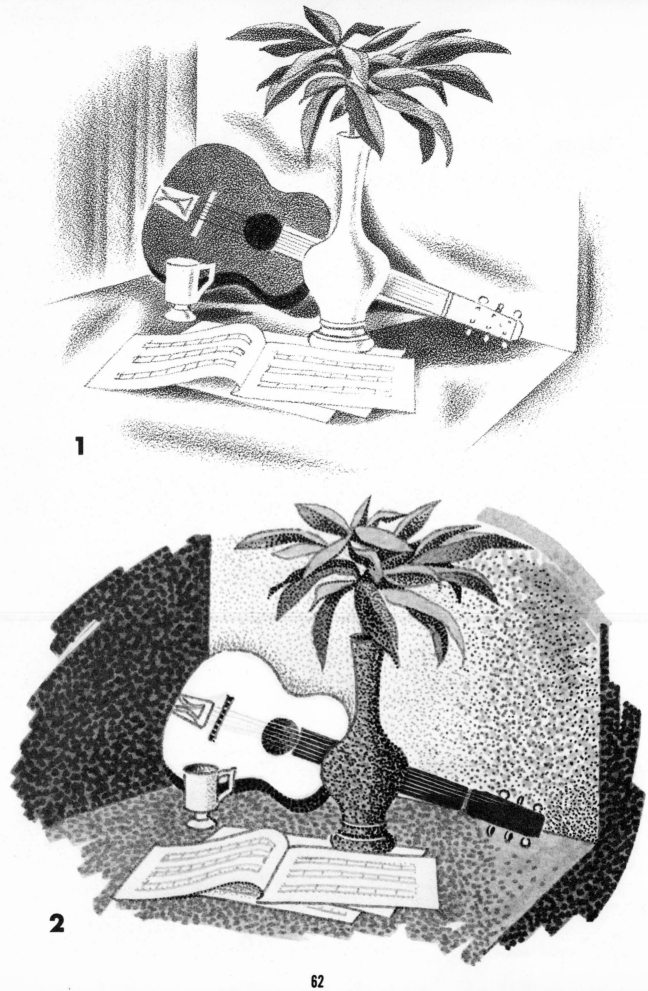

1

2

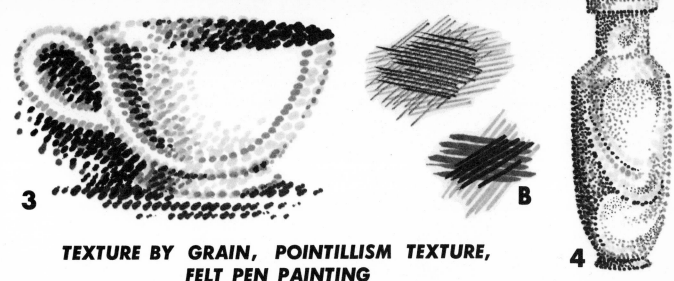

3

B

4

TEXTURE BY GRAIN, POINTILLISM TEXTURE, FELT PEN PAINTING

With our attention still focused on "texture" we turn to other ways of securing these effects. In the fig. 1 composition texture has been achieved owing to the grain or "tooth" of the receiving surface. The pencil medium has been pulled across the coquille board leaving a stippled effect. The paper, board or canvas surface may contribute to texture's outcome. There are no solid darks in fig. 1 for the paper's white indentions were permitted to show through even in the darkest places. Two other examples of texture by tooth (or grain) are figs. 5 & 6, though fig. 6 is a combination of stroke and tooth. Definite strokes with varied pressure on the sketch pad are laid side-by-side.

In fig. 2 the same still-life setup appears with different coloration on the guitar, vase, etc. This time, however, the medium is the felt pen, sometimes referred to as a wick pen or brush. The Neo-Impressionists led by Seurat developed a painting system whereby they placed pure color dots or flecks on canvas, relying on the eye to optically mix the colors. For example, blue and yellow dots or points (the reason the system became known as "pointillism") from a distance looked green; red and yellow dots looked orange, etc. Also, complementary colors (across from each other on the color wheel) as closely arranged dots produced a certain vibrancy or "luminosity." Because these colors were broken or divided these early originators called their technique "divisionism."

It is a pleasant thing to experiment with these felt pens combining flat undertones with dots or points as we see in fig. 2. The markers or pens are available in a wide range of colors. The cup in fig. 3 is done with these instruments. Here a short stroke is used -- some are allowed to overlap others. The fig. 4 vase is made up of points of different colors. This mode of working is painstaking, but it is one fascinating way of getting texture. Figs. A & B above are crosshatches from different-colored felt points. This crossing permits bits of white paper and understrokes of the previously applied color to show through. Not all pictures need texture, but even slight texturing may add interest to an otherwise plain area.

5

6

THE DRAPE IN STILL LIFE

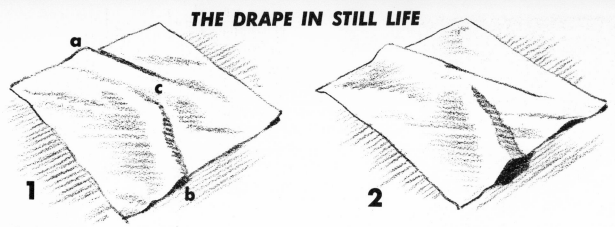

1 **2**

The drape is given as the fifth essential or basic shape in still life on page four of this book. The drape is the "fit-in" servant of the still-life artist. Often it may be extracted as easily as it is introduced, according to need. It is the most adaptable of any of the materials, and it is the most willing to play the supporting role. It may alleviate heaviness in a composition beset by hard, unyielding edges. If the reader has the book by this author entitled <u>Drawing the Head and Figure</u>, the section on folds from page 109 to 115 will be of value. The laws governing folds are as relevant in clothing as in curtains, tapestries, etc. Seldom does still life incorporate humanity, but humanity in a picture sometimes draws in still-life elements.

On this page an exercise is presented using a simple napkin. Its chief purpose is to help the student with the problem of depicting fabric on a table top, shelf or on the floor. It is true that

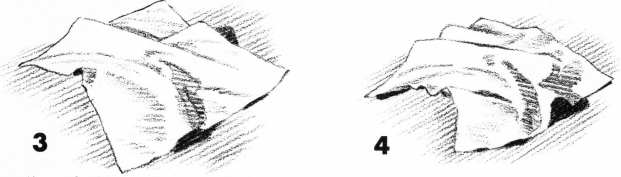

3 **4**

many times the fabric will be smoothed out and not gathered on the supporting surface as is demonstrated on the smooth top of the stand in the photo across the page. And the fabric may not bunch as it is pictured on the second plane in these same photos. However, the still-life artist should be able to alter and shape the material so that it complies with his wishes.

Fig. 1 above is a napkin with the two halves slightly compressed toward center. The sides of the square cloth are only partly disturbed. As the fold furrows lift from the table, their rise is marked by the small arches a & b as well as the shade streaks of middle-tone, light and dark. At c these furrows taper back into near contact with the table. In fig. 2 the napkin's halves are pres-

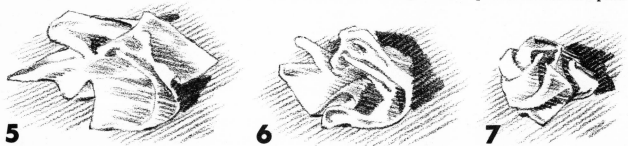

5 **6** **7**

sed into causing more rise in the fold furrows. Secondary disturbances begin to lift in response to this compression. Notice that, for the most part, the differences in value are made with parallel sketch lines throughout the figs. 1 to 7. Fig. 3 records folds brought on by slight pushes on the material from all four sides. Small arches now set in on every side of the napkin, and there is a general convergence toward center. Fig. 4 registers more crush with the plain flat areas beginning to disappear. Though such compression in a still life, as is pictured in figs. 5 to 7, is unlikely in such a small piece of cloth, a similar crush might be observed in parts of a larger cloth. Drawing the final closures in figs. 6 & 7 (resembling a rose) affords practice in portraying tight compression folds.

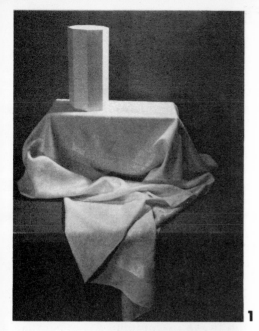

1

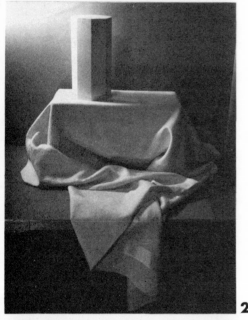

4

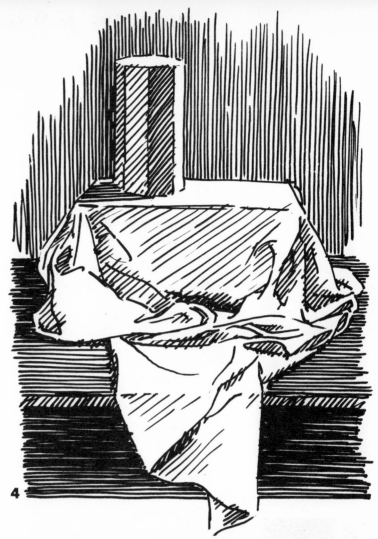

2

3

FOCUSING ATTENTION ON THE DRAPE

In order to concentrate on the drapery folds we have removed every possible distraction. None of the customary still-life subjects are before us. Only one piece, other than the drape itself, has been brought into play: the white octagonal prism. The reason for its inclusion is as a light and shadow indicator. Too, its exacting edges serve to emphasize the relief role of the naturally supple qualities of the softer drapery material.

There are three kinds of lighting shown in the photo column: fig. 1, side lighting right; fig. 2, side lighting left, partly from the rear; and fig. 3, front lighting right. The top of the prism lets us know that these three light sources are from overhead.

The first thing one should look for in drawing or painting folds is the tension response from the existing supports. In this case there are two planes, four corners, and five edges involved. There is mild tension from the corners resulting in loose, relaxed, voluminous folds. Though the tension is almost equally divided, there is a stronger pull to the right if we take into account the hanging drape fold coming from the left corner in fig. 3. The next thing to consider are the highlight, half-light, half-shade, shade and shadow effects on and about the folds. These need to be interpreted in whatever medium we choose for our picture. Fig. 4 sets forth this drapery arrangement in bold pen lines.

VARIOUS USES OF DRAPERY

So we decide to use drapery in some way in our still-life composition. What are some of the ways in which this may be done? The miniature sketches from 1 to 21 illustrate various possibilities. The drape may be completely in front of (fig. 1) or completely behind (fig. 2) our still life proper and yet remain a part of the overall picture. These curtain folds are chiefly, if not altogether, perpendicular. Fig. 3 shows these curtain folds combined with a second horizontal drape beneath the still-life objects. Fig. 4 contains two curtain drapes diagonally placed. Notice the area difference of the two drape sections in both figs. 1 and 4. The lines of the fig. 4 drapes are dynamic as opposed to the static hang of purely perpendicular lines, yet both have their place.

The large drape in fig. 5 assumes a major role. In addition, a small secondary drape comes off the corner beneath the chest in the same picture. Fig. 6 features a large drape above a table cloth. The several still-life items take their respective places between these materials. Figs. 7 through 11 continue to have background drapes coming into the viewer's range from overhead. Some of these drapes figure more prominently than others. In every case there are directional flows in the pictorial space which are pleasing to the eye.

Figs. 1 to 11 feature drapes with overhead support. Figs. 12 through 21 contain drapes with underneath support. In no case, at any time, do lines within the drapes go to a corner of the picture -- this is important. In nearly every case, there are some lines within the drapes which go behind the still-life objects. These lines promote and encourage the viewer to give full recognition to the principals in the composition. In most every instance the fabric becomes an obedient accessory.

In retrospect, a viewer will seldom name or even remember the drape -- it's what's in front of the drape, or behind it, or encased in it that counts. In fig. 12 the servile cloth is large; in fig. 20 it is small. No still-life artist ever used the drape more effectively than did Cezanne. Matisse often selected highly patterned drapes.

The underlying cloth in fig. 13 serves as a binder for the apples, and here is a positive necessity. The "rolling action" in fig. 16 (also see page 52) is due to the drape. Similar action is introduced in figs. 17 & 18 by drapery. In fig. 19 an extra spatial thrust is achieved by fabric hung over diagonals. Usually drapes help to tie things together; and yet, at times, they are in a clump by themselves (fig. 21).

CHARCOAL DRAWING AND MARKER PAINTING
(Utilizing drapery)

Fig. 22 is a simple charcoal sketch using a plain table cloth. The several folds radiate from the corners of the stand then give way to flat changes of plane. Fig.23 is a wick or felt marker painting done on a middle-tone paper. The markers are of three types: a fine line marker for outline work, larger markers with quarter-inch rectangular wicks (these come in over 100 colors), and a round opaque marker for highlighting. The larger markers are transparent and may be worked one over the other as in a wash. **22**

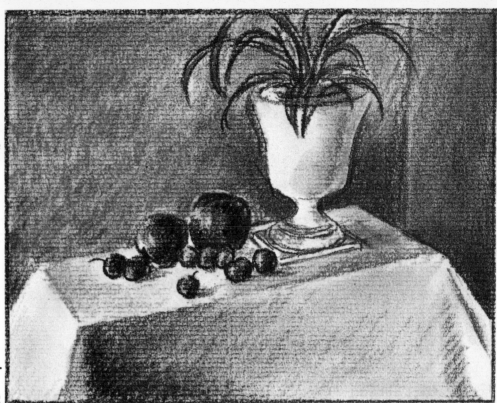

23

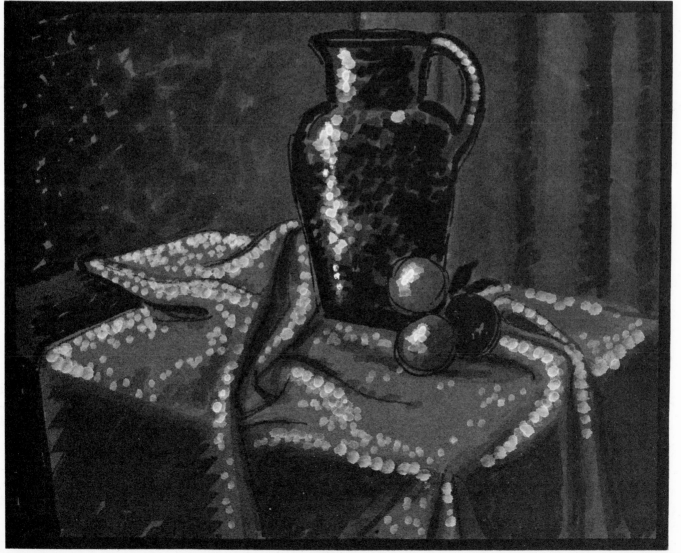

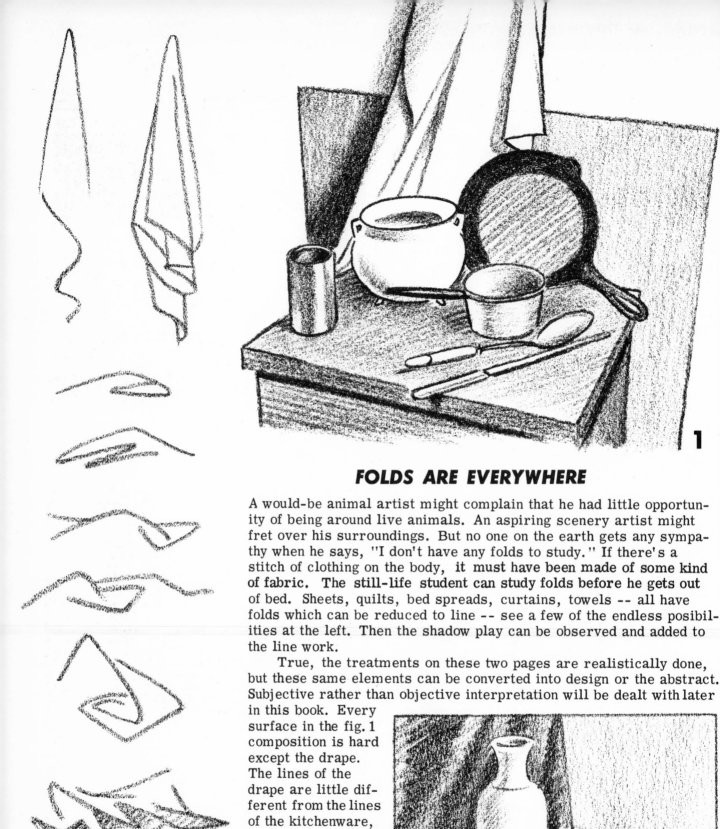

FOLDS ARE EVERYWHERE

A would-be animal artist might complain that he had little opportunity of being around live animals. An aspiring scenery artist might fret over his surroundings. But no one on the earth gets any sympathy when he says, "I don't have any folds to study." If there's a stitch of clothing on the body, it must have been made of some kind of fabric. The still-life student can study folds before he gets out of bed. Sheets, quilts, bed spreads, curtains, towels -- all have folds which can be reduced to line -- see a few of the endless posibilities at the left. Then the shadow play can be observed and added to the line work.

True, the treatments on these two pages are realistically done, but these same elements can be converted into design or the abstract. Subjective rather than objective interpretation will be dealt with later in this book. Every surface in the fig. 1 composition is hard except the drape. The lines of the drape are little different from the lines of the kitchenware, but the drape identity is unmistakable. The pencil lines in fig. 1 are set down by "tight control" as opposed to "loose

68

control'' (see discussion on page 56). Four or five weights of drapery material are used in figs. 2, 3 & 4. Nearly 3/4's the area of fig. 2 has drapery in it. Perhaps only 1/8 th the area is taken by the vase and fruit; but, if we were to entitle the sketch "Vase with Fruit," the tag would fit.

Fig. 3 has a thick drape well away from the wall. The material has two supports, each apart from the table. Voluminous folds of heavy material were sometimes used by the old Dutch masters for a luxurious or regal effect. Even though the folds on these pages are relaxed, bringing about a feeling of comfort, their directional flows are pitted against other diagonals preventing compositional weakness.

Despite simplicity of line in fig. 4, the surfaces depicted are convincing enough to the eye: the wooden frame of the acrylic painting, the highly reflective metal tray, the peaches, the reflective aluminum tumbler, the plastic pitcher, and, lastly, the plain white drape. The free-fall of the visible part of the drape is without appreciable tension in its folds, yet, from left to right there are tube folds, variable surface folds, a loose curl fold (at the top), and an abrupt base convolution resting on the table top.

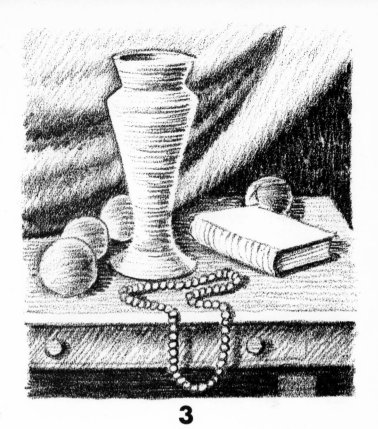

3

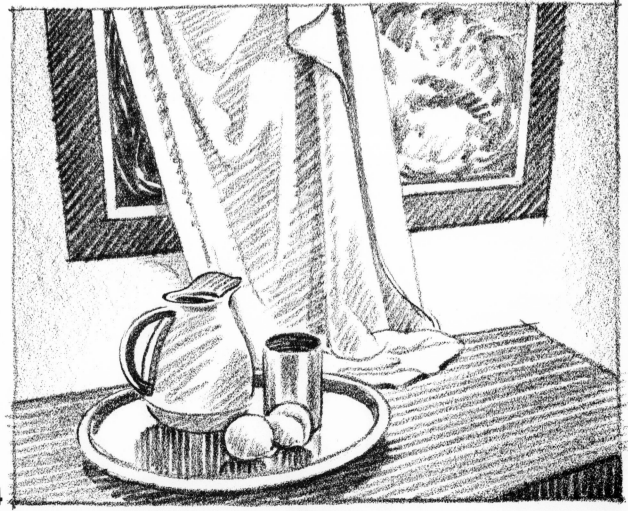

4

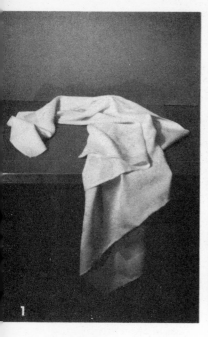

1

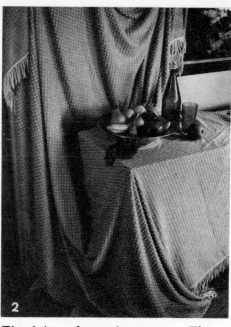

2

3

PASSIVE AND ACTIVE DRAPERY

Fig. 1 is a drape in repose. Thus it is "doing no work," and, in its quiescence, is an obliging base to receive "active" still-life sub-

jects. These subjects may have the potential of telling a story or motivating the viewer to reminisce. Often memorable experiences are "brought to life" by still-life paintings and drawings.

Since our specific purpose is to examine drapery, we get on with a comparison. In fig. 2 the drape is enormously

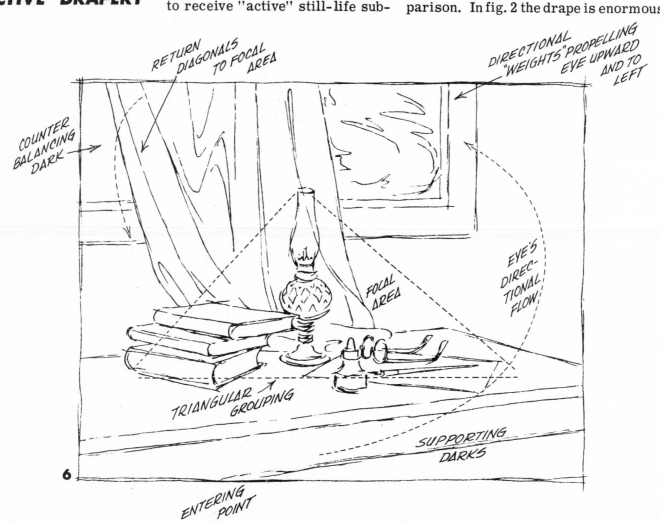

Above is a working diagram of the watercolor wash across the page (fig. 7). The concept was first lightly sketched in pen line. The transparent watercolor was then added, leaving crisp bits of paper showing through. The drapery is kept at its simplest as it strongly supports the lead items in the composition.

active. Granted, the material itself is enormous, and it swallows up the still-life items. Fig. 3, on the other hand, would be considered a close-up. The tapestry in 3 is as <u>active</u> as the sweeping lines of fig. 2.

Fig. 4 is a still-life setup in a light key with the drapery as "featured" as can be. A good part of the fabric is on a horizontal plane; the rest has been elevated. In every period of painting, drapery has been lifted face-on for various purposes, whether in the overt cubist works of Picasso, Gris or Braque, or the billowy realism of the earlier classic painters. Fig. 5 is a study in vivid contrasts, an example of drapery in action owing to arrangement and lighting.

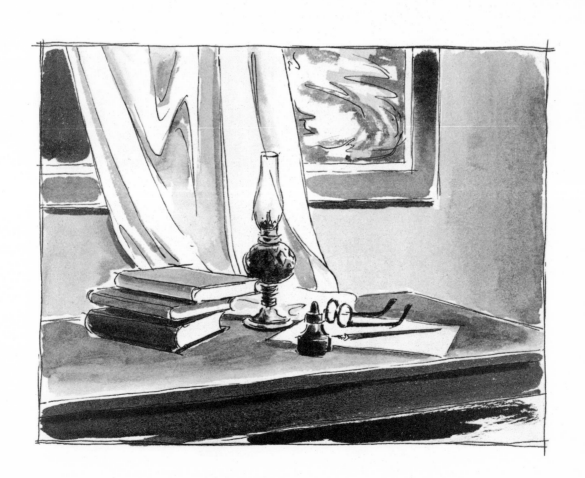

7

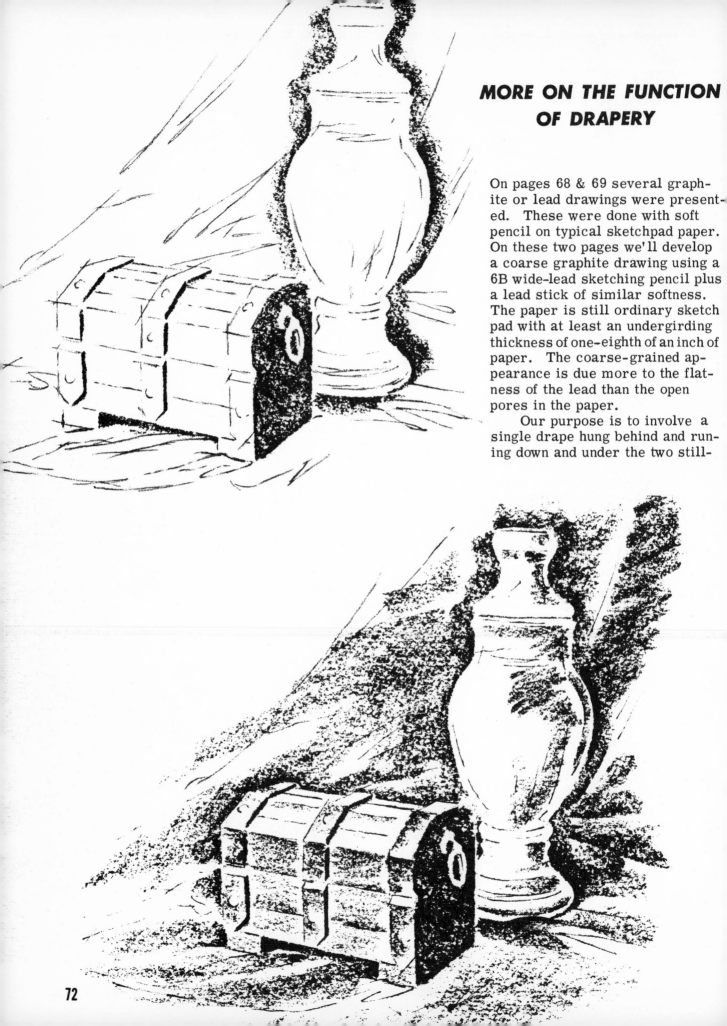

MORE ON THE FUNCTION OF DRAPERY

On pages 68 & 69 several graphite or lead drawings were presented. These were done with soft pencil on typical sketchpad paper. On these two pages we'll develop a coarse graphite drawing using a 6B wide-lead sketching pencil plus a lead stick of similar softness. The paper is still ordinary sketch pad with at least an undergirding thickness of one-eighth of an inch of paper. The coarse-grained appearance is due more to the flatness of the lead than the open pores in the paper.

Our purpose is to involve a single drape hung behind and running down and under the two still-

life subjects, the small chest and the glass jar. We have four surfaces to consider: the wood and metal on the chest, the highly reflective glass of the jar and the thick light-absorbant folds of the velvet drape. As we move along in our progression, our chief concern will become the drapery. It is the only pliable element in our picture. Though we may move the chest and the jar about, their surfaces are fixed and adamant. Not so with the subservient drape; it is the cooperating variable. However, we must zero in on the chest and jar, so in fig. 1 the two are outlined, and the backup darks are begun. The glass is, at first, left entirely light. The chest has its dark shadowed areas filled in. The sweeping extremities of the drape lines are not shown here, only the portions affecting the subjects.

In fig. 2 a further roughing-in of the focal area is shown. We're building out to the picture's margins. The flat planes of the chest are indicated, and the round turning of the jar is begun. By working broadly over the focal area we do not become unduly wrapped up in isolated details.

The drape lines in fig. 3 have been extended and the folds sketched in. In so doing, these are the particulars to be kept in mind: (1) The drape lines must furnish most of the action and movement in the picture, (2) the drape lines must bind the total composition together, (3) the drape lines must carry the eye in and swing the eye back in a travel experience, (4) inasmuch as the two still-life items are resting on the drape, the folds must record the environmental space surrounding them. Notice that the foreground folds sufficiently overlap the chest and jar to position them in middleground. Also, the background folds run behind the subjects, thereby assisting further in creating pictorial space. Observe, too, that the base folds in front are kept in a lighter key.

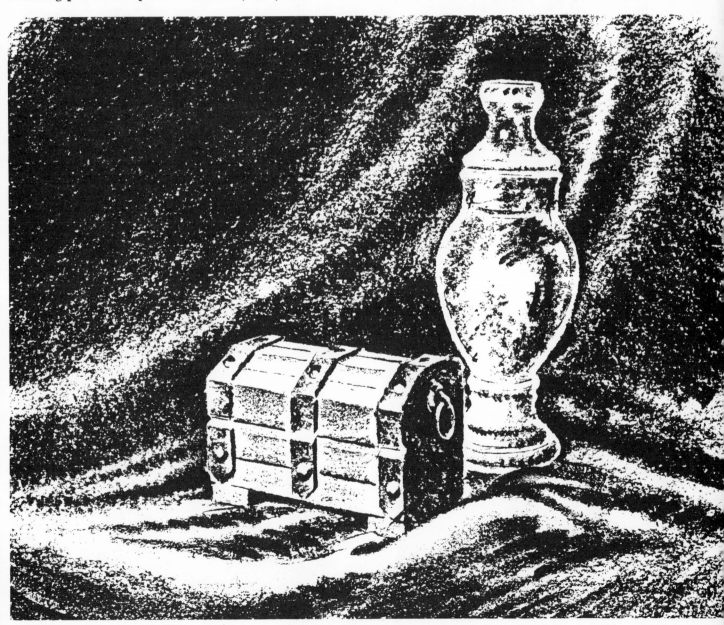

1

2

3

4

INTRODUCTION TO ABSTRACTION

There have been many definitions of abstract art. Perhaps no single definition is entirely satisfactory. It has been called a "total departure from any reality." In its purest form "it possesses no recognizable thing." It is "nonrepresentational" in that it is "devoid of a specific likeness of any kind." Then there comes the question: Can its existence be justified? Is it so "far out" that it serves no purpose?

Let's begin with an experiment and see if we can resolve some of the problems in the doing. Some will dispute our beginning with an <u>actual thing</u>, for they believe we must begin with "nonexistence" except for a theme or a mood or a conjecture -- or even less than that. In this regard the student might check out the

A

B

C

D

5 **6** **7**

works of Mondrian, Rothko, Newman and Noland. On forthcoming pages we will begin with a "non-thing," but for now, let's take a "thing" -- in this case an ordinary spoon that most readers have held in their hand today.

First we'll view the spoon from many angles (figs. 1 through 7). Observing its form, its symmetry, its reflective surfaces, we'll begin to work. Fig. A is one view of the spoon as it actually is. In this drawing we have rigorously kept to scale. We have sought to record the metal, its thickness, its total aspect. In fig. B we have begun to be selective, to interpret, to veer slightly from reality. We think of design and composition within a prescribed frame. The shadows, the base line, the reflections, have been utilized inventively. But we agree: the spoon is very much there.

In fig. C we try something different. We simplify, yet preserve certain lines from our subject. Fig. D is the spoon repeated in part with a dark and light pattern evolved from the crossover outlines. In fig. E there is a departure from "collected reality," but we refer to our subject enough to use many separate features of the spoon itself. If we entitle E "The Spoon" most viewers would go along with that. But more important than title or subject is a new creation that presents a challenge NOT TO FIGURE OUT WHAT IT IS but to stimulate our minds to engage in an imaginative experience. Has it become "pure abstraction"? Isolate the picture from its setting and this discussion completely and some would answer "yes." This could be true with C and D.

Leaving pencil we engage in ink and topsheet overlay for a different effect in F. Knowing what we do, we can still see <u>spoon</u> in the composition. Again, isolation before a new audience would probably change this. Fig. <u>G is</u> made up exclusively of a patterned topsheet cut and overlaid. Might this not be our first "pure abstraction" -- knowing what we do? And, since we got our inspiration from --

that's right -- so
we'll call it:

"THE SPOON"

F **G**

DEPARTING FROM REALITY

On the preceding pages an example was given wherein a common spoon was used in making varying degrees of abstractions. Using two All-Stabilo pencils, a black 8046 and a white 8052, the following six sketches were made on gray charcoal paper. In fig. 1 the actual bananas in the corner of a shadow box are drawn. They are not dropped at random, but are arranged with maximum potential (not to discredit other positions). The curved sweep of the fruit and their relation one to the other cannot be over-

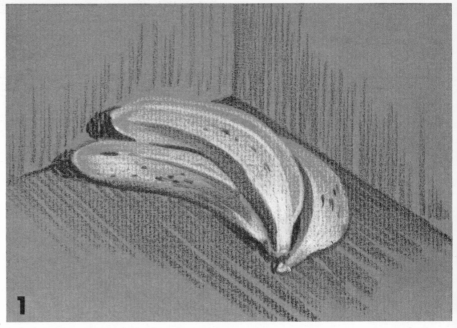

looked. Notice two of the bananas are partially concealed. The sectional contours of each afford useful planes. The adjoining planes of the shadow box are of equal importance.

Fig. 2 is a quick departure from reality, yet it is not difficult to trace the newly drawn elements back to the parent drawing. The light planes are revamped, reshaped and, to an extent, are relocated. The speckles from the bananas are used in new ways both on and off the fruit. The end shadows are retained but assume a greater role as part of the design. The grays, blacks and whites are loosed and given "new freedom" from the parent drawing. We are purposely becoming inventively unrestricted.

Fig. 3 is no more a departure from fig. 1 than perhaps is 2. Here altogether different darks around the bananas are improvised -- thinking of unique space division. All the lines outside the fruit are straight; all the lines inside the fruit are curved. Observe the three darks on the bananas and their directional influence in the composition. What is portrayed around the fruit cooperatively insists on as much attention as the fruit itself -- this is quite all right.

Fig. 4 is lineal in construction and transparent in its implied body parts. The floor edging penetrates the fruit and the banana speckles are laid on the floor in groups. The whip-lash effect of the central lines is steadied by the top-right and lower-left enclosures which are passive by comparison.

4

Fig. 5, like 4 and 6 to follow, is a far-out removal from the real-life subject. But the inspiration for the concept can be traced back to the original bananas. Some of the curves have been straightened, and the speckles in the background have been profusely repeated. This, the most elongated

composition of the six pictured, has been forged from the parent drawing. The advancing whites overlap the darks, yet the visual experience is in relatively shallow space -- this is true of many abstractions. Some remain right on the picture plane itself. Others refuse to stray far from it.

5

If fig. 6 were isolated and hung by itself, there would be a strong cry that the artist had "gone bananas" -- especially if the picture carried a title by the same name. However, perhaps we can be a little more appreciative of a total abstraction on a museum wall which carries a title that

seems to have no bearing at all on what has come from the artist's brush. Léger's "Woman in Blue," Duchamp's "Nude Descending a Staircase" and Gorky's "Waterfall" are cases in point. Such paintings evoke the comment,"I don't see it!" Most of Klee's work, most of Picasso's work, most of Kandinsky's work (the **last painter being** called "the father of Abstract Expressionism") are <u>nonobjective</u> paintings. Each artist could have produced objects with camera-like exactness. But what

6

was before them started creative wheels moving. Differences often make the world more exciting than samenesses. Just as many abstract pieces of music set the stage for thought, so abstract art may stir the imaginative processes. <u>Thought</u> is <u>nonmaterial,</u> after all.

Getting back to fig. 6, the "rounds" of the curved bananas have been moved to the outside, and the flat planes of the inside have been made into angular sections. The speckles have become texture behind and under the planes. The picture might better be called "Composition No. 6" with no reference to fruit. Completely nonrepresentational works sometimes carry subjective titles such as Rhythm, Silence, Staccato, Ecstasy, Exuberance, Memory, etc. The **dominant color in the** composition may describe these designations. The student is urged to try some on his own!

1
2
3

In defense of art as "pure idea" may it be said simply that it begins as a mental concept and graph-ically becomes a visual record. Surely it is possible that artistic idea may be an experience not directly due to sense stimulation. If so, then it must find a sensory vehicle for its transmission into the mind of others. Obviously, of all the senses "sight" is the special moving agent for the painter. Who is to say that any artist at any time, having made certain claims for his art, does not fulfull his avowed purposes? Who on the outside can really know what takes place inside of the artist's mind before, during and at the completion of his picture?

All through the history of art reasons are given for its existence. Sometimes a critic will come up with a reason that never occurred to the artist himself. Sometimes the artist gives a rea-son that leaves everyone else stone cold. Then there are common-ground reasons which most art-

4
5
6

ists agree upon. In connection with the following discussion pages 39 to 47 have relevance.

In fig. 1 we have three planes angularly lifted in pictorial space toward the viewer. Plane "a" thrusts into this space and to the right, plane "b" picks up this thrust and hands it on to plane "c" which backtracks it to plane "a" again. Thus we have an "eye cycle" which is what most artists want in the way of a travel experience in their pictures. In fig. 2 a vase and two pieces of fruit are presented in sheer outline and pervious to light -- one can be seen behind the other. Fig. 3 is fig. 2 laid over fig. 1. Now further proof of 2's transparency is established as none of fig. 1 is pre-vented from showing through. Though we can see through 2 into 1 in fig. 3, we do not have in-depth interplay between 2 and 1.

Our next objective is to give the fruit and the vase partial substance. So, instead of their being altogether transparent, we'll make them translucent in places. Light will be diffused as it comes through and these new, flattened "objects" will penetrate the planes. The planes in turn will pene-

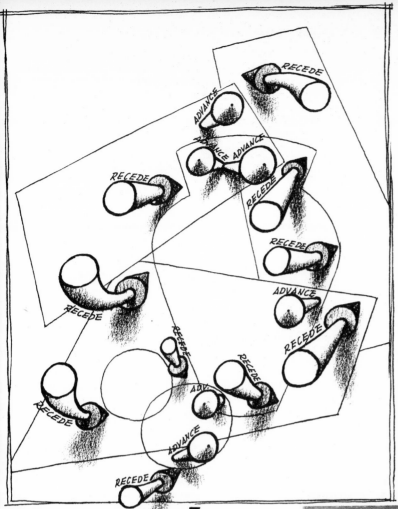

7

the eye followed darks; here it follows lights.

In fig. 7 the principles in the abstraction are finely outlined. The heavier arrows are labeled "recede" and "advance." The recede arrows go back, and the advance arrows come forward. They illustrate what those particular planes are doing with reference to the adjacent planes. By now the reader is well aware that both light and warm colors advance, whereas dark and cool colors recede. So this may be nothing new. But a part or plane in a picture slipping into or under another part or plane in cooperative interplay may be something new. Concentrate on the neck and shoulders of the vase in fig. 8. Also look at the fruit below.

Follow these principles of <u>transparency</u> and <u>interpenetration</u> in the <u>abstract</u> works of cubists Picasso, Braque, Gris, Léger, Metzinger, Delaunay, Duchamp and others. Use them yourself!

The example given here is extremely elemental. Its purpose is to explain. In many canvases such interaction may be less obvious. Sometimes the permeation is implied by small plane surfaces and pieces being placed side-by-side.

trate the fruit and vase. Thus we have retained a high degree of transparency as well as having engaged in "interpenetration."

Figs. 4, 5 & 6 are variations of this principle. In fig. 4 we have a <u>seeing</u> <u>through</u> from one plane to another. By no means is the vase fully rounded but has joined the three original planes in a close relationship.

Compare fig. 5 with fig. 4. Except for the center triangle, the vase's values have been switched. The darks are now light, and the lights are now dark. The top-right side of the vase recedes and, in so doing, penetrates the lighter plane behind it. Fig. 5 has been reproduced in acrylics in fig. 8. Fig. 7 is a diagram of what has happened in fig. 8. Before we discuss this "happening," let's look at fig. 6. Here the planes have been changed in character but not in shape. The whole composition has a new setting on a field of dark. Dark was the rule within the earlier compositions, but now light has taken over. Transparency and interpenetration are in evidence. We see through one plane to another. Before

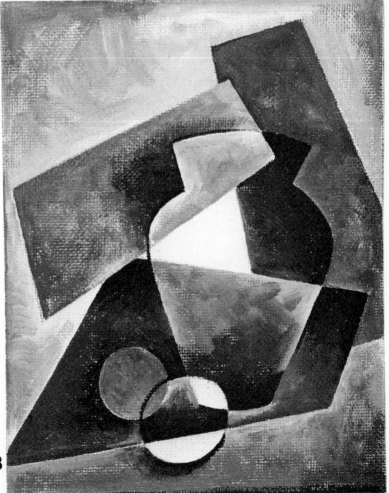

8

1 **2**

EXPERIMENT IN ABSTRACTION

Since three-dimensional space in pictures must be expressed on a flat plane, it remains that this expression must be in the realm of "idea." However, two-dimensional space, up-down-across, is actual space and can be divisionally portrayed. Lineally speaking, we have only straight and curved lines. Directionally speaking, we have only the horizontal, vertical and diagonal. If we ignore the idea of recession into pictorial space, and think only in terms of "flat" space, we can begin with such figures as are seen on these pages (limited recession may be argued, due to lights and darks).

First let's use but two horizontal lines, a & b, in our fig. 1 rectangular frame. These could be in scores of positions as they relate one to the other. Next we'll take two perpendicular lines, c & d, and add them experimentally. Notice that, each time we add lines, we are careful to avoid "halfway" divisions. Of themselves, the a & b lines produce interesting variety in spacing; likewise the c & d lines. Though we could add some shorter perpendicular lines, we'll add five horizontal segments, the purpose of which is to leave a variety of shapes. A prime concern here is to formulate pleasing overall pattern in the larger frame. We have achieved a feeling of progression and balance (along with this see related discussion on page 26). In fig. 2 the spaces have been assigned

3 **4**

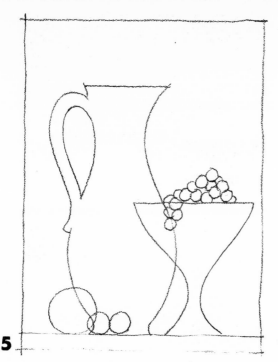

5

6

three values: dark, light and middle-tone. Look at them independently, first the lights, then the darks, then the middle-tones. In fig. 3 we have chosen three diagonals aligned as a triangle. As the lines and spatial choices in figs. 1 & 2 might have been much different, so this triangle's shape and placement could be different also. Our continuing theme: interesting variety and sound pattern. Fig. 4 has the triangle superimposed on fig. 2 with a little transposing of values (or colors). In all, the changes have been kept simple. Our ruling theme still obtains, and the results are pleasing to the eye. Our field upon which we will build our still life, later making it an integral part, has been established. Up to now we have been working in pure abstraction (with no reference to worldly objects).

In fig. 5 we have some knowns from our actual world introduced, where we will carry on with semi-abstraction. Fig. 5 brings with it the curved line as the fruit and receptacles are defined. As we will engage in "interpenetration" as we go along which will see one thing or plane diffuse itself through another, these still-life subjects are drawn with "overlapping transparency"--one does not go behind or in front of the other. Fig. 6 is a combination of figs. 1, 3 & 5; whereas fig. 7 sees only 3 and 5 put together. In either case, our flat spaces unify compositionally. Fig. 8 contains elements from all figs. 1 through 7. These have not been combined without thought and deliberation.

7

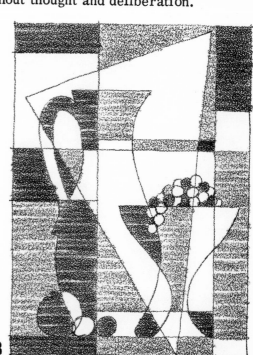

8

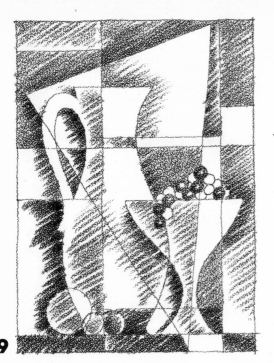

9

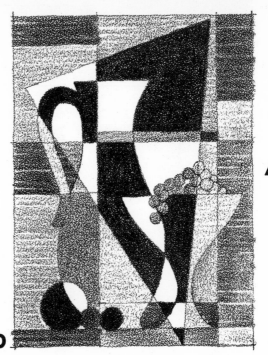

10

In fig. 9 we have a combination of flat pattern and pictorial space. By tucking darks behind the edges of the fruit, pitcher and fruit dish, we lift these objects toward us -- or rather push the geometric pattern back from the upfront picture plane. Anyway, there is a "separation" bringing on an invasion into the third dimension without fullness of form. Many abstractionists lift or suppress edges, thereby "skirting" reality as it actually exists. In fig. 10 all areas are once again flattened and recession into pictorial space is only suggested -- this time by receding darks. Since warm color advances and cold color recedes, these darks would more noticeably retreat if they were cold and if they were next to warm color. The darks in fig. 10 have been confined to the triangle with the exception of balancing darks in the fruit at lower left.

In fig. 11 light and shade variance takes place within the design blocks themselves, often going from one extreme to the other. The geometric field becomes in every way as important as the identifiable objects. So then, a broad interplay of pattern absorbs the objects which as yet have not yielded to distortion. In fig. 12 disproportion becomes evident. But disfigurement is more refigurement, for the still-life subjects, in breaking with conformity, are changed in order to possess a new measure of individuality. A feeling of solidity is introduced as form is emphasized.

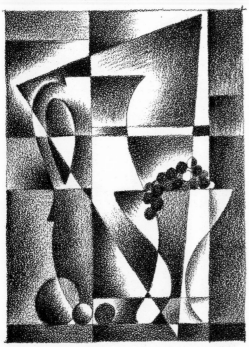

11

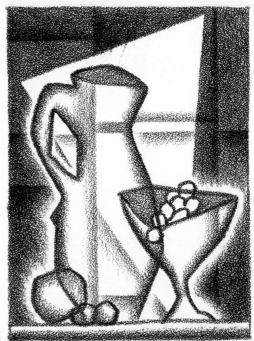

12

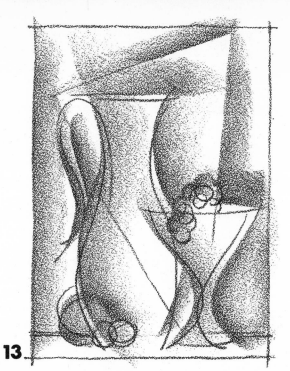

13

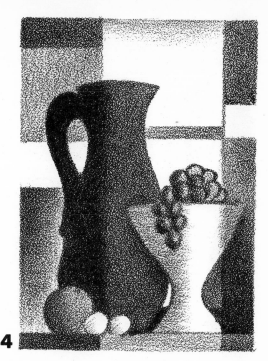

14

Fig. 13 is a departure from hard edges by means of loose multiple outlines. Only the triangle remains (see fig. 7). The rectangular spaces have been dropped because of their incompatibility with the informal contour of the objects. Oftentimes a feeling of vibrancy can be obtained with a multiple outline, and inanimate objects can be given a kind of pulsebeat. Fig. 13 is the lightest concept of our experiment and fig. 14 is the heaviest. The transparency factor has been abandoned in fig. 14 as one object is definitely in front of the other. However, the two original verticals are implied in the pitcher and the fruit dish. The several objects have been given weight structurally and have become our closest approach to naturalism. A semblance of the abstract remains in the background.

Fig. 15 is an angular use of distortion with all the still-life articles appearing to be made out of a common material. Here brilliant warm and cool colors may be pitted against each other making color contrast the most important aspect in the picture, over and beyond subject material. Fig. 16 is a step into surrealism which often is drawing or painting material in an immaterial manner. The surrealist usually goes "way out" into realms of fancy, even the mysterious. Fig. 16 is active surrealism -- things appear to be moving or floating. In passive surrealism still life may become "deathly" still. The student is urged to create new concepts in these 1 to 16 catagories!

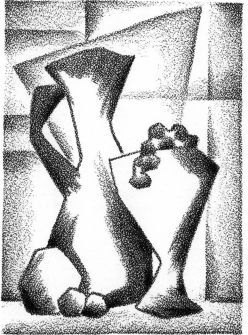

15

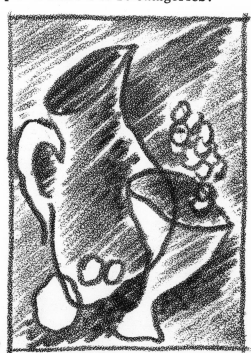

16

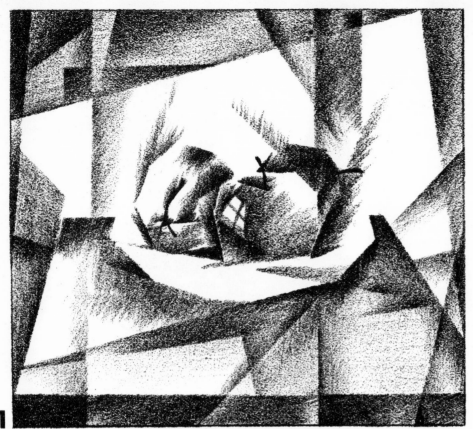

ANGULAR LINES AND SEGMENTED PLANES

Fig. 1 is a composition of angular lines which carry the viewer into a dynamic pattern. Just enough of the vertical and horizontal have been used to stabilize the intense activity. The small table holding the dish of apples submits to and is absorbed by the aerial lines running over it. The lighter form just behind the apples keeps the attention within the shallow space by joining the dish. Notice the dark "binder" that goes clear around the outside. This is sometimes done in abstractions as an assist in containing the eye. Round apples and a round dish are here done in straight lines.

In fig. 2 the curves of realism in the objects are crossed again and again by atmospheric streaks of light which form an ethereal network in front of and behind the objects. Though they might have been, the objects here are not distorted as they are in fig. 5. The superimposed pattern dominates the symmetry of the pieces and restrains their realism.

When it comes to using segmented planes in the broad scope of art, Feininger was probably the most skilled. Without forcing pattern he aligned it so naturally with individualized straight-

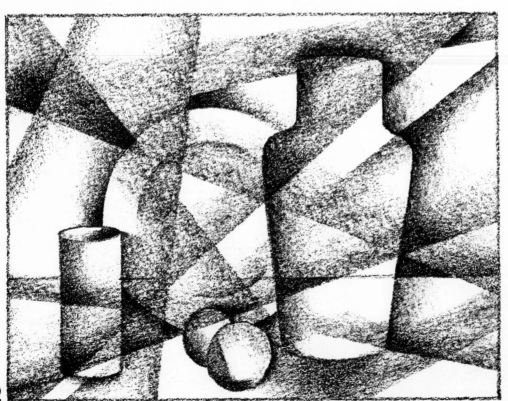

line limitations, seldom using curves, that his transposition of forms and volumes into simplified planes produced beautiful effects. Feininger would have allowed straight lines to do all the work of the curves which we find in fig. 2.

In developing geometrical schemes such as these, the artist should start with what he considers the major divisions, then follow with the lesser. After that, decide on the dark and light pattern. The area on one side of each line is made darker than that on the other side, thus the division is preserved. Position the still-life items first

Fig. 3 has the pictorial space divided "in the air" above the table top. The left sides of the divisional lines are shaded with darker values defining the edges of the still-life pieces. The knife and three folds in the table cloth carry the eye into the heart of the composition to meet the diagonals of the air-space. The folds are in perspective. This is a case where the tangible meets the intangible. Any incongruity is taken care of by the overall unity in the picture planning.

Fig. 4 is an example of "halted" spatial planes in the composition. The two that are cut off assume greater importance than those which transverse the entire picture plane. Because of the economy of line and the simplicity of shape, there is purity of pattern. Consider the relatively small size of the still-life subjects, yet their importance cannot be questioned. Despite the exacting geometrical shapes, there is a bright warmth to the clean-cut arrangement. Its very immateriality gives it a certain "spiritual" quality.

Fig. 5 is a totally different departure: interpenetrating planes set at right angles and diffused into the subjects themselves. The flat background is parallel with the picture plane and has multiple rectangles lying in a tartan pattern. The out-of-symmetry receptacles have flat bases. The integrating distortion of the subjects ties in with the abstract motif. At the bottom of the picture the directional entry goes left instead of the occidental right. Though this approach is completely different from Cezanne's, his dish and bowl tops were usually not true ellipses. The artists who permitted asymmetry in their works are legion: Picasso, Nicholson, Matisse, Van Gogh, Gris, Braque, etc. Photo-real objects in fig. 5 would be incompatible with the aesthetic purpose that pervades the entire design.

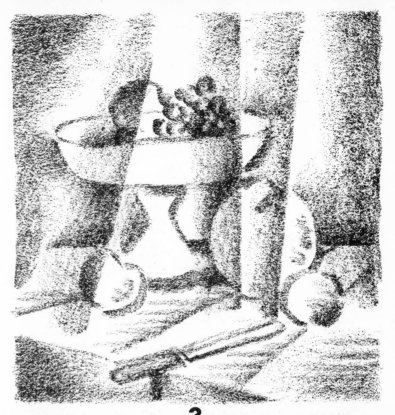

3

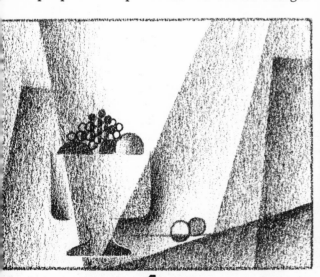

4

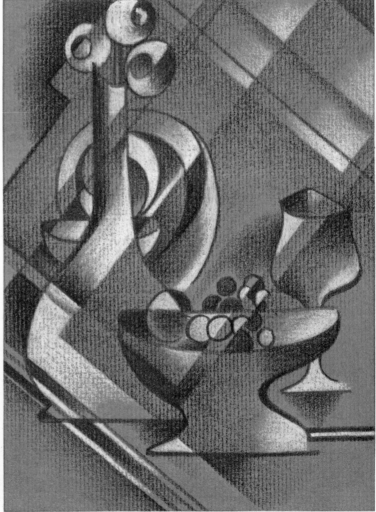

5

ABSTRACT EXPRESSION IN STILL LIFE

A B C D

For those who want to invade the Expressionistic world and take a turn into Cubism, we present a still-life experiment which is reduced to the simplest forms. Steering clear of realistic interpretations, we draw the above pieces in bold lines on a clear acetate sheet. These are then cut apart so they can be laid one over the other. The items A, B, C & D are "equivocally" drawn; that is to

say, they have two or more significations, they could be looked at in more than one way. For example, they could be taken as "flats" with no depth qualities at all as they appear in fig. 1. Or they could be taken as separate entities, existing as definite forms one behind the other as in fig. 2. Here

the table takes on certain recession into space because
of the new items' "acquisition of being" and their rest-
ing on a solid though distorted supporting surface. Our
movable pieces, A to D, can refuse to cooperate with
one another and peevishly remain equidistance apart
as in fig. 3 where they are "not on speaking terms." Or
they can gang up and overbalance the table with their
"weight" on the weak side as in fig. 4.

5

Now, what the author is doing is engaging in a free ex-
pression of an inner experience which he feels. Thus,
he invites the viewer to enter into this subjective un-
derstanting. THAT'S WHAT "EXPRESSIONISM" IS ALL
ABOUT.

Most expressionistic or cubistic drawings or paintings
rely on more than pure line; they depend also upon col-
or or value gradations to communicate a message. Ob-
viously, when color or value gradations are held in
bounds by line, there is a semblance of form. Or, in
some instances, blocks or shapes of color or value
become forms in their own right.

This artistic effort often reveals strong emotion which
goes beyond the limitations of realism, but it retains
an ultimate reference to reality.

6

In fig. 5 we have the equivocal characteristics expres-
ed again. Here are solid objects on the one hand with
definite planes, yet there is a crystal transparency
with interpenetration of these planes. Ordinarily light
and shade are very incidental to the cubist painter, as
will be revealed in the next two figures. Some would
consider fig. 5 as having a touch of violation because of
the light and shade suggestion. But there is a wide
margin for individuality in the abstract approach. Gris
and Beckmann had some feeling of light and shade in
their abstract compositions, as did others. Often it was
used to "protrude" an element or part and little more.
This is seen to crop out occasionally in practically all
the abstract movements.

In fig. 6 flat geometric pattern is laid over the four
items. Here the composition is interestingly held down
by this overlay. Depth into space is minimal.

In fig. 7 there is a breakaway into dynamic movement
by both circular and angular additions. It is not nec-
essary that these directional lines be bold-faced for
they would compete with the objects themselves. All
the foregoing are simply elemental diagrams intend-
ed to acquaint the student with the complex by means
of the shortest route. Good art does not have to be
loaded down with many components, especially when
one is learning.

7

1

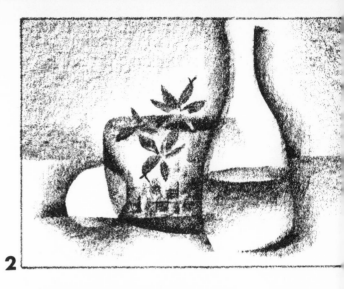

2

FLOWERS IN STILL LIFE

In this book there is an early suggestion of flowers being included in still-life painting and drawing. When we began to explore the basics of our study, flowers first appeared on pages 7 (fig. 5) and 9 (figs. 14 & 15). Fruit, vegtables and various containers have predominated thus far except for spot uses of leafage and flowers (pp. 44, fig.1; & 45, fig. 4). It doesn't take many flowers or pieces of fruit (p. 61, fig. 5) to make a still life. Too, one may use only leaves (p. 62) or only flowers (p. 63, fig. 4). Elsewhere, collective foliage has been used somewhat incidentally (pp. 66 & 67).

In. figs. 1 & 2 on this page flower bits give a vernal touch to these abstractions. That flowers may fit into almost any still life harmoniously is illustrated by their being used with potatoes in fig. 3. This is a Prismacolor 965 pencil on Media Clay coated Paper. Floral art finds its way into many great paintings featuring people. Examples of this include Dürer's "The Madonna with the Iris," Rubens' & Beert's "Pausias and Glycera," and Holbein's "Portrait of the Merchant George Gisze" to name but a few.

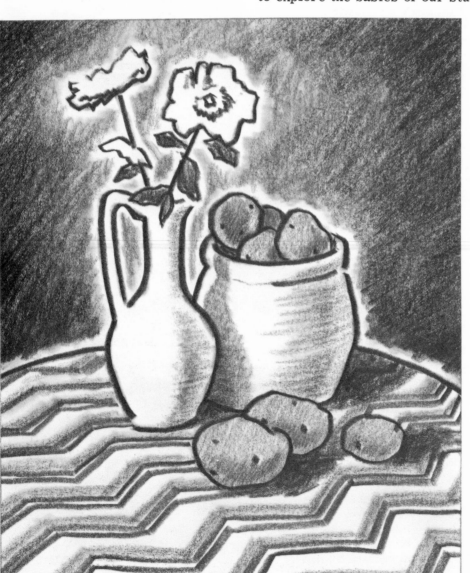

3

FLORAL STILL-LIFE BEGINNINGS

In these lines it is difficult to refrain from mentioning certain artists who followed particular layout mannerisms. More importantly, the student should be alerted to some of the ways flowers and their receptacles may be treated. These comparisons are in no sense exhaustive, yet they may give the student a starting place to do something on his own. Many times a beginning flower paint-

er is stymied with "Just a vase and flowers -- what different can be done?" Surely other items can be brought in: drapes, books, trays -- even butterflies, birds' nests, snails, seashells, etc. But here we're thinking of the main subject. At the outset the flower painter is confronted with where to position the container itself. Will it be below eyelevel (see arrows), fig. 1; on eyelevel, fig. 2; or above eyelevel, fig. 3. Fig. 4 is extremely below as figs. 5 & 6 are well above eye-level. A single hang-over

flower helps in many cases, fig. 5, or other foliage is sometimes introduced, fig. 6. It is a fact that scores of very fine flower pictures have containers resting on assumed bases; that is, no definite table top, pedestal, or other support (see figs. 7 through 18). In these the space about the subject may have a dark foregound, fig. 7, or a dark background, fig. 8. The flowers proper may be of darker value on the shadow side of the vase, fig. 9, or they may be darker on the opposite side, fig. 10 -- this

for variety or on account of special lighting. Fig. 11 has overhead lighting; 12 has a light emphasis beneath. Fig. 13 is like 10 except for a dark foreground. In fig. 14 there is a center light on the bouquet. Fig. 15 has dark variations in the negative space. In 16 there is a base shadow; whereas 17 has a back shadow. Fig. 18 has encompassing darks. A geometrical shape holds the subject in 19. Fig. 20 shows the partial table top. Fig. 21 has a fallen flower. A foreground shadow is in fig. 22. Fig. 23 con-

tains a thrusting plane and a back plane. A halo effect is around the flowers in 24. In fig. 25 we have an example of the flowers filling most of the pictorial space; whereas in 26 only two flowers are featured. In figs. 27 & 28 there is a flower in front of and behind the neck of the vase. Rarely will a vase go below the frame line as in fig. 29, but it can happen. In fig. 30 there is a definite follow-through in the flower arrangement. Most good floral pieces do not have the flower heads arranged haphazardly. Additional suggestions with drapes may be found on page 66, figs. 9, 11, 12, 16, 20 and 21.

FLORAL FORM

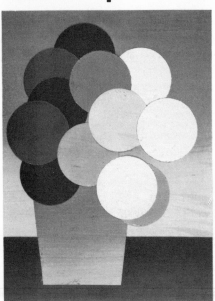

1

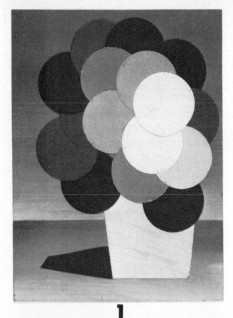

2

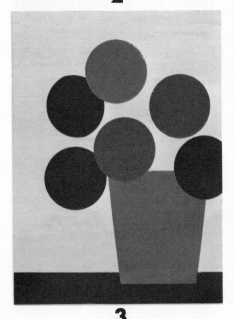

3

In examining the great flower paintings which have come down to us through the ages, one becomes aware of (1) the <u>number</u> of flowers in each composition; (2) the <u>values</u>, as well as colors, of the flowers as they relate one to the other; and (3) the <u>compositional arrangement</u> of the flowers themselves.

Renoir often painted numerous flowers in a single picture. So did Monet and Moser. Others, such as Cezanne, Pissarro and Manet, selected only a few for their still-life and works. A dozen or so were enough for Van Gogh. The kind of flower and the typical number on the stem sometimes were influential in the artists' choices.

Figs. 1 to 5 were set down as talking points for our study. In order that we might not concentrate on a particular kind of flower, plain circular shapes have been used instead of flower heads. In fig. 1 the light-colored flowers have been placed closest to the viewer. They naturally advance anyway (as the darks recede), and the arrangement takes on convincing dimension with the pot upholding the grouping centerways. If the pot is of light color, a darker flower or several in shadow may differentiate between the bouquet and the container.

Some of the most successful floral arrangements in art have been those which have had the lighter flowers in a cluster, either facing the viewer or toward the source of light, as in figs. 1 & 2. Many old masters tried so faithfully to reproduce the intricate details of the individual flower that they made each one a miniature showpiece. They might not have been so painstaking if the color camera, as we know it today, had existed in their time.

It is a wise artist who considers the negative space or the space left around the flower heads (see fig. 3). Is this space inter-

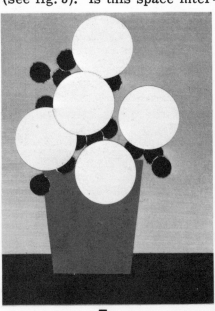

A

B

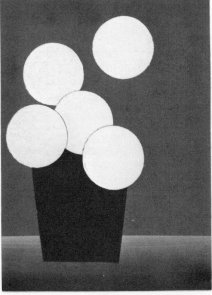

4

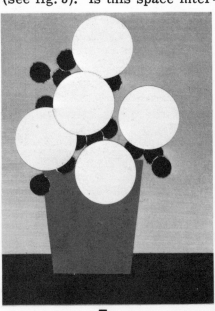

5

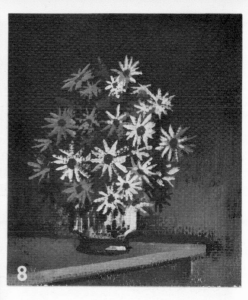

esting or is it monotonous? Of course, it could be partially dealt with by stems and leaves, but all flowers equidistant apart look too tampered with. Brueghel (Jan the Elder), Arellano and Linard were famous flower painters -- despite the fact that they lined up their flowers with almost mathematical precision. Fig. 4 has three of its white flowers lined up in a row, but the placement of the other two lends an informal air. Leaves are many-shaped -- in fig. 5 the circular bits accentuate the flowers. Where the unobtrusive leaves go is important. One should not be ruled by stubborn reality -- be inventive! Figs. A & B show that form can be expressed in a bouquet. This light and dark principle is carried out in sketch paintings 6, 7 & 8. We don't like flat trees, but we tolerate flat bouquets in pictures. A case in point are figs. 9 & 10. They are included here to call attention to backgrounds. When the floral bunch is so varied, the plainer background of fig. 9 might be preferable. This becomes a matter for the artist to decide. Exceptionally bright flowers in fig. 10 would take care of the "busyness" behind, provided the background were subdued in color.

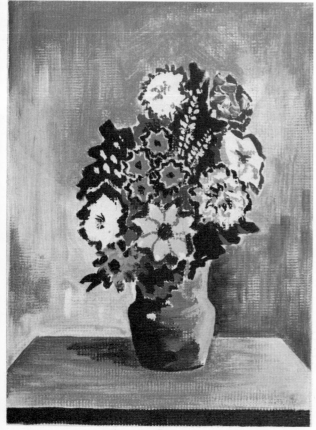

9

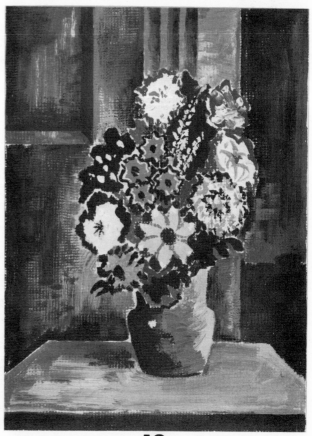

10

1

Some still lifes rely heavily on backgrounds for effect and have the capacity to arouse certain emotional responses. On this page are two pictures, the types of which may be done in either oils or acrylics. The background paint of fig. 1 is applied with flat bristle brushes moving either vertically or horizontally; whereas the background of fig. 2 is applied with palette knife moving diagonally. The flowers in each are painted with round red sable brushes. The mysterious sky of fig. 1 shows through the transparent flowers which build up a counter-tension with a transparent moon. Fig. 2 has objective flowers in a flat silver bowl set against a broad subjective sky. Notice the vivid contrasts of darks and lights in the flowers and bowl. In both pictures the skies are painted first and allowed to dry, then the floral pieces are laid out in pencil and painted.

2

92

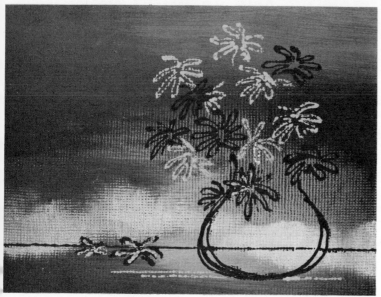

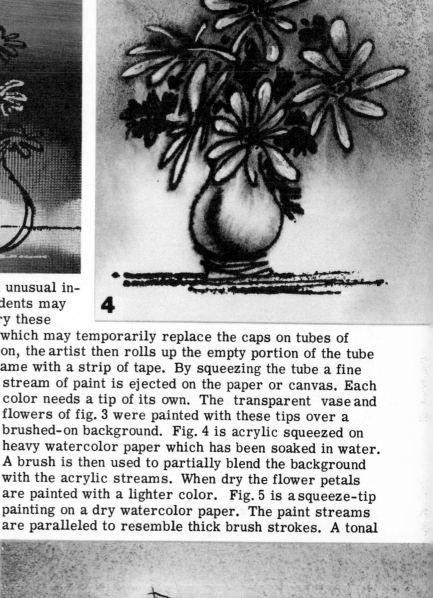

4

SQUEEZE-TIP PAINTING

"Squeeze-tip" painting is an unusual innovation which still-life students may wish to try. Art stores carry these small spout tips or nozzles which may temporarily replace the caps on tubes of paint. After screwing them on, the artist then rolls up the empty portion of the tube from the bottom, securing same with a strip of tape. By squeezing the tube a fine stream of paint is ejected on the paper or canvas. Each color needs a tip of its own. The transparent vase and flowers of fig. 3 were painted with these tips over a brushed-on background. Fig. 4 is acrylic squeezed on heavy watercolor paper which has been soaked in water. A brush is then used to partially blend the background with the acrylic streams. When dry the flower petals are painted with a lighter color. Fig. 5 is a squeeze-tip painting on a dry watercolor paper. The paint streams are paralleled to resemble thick brush strokes. A tonal

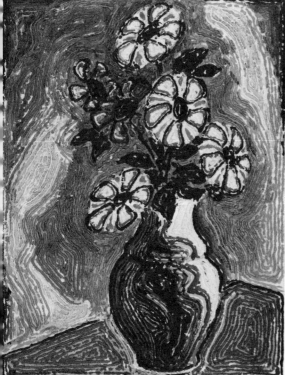

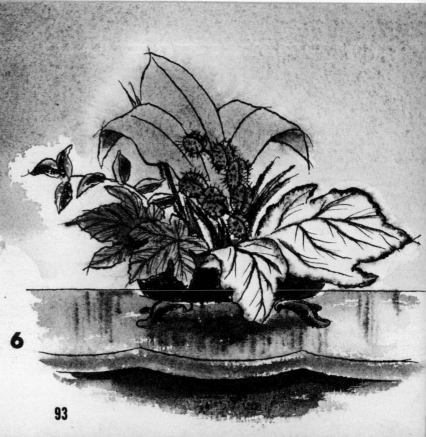

6

wash is added in places after the paint is dry. Remember the compositional principles discussed earlier in this book when planning your paintings.

PEN & INK WITH WASH

Fig. 6 is a drawing in pen and waterproof ink on watercolor paper. A wash is then worked over the pen lines. Experimentally try a leaf or two on a scrap before beginning on the outlined drawing.

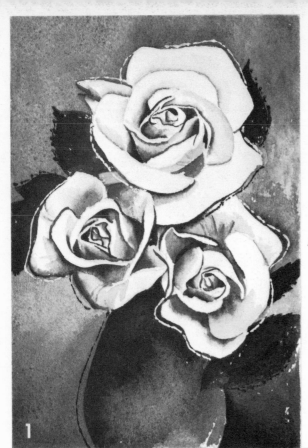

DRAWING AND PAINTING THE ROSE

Since the rose is the most widely cultivated shrub on earth, it should command our attention in a special way. Roses in some respects are like the rolling sea; there is something dramatically mysterious about them which seems difficult to capture. Rose experts say there is no "typical" rose, for there are hundreds of wild species and thousands of horticultural forms. In depicting the rose it

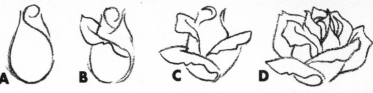

helps to remember the attractive urn-shape of the unfolding bloom (fig. A), the petals as they begin to separate and roll back (fig. B), the continuing lowering of the petals (fig. C), and the final regal spread of the glorious flower itself (fig. D).

Fig. 1 is a watercolor of three white roses. Like a fingerprint each flower has its own individuality. Fig. 2 below is a single rose done on velour paper with pastel. Observe the unwinding center coil

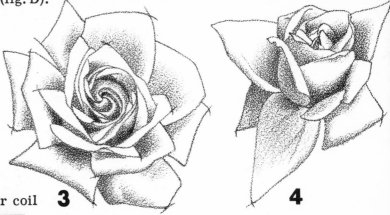

in the overhead view of the rose in fig. 3. Though all petals are rounded, they may appear squared as the edges roll back and under as in fig. 3, or some may appear triangular as in fig. 4. The rose in fig. 5 is a wash on wet watercolor paper. Across the page is an example of "mist" painting, further explained on p. 98.

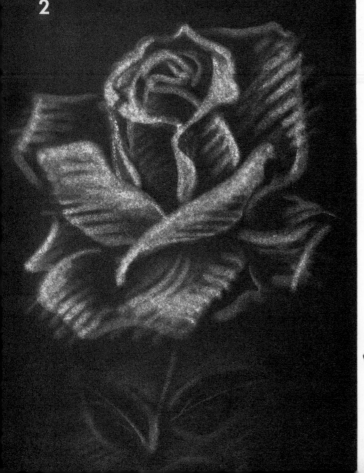

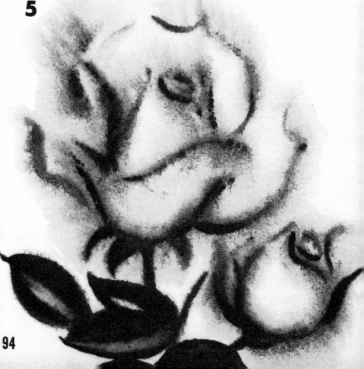

THE ROSE DISSECTED AND ANALYZED

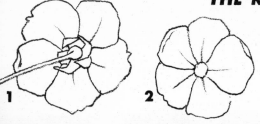

1 2 3 4 5 6 7

8 9 10

Figs. 1 through 10 are all parts of the same rose. Viewed from the bottom, the petals are removed by layers so we may see their true shapes. Finally, in the last two stages (9 & 10) only the stamens and stigmas remain.

The wild rose frequently has only five petals. The Provence rose, also called the "cabbage" rose or the "rose with a hundred petals," was a favorite with the old masters. Evolved by Dutch breeders, it was painted by the celebrated Jan van Huysum and other Dutch artists. Later, Fantin-Latour, the French artist, further immortalized the cabbage rose. Because of its short flowering season, it is seldom cultivated today.

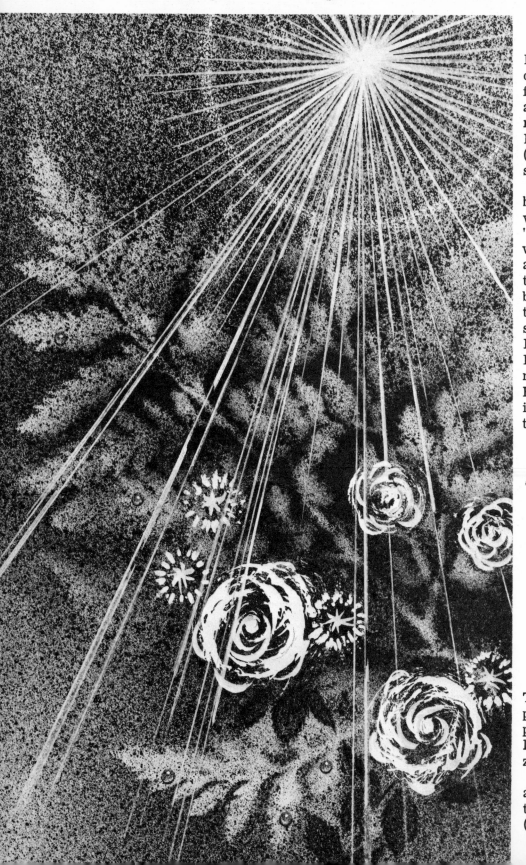

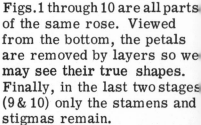

INNER BOWL OF PETALS

ZIGZAG

OUTER OR GUARD PETALS

The above diagram shows the pinwheel or shingling of the petals. Not all, but most follow this pattern. The petals zigzag in toward center.

The roses in the fantasy at the left were painted by the twisting of a "stamen" brush (see p. 116).

THE SIX BASIC SHAPES OF FLOWERS WITH EXAMPLES

Even though there are some 200,000 known kinds of flowers, nearly all of them may be classified into six basic shapes. Of course, the last two, "combination" and "variation," will take in all the odd and unusual. The vast majority, however, will come within the first four shapes listed in the lefthand column. As has been brought out in the earlier pages of this book, the artist always does well to cast a general outline around anything he ever draws or paints. He may at times do this mentally if not on paper or canvas. Yet, most successful artists readily admit to the wisdom of lightly blocking in their composition before getting to the component parts and detail. Since a floral arrangement is no exception, it is well to first think in terms of basic shapes within the larger compositional boundry. The visual angle may foreshorten a shape or turn a circle into an ellipse.

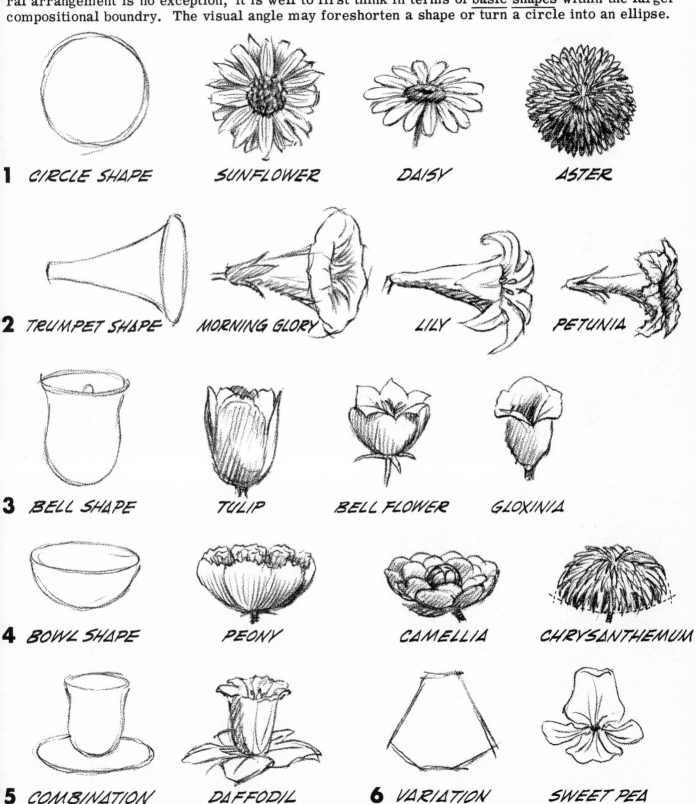

1 CIRCLE SHAPE SUNFLOWER DAISY ASTER

2 TRUMPET SHAPE MORNING GLORY LILY PETUNIA

3 BELL SHAPE TULIP BELL FLOWER GLOXINIA

4 BOWL SHAPE PEONY CAMELLIA CHRYSANTHEMUM

5 COMBINATION DAFFODIL 6 VARIATION SWEET PEA

A

2

MIST PAINTING FLORAL STILL LIFES

As a pleasurable diversion "mist" painting is a helpful adjunct to floral art. It is not difficult and can teach the student much about composition. What's more, no vicinity on earth is without subject material. It is one of the least expensive ways of painting; besides, it possesses the element of immediacy -- it does not take long to accomplish. Principles of good

1

space division need to be applied, however, and this has been discussed and emphasized repeatedly in this book.

On these two pages are four simple approaches to mist painting. All the examples presented throughout are done with a low-priced atomizer which can be purchased at any art store. Fig. A shows two folding types which are about five inches in length. The two metal tubes fold out to 90° and the more narrow tube is submerged in ink or watercolor. The larger tube which is blown through is held in the mouth by one hand while the liquid is held by the other.

The several easy preparatory steps are explained on page 100, but here we'll talk about the pictures before us. Fig. 1 is one unretouched image made from one "burst" of solution. Fig. 2 consists of two images: the larger image (the righthand stem and leaves) was laid on the paper first and sprayed with the first color. The smaller image (the lefthand stem) was laid over the first impression and sprayed with a second color. The paper showing through was protected from the paint by the first image and also the second.

Fig. 3 is a single image laid on sketchpad paper and spray painted in the same manner as fig. 1, except that (1) a slightly prolonged application gives a more solid coverage, and (2) after the color has dried, part of the image is shaded with Prismacolor pencil to add a degree of recession into pictorial space (note the darker grass blades). Inasmuch as the paper was nearly upright when it received the heavy mist, over-saturation would have caused the color to run. Practice on scrap prevents this.

3

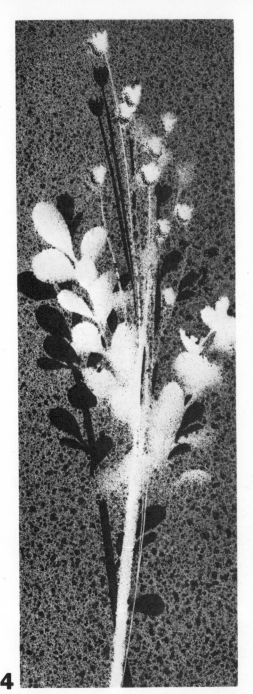

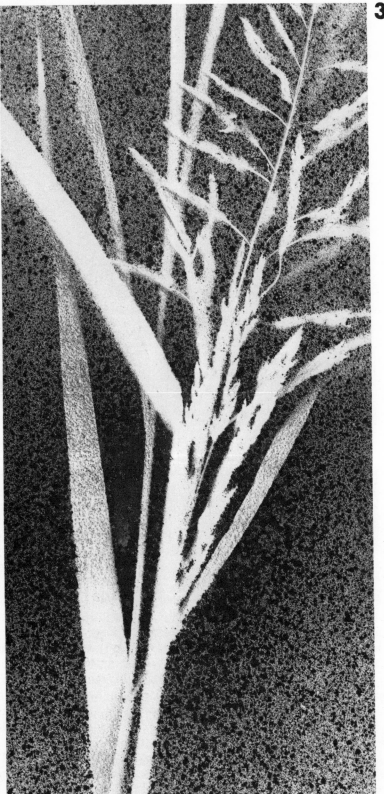

4

Fig. 4 is made up of two field greeneries laid down together; the first has a small flower. An even "burst" of liquid was then applied. The grasses were removed and a darker image was painted in separately with a brush, following the characteristics of the two images. In other words, the darkest part of the composition was not a result of the spray at all. Because the background is a decided middle-tone, both the very light and the very dark parts show up to the best advantage. The darks are strategically placed, not as **mirror** images of the lighter foreground pieces -- they are not intended as mere shadows. (More of these, pp. 104, 105)

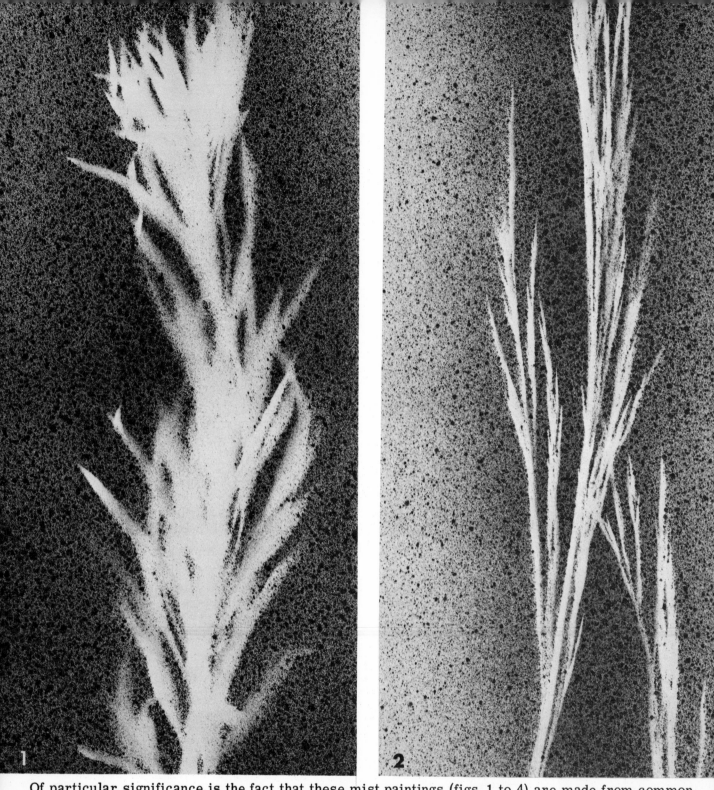

Of particular significance is the fact that these mist paintings (figs. 1 to 4) are made from common field weeds and grasses. There is no retouching here after the initial mists are applied. In each of the first three, a lone plant variety is used; in the fourth picture we have a short section of heavy grass and two ferns. The artist may use brilliant concentrated watercolors or inks and achieve striking effects. Let's take to the field or a vacant lot where uncultivated plants appear. Some old gloves will protect hands from thistles and will assist in uprooting tough weeds. Soon after the plants are cut or pulled, thrust them in a bucket partly full of warm water. Their remaining green will be an advantage later; dried plants tend to break up more. After returning home or to the studio, choose from your collection a likely **specimen**, decide which side you prefer, then lightly spray the other side with spray adhesive (the kind that allows repositioning). Wait a minute, then press the subject on the paper with this in mind: a portion in close contact will yield a sharper image; a slightly loose portion will result in a less distinct image. Beautifully ethereal effects can be

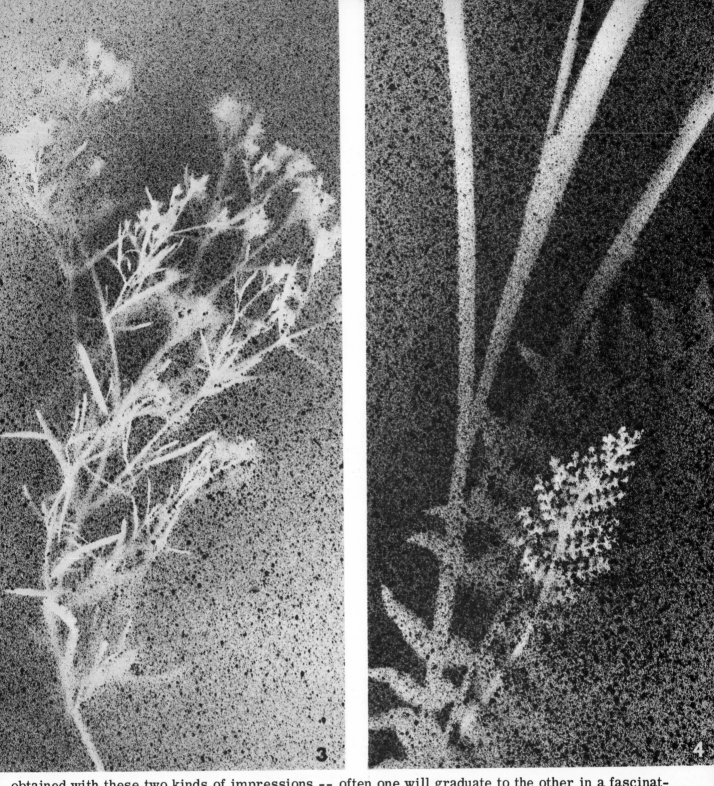

obtained with these two kinds of impressions -- often one will graduate to the other in a fascinat-
ing manner. Next pin the paper to a section of heavy cardboard or plyboard and stand it on a table
backed by a wall. Be sure the table, wall and floor are protected with old newspapers. In blowing
solutions through the atomizer, blow just to one side and then across the specimen. A little prac-
tice on expendable weeds pays off, costs little, and gives the student a chance to discover the sur-
prising possibilities. After spraying, the plant may be removed carefully even before the paint is
dry. The degree of paper absorbancy usually determines this. If some parts of the more tender
plants have broken off, they may be picked up separately. It is possible that too much spray ad-
hesive was used. Fig. 1 was a one-time application. A second breath of mist could be laid down
on top of this from the bottom or top, or a near solid of a much lighter color could be added. If
an unusually springy stem is stubborn and won't stay in place, a small straight pin may secure it
to the receiving surface. Sometimes ideas for oils or acrylics evolve from these experimentations.

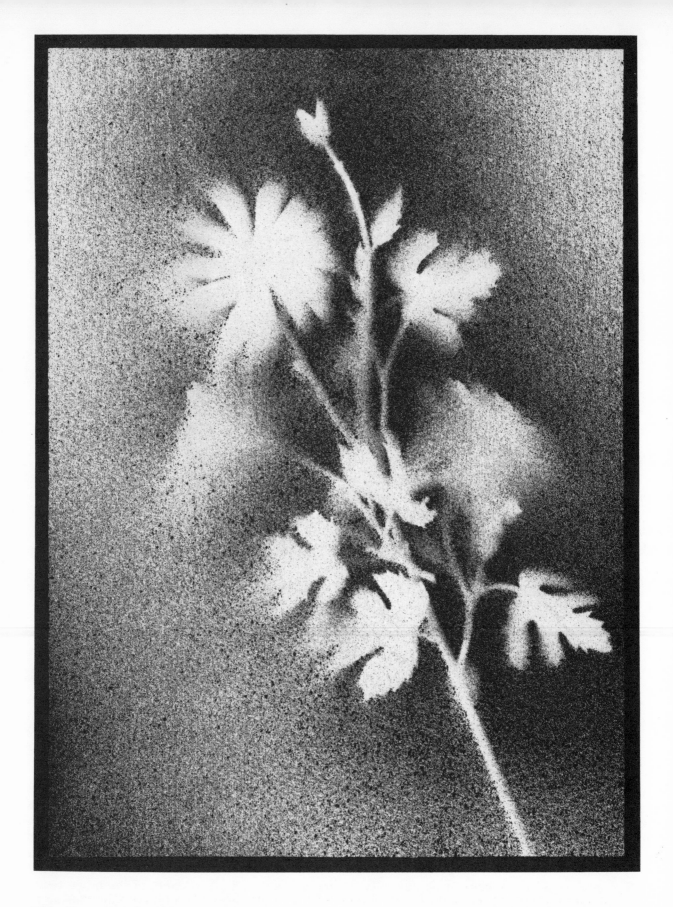

The above floral mist painting is done with the same atomizer as the one across the page. The parts of the subject which are very light resulted from holding those parts close to the paper by means of small pins. Those edges which are sharp cut the mist as it hit the paper; those which are blended were raised sufficiently to permit mist to infiltrate beneath.

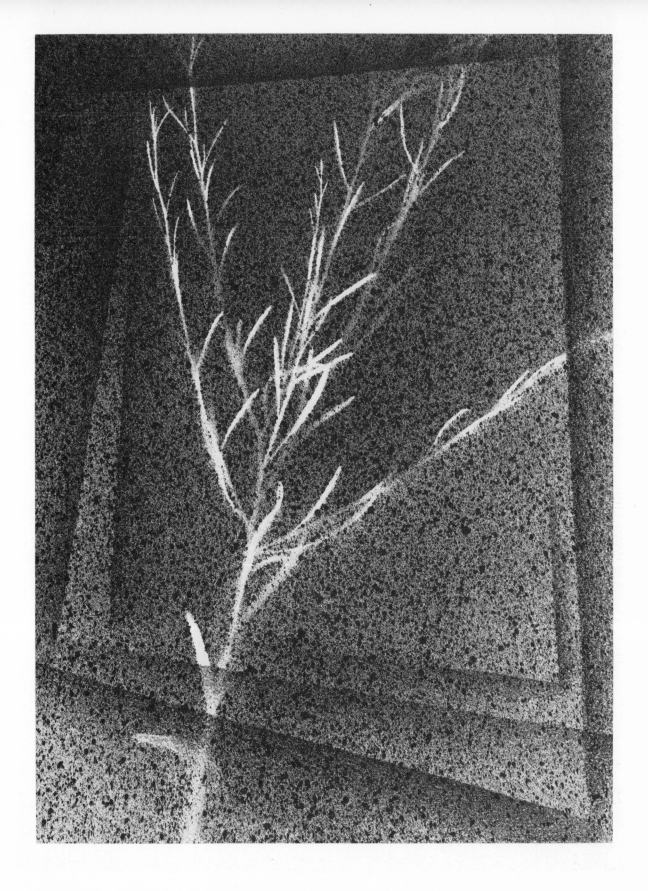

The coarse mist in this painting is obtained by less pressure through the atomizer. By varying the pressure and the distance from the paper, the student will discover different effects will result. The straight lines set down in a geometrical pattern are added later by a lithographic crayon. There is no end to the creative variations which will come through persistent experimentation. Mist painting combines pattern with painting.

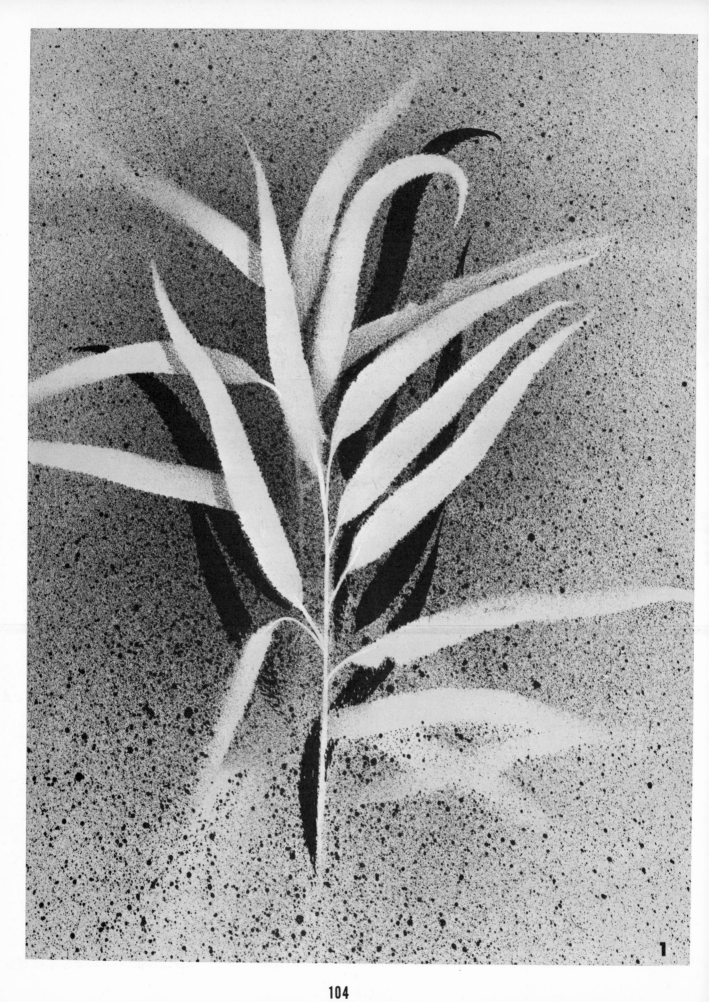

1

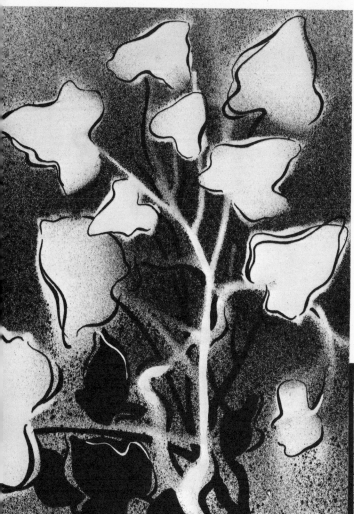

in single or double brush lines (No. 2 pure red sable brush). Additional stem runners are painted in also as ivy stems are difficult to flatten for spraying. The dark leaves below give good support to the composition and furnish interesting contrast.

In fig. 3 the multiple leaflets produce an entirely different foliage picture. The light leaves are given the same simple processing as those in the other compositions. The mid-rib of the light leaves is drawn in but not the veins. It is up to the artist as to how far one should go in leaf detail. The upper straight stems of fig. 3 serve as good directional lines in managing the eye travel as the bottom stem returns the attention for a "stay-at-home" pictorial experience. The tri-leaflet shape is repeated in darker values, having been added after the spraying. Later, more abstract treatments will be presented. The student should not permit a submissive binding to realism; one needs to flex the "art muscles."

MISTING COMBINED
WITH PAINTING AND DRAWING

Fig. 1 on the opposite page and figs. 2 & 3 are examples of controlled spatial pattern in mist painting. The actual greenery is lightly sprayed on the reverse side with a repositioning-type of spray adhesive. Then the leaf placement is planned to conform with the principles of good space division. In each case the darks are added after the misting process. Fig. 1's half-dozen dark leaves afford a backup dimension for the composition. The several shadows on the light leaves at the left were also added. The three parallel light leaves at the right of the stem help stabilize the many offshooting angles. Two leaves to the left and one to the right reach the border to anchor what would otherwise be a bothersome floating of the subject. Prismacolor penciling and pen stippling supplement the misting in particular places. The paper used here is from an ordinary sketch pad.

Fig. 2 is done on a smooth two-ply bristol. The original ivy leaves are only partially secured to allow indefinite edging. After the ivy is lifted, the pleasing leaf contour is repeated

3

MISTING
ENCHANTING
PATTERNS

Any plants which have
featherlike leaves make
wonderful mist paintings.
The acacias which have
fernlike leaves or the
mimosas, of which fig. 1
is an example, lend
themselves to enchanting
pattern and design.
Plants where the leaf
margins are finely indented
take colored mist excep-
tionally well. The overall
leaf area is fairly flat and
may be easily and gently
pressed on the receiving
surface. Here again,
it is unwise to insist on
100% contact. Let some
portions of the foliage be
completely free from
paper attachment.

1

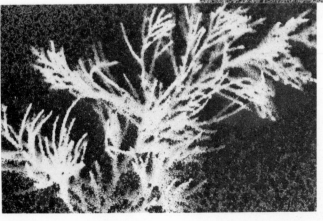

2

Evergreen shrubs and trees often have tougher
and more leathery leaves than many delicate
plants, and for that reason will pull away intact
after being temporarily secured (with reposition-
ing adhesive) then misted. Also, they are green
even through the winter season when field grasses
have dried to a crisp. Few regions are without
some form of evergreens. Actually, dried foliage
will work, but sometimes it breaks up and must
be picked off with tweezers. The visual thrills of
iced-over evergreens can be captured without the
ice. Figs. 2, 3 & 4 are examples of permanent still-
life preservations. Naturally, figs. 2 & 3 call for

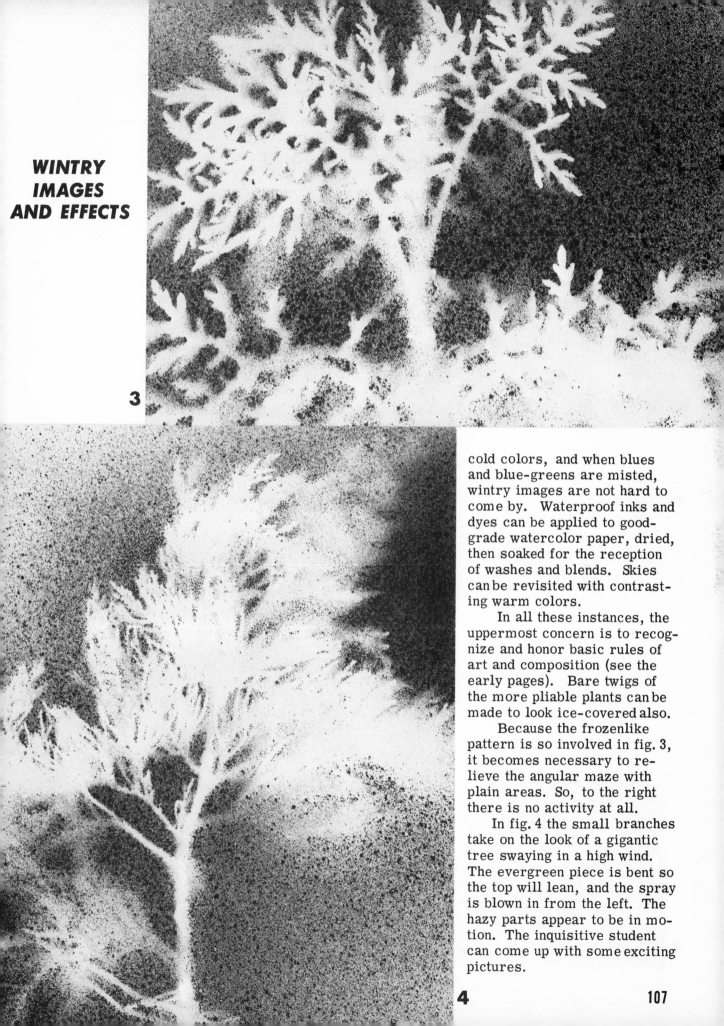

WINTRY
IMAGES
AND EFFECTS

3

cold colors, and when blues
and blue-greens are misted,
wintry images are not hard to
come by. Waterproof inks and
dyes can be applied to good-
grade watercolor paper, dried,
then soaked for the reception
of washes and blends. Skies
can be revisited with contrast-
ing warm colors.

In all these instances, the
uppermost concern is to recog-
nize and honor basic rules of
art and composition (see the
early pages). Bare twigs of
the more pliable plants can be
made to look ice-covered also.

Because the frozenlike
pattern is so involved in fig. 3,
it becomes necessary to re-
lieve the angular maze with
plain areas. So, to the right
there is no activity at all.

In fig. 4 the small branches
take on the look of a gigantic
tree swaying in a high wind.
The evergreen piece is bent so
the top will lean, and the spray
is blown in from the left. The
hazy parts appear to be in mo-
tion. The inquisitive student
can come up with some exciting
pictures.

4

CREATIVE EXPLORING WITH MISTING

For those who wish to pursue floral art requiring blown colors and inks, halving certain bowllike flowers, various thistles and powderpuff blooms will make it possible for the surrounding spray to record their shape. By carefully slicing through some of these subjects with a single-edge razor blade or sharp knife, the flat inside may be laid against the paper. The stem beneath does not need to be halved. The calyx or underparts of the bloom are added afterward to produce the full dimensional appearance -- see fig. 1 at left. Further modeling of leaves is also additional. Fig. 2 is another example of prickly thistle registration.

One of the important functions of mist painting can be its opening creative doors for expanding ideas. A template "finder," which is simply a rectangular hole cut in cardboard, or two "L"-shaped cards brought together as adjustable boundaries can "frame" possible picture material. Most worthwhile undertakings have small beginnings. "That gives me an idea," is one of the best lines ever to run through an artist's mind. Surely the student who searchingly probes is on the way to a productive life.

The figs. 3 through 10 on the opposite page might be called "stimulators." They are just cross-sections from sprayed sketch pad sheets. Some are so abstract as to defy their source. With the exception of fig. 10, everything else has come from plant life. Already we recognize another mimosa pattern (see p. 106) in fig. 3 Both figs. 4 & 8 are from plant roots (see pp. 112 & 113). Fig. 7 is from field grasses laid horizontally. Fig. 5 is an insignificant weed (as are most of them). In fig. 6 large field grasses are laid over each other. Fig. 9 is inked grass slapped over sprayed grass. Fig. 10 is a floral lace impression. The student is urged to try some of his own. In the incubation process such happenings as these can be used as promising beginnings for something never done before.

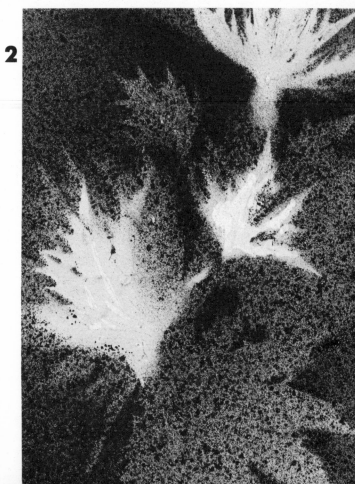

1

2

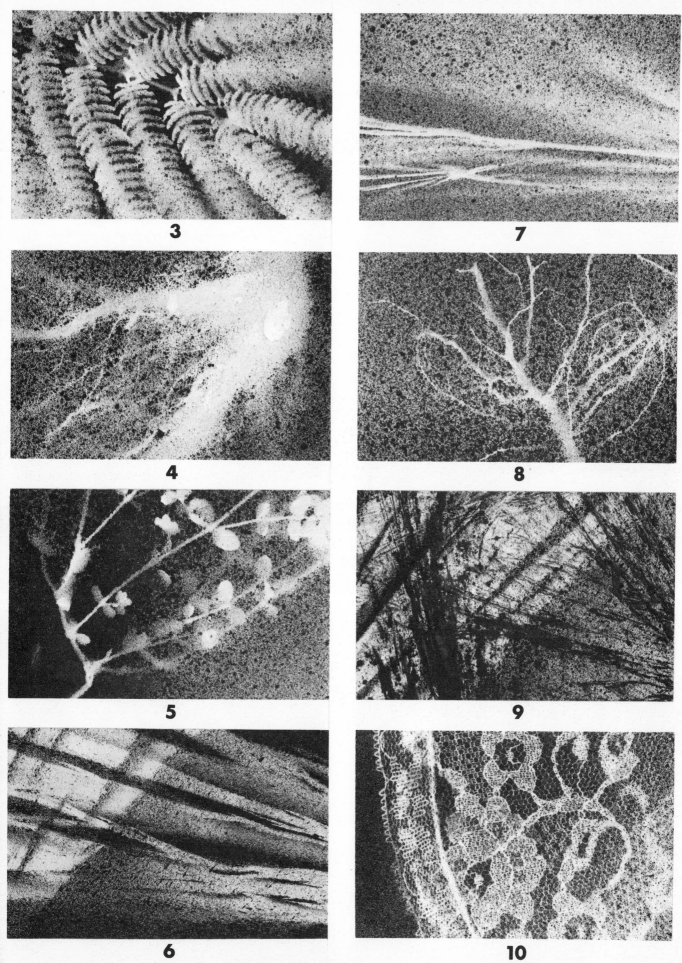

3

7

4

8

5

9

6

10

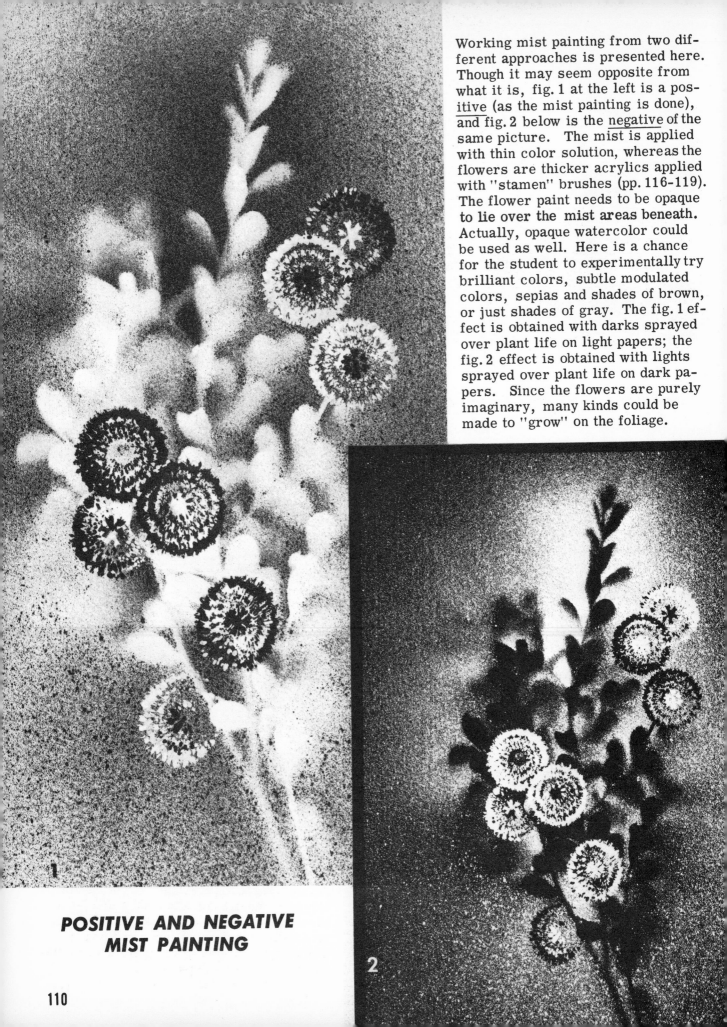

Working mist painting from two different approaches is presented here. Though it may seem opposite from what it is, fig. 1 at the left is a positive (as the mist painting is done), and fig. 2 below is the negative of the same picture. The mist is applied with thin color solution, whereas the flowers are thicker acrylics applied with "stamen" brushes (pp. 116-119). The flower paint needs to be opaque to lie over the mist areas beneath. Actually, opaque watercolor could be used as well. Here is a chance for the student to experimentally try brilliant colors, subtle modulated colors, sepias and shades of brown, or just shades of gray. The fig. 1 effect is obtained with darks sprayed over plant life on light papers; the fig. 2 effect is obtained with lights sprayed over plant life on dark papers. Since the flowers are purely imaginary, many kinds could be made to "grow" on the foliage.

POSITIVE AND NEGATIVE MIST PAINTING

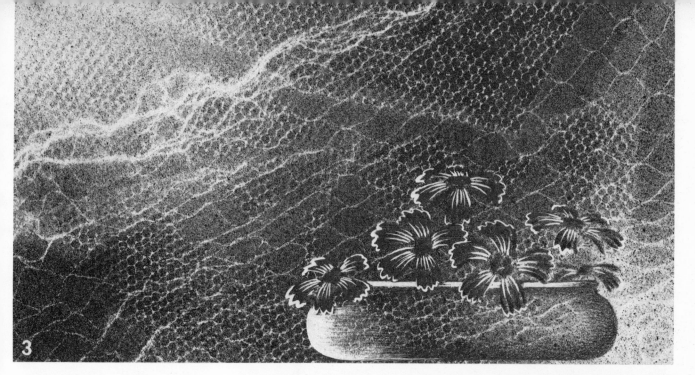

3

UNUSUAL EFFECTS

On p. 95 there is an example of
a net being used to mist an un-
usual textured background. In
fig. 3 above we have two other
thinner nets with different mesh,
both laid down informally for a
delicate ethereal background.
On top of and in the foreground
a bowl of flowers is painted. As
the background goes dark, our
bowl turns light; as it goes light,
our bowl turns dark. The nets
are permitted to show through.

At the right in fig. 4 is a
floral departure. The student
may cut from card or form with
wire a shape of his own design.
Spray adhesive is then applied
on all sides of this shape. After

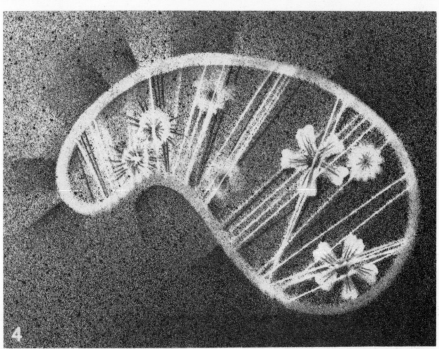

4

this is done, threads or strings are wound
around the shape and held by the adhesive.
Flowers are inserted between the strings
and the whole thing is pressed on paper for
misting. The darker strings, lines inside
the flowers, and flat "rays" around the shape
may be done with either lithographic crayon
or transparent watercolor.

Fig. 5 is bold and direct. But, in its
simplicity, it is pleasing. From nature
comes another suggestion for a semi-ab-
straction which could be enlarged to great
size with considerable force and power.
The tempting fields are replete with invita-
tions to explore and paint.

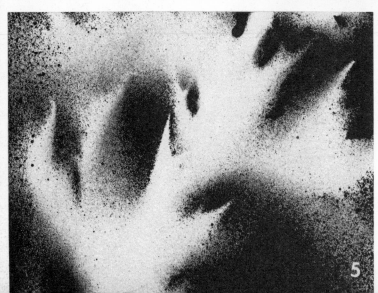

5

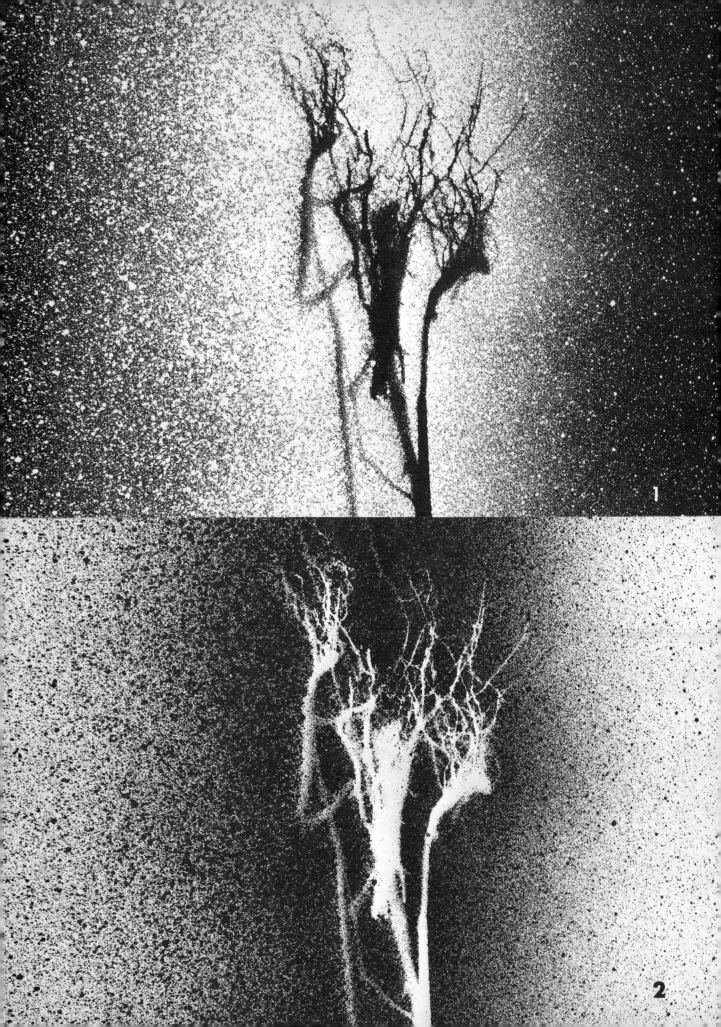

1

2

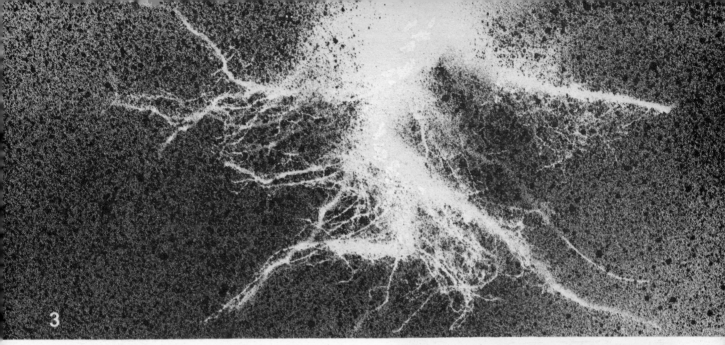

3

MIST PAINTING PLANT ROOTS

There is "unearthly" beauty beneath the ground. After roots are washed and dried, they may be prepared for misting in the same manner as described at the bottom of page 100 (remember: spray where there is ventilation; avoid breathing air laden with mist). Fig. 1 is a reverse image of the fig. 2 picture consisting of fibrous roots of large field grasses. The root hairs and rootlets extending from the root branches make ingenious designs. Figs. 1, 2 & 4 are upside down; fig. 3, which resembles convulsive bursts of lightning, is rightside up.

One important aspect of root painting is the invigorating stimulation which can come from it. There is no end to the abstract ideas which root systems suggest (see also p. 109, figs. 4 & 8). Figs. 5, 6 & 7 are but starters. Fig. 5 is prompted by fig. 1. Fig. 6 is an interpretation of a small section of fig. 3. Fig. 7 might be two opposing forces attacking each other. Most of the art

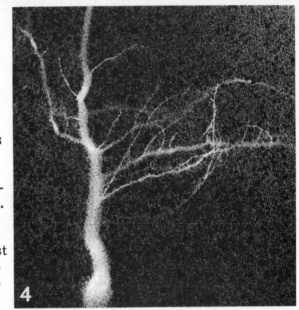

4

concepts one gets from root study are dynamic and electric. The myriads of root extensions are forever dividing volumetric space. It is a revealing exercise to hold a root before the eyes and slowly turn it with the fingers. Abstract expressionist **Pollock's work is akin to multiple root systems**

5

6

7

113

1

2

ABSTRACTS FROM PLANT LIFE

Well-chosen straight lines and angles combined with a few of plant life's gentle curves can mean an engaging work of art. Figs. 1 & 2 come very near being pure abstractions; yet identifiable traces of reality remain. The plant portions are recorded first, then cutout triangles of paper are laid over the first impressions and sprayed again, after which the triangles are removed.

Fig. 3 is made by wrapping string and finer threads around paper mounted on card, spraying the lefthand area heavily, then adding the dark and light floral bits.

Figs. 4 & 5 are ridged "three-dimensional" pieces; that is, as you run your fingers over the surfaces, you feel noticeable ridge lines. The verticals and horizontals in fig. 4 are made by folding 5-ply linen paper and hammering the folds. Then, as the folds are opened up, the fold lines become raised. After that, spray is shot in from below and at an angle, hitting the raised ridge lines. The circles are squeeze-tip lines of acrylic (see p. 93) which dry in a raised condition.

Fig. 5 is a semi-abstraction done on heavy watercolor paper with squeeze-tips. The impasto lines of white acrylic are sprayed from an angle. When dry, a wash is applied in the areas appearing very dark, giving an additional dimensional effect. When the piece is dry, the whole thing is sprayed five or six times with clear shellac which slightly yellows and antiques the work -- it also gives the acrylic a sheen.

The geometrics of the figs. 1 through 5 should not be overlooked. Not once, but many times in this book reference has been made to space division. Where there are no straight lines (as there are here) there are implied straight lines in nearly all the pic-

3

tures. Actually, it is difficult to find great works of art which do not have implied lines placing the picture parts in tandem. In other words, and with renewed emphasis, let the student realize that imaginary or implied lines run through or encase the vital elements of the composition. Run a line through the little flowers of fig. 3 -- they are in a near geometrical formation. Encase the circles of fig. 4 in a triangle. Examine the implied diagonals joining the circular shapes in fig. 5. Latch on to this fundamental truth and make use of it!

4

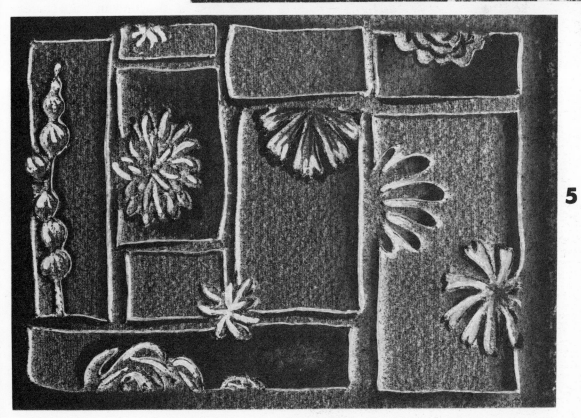

5

STAMEN BRUSH PAINTING

Many books as well as art store leaflets contain good guidelines on the selection and care of quality brushes. Because of the unusual nature of the "brushes" displayed in fig. A, word is included here about their make-up and function. This kind of painting is presented more as a diversionary sideline than anything else. First of all, one can make limited impressions with the stamen or center area of <u>real</u> flowers. Fig. B's impressions are from a real sunflower dipped lightly in paint. But real flower stamens are tender and cannot be rinsed well and reused.

The average "brush" in fig. A costs very little. They are made by dismantling inexpensive plastic flowers: removing the stems, taking off the petals and pushing the handles of cheap or worn-out brushes into the stamen center pieces where the plastic stems were originally. All the patterns on these two pages were made by impressing, tamping and/or twisting these remounted plastic bristles. Some of the designs were made by combinations of more than one "stamen brush." The natural shape of many of these brush heads is in the form of a ring or cup. None of the impressions shown here have been retouched -- in an actual painting they could be if the artist deems it necessary. Notice that a number of the designs above are not radially symmetrical. The second impression, made after the outside first, is purposely off-center. A side-view flower may be depicted by allowing only half of the "circle" to make contact with the canvas or paper.

USING THE STAMEN BRUSH

1

The "stamen brushes" (p. 116, fig. A) may be used in a number of different ways. They should not be thought of as substitutes for authentic pure red sable or white bristle brushes. Their "feel" to the user is quite dissimilar. In one sense they are pattern applicators. However, all will agree there are many ways of applying paint. Figs. A, B & C were done with stamen

2

brushes. A consists of repeated impressions. B is made by rolling the sides of another, while C is a tamping of still another. Abstraction figs. 1 & 2 might be called "Astral Flowers." It is not hard to detect the difference between the tamping and twisting impressions. The screens in fig. 1 are overlaid topsheets. These could be areas of color with the "flowers" added later. The big flowers in fig. 2 are obviously a twist and a tamp.

Fig. 3 is a simple still life done with a trowel-shaped palette knife and stamen brushes. The paint may be either oil or acrylic. The background is prepared with the knife, then the vase. The flowers are done with stamen brushes.

If acrylics are used, it is good to have soapy water in one container and clear water in another. Then after a stamen brush is used, swish it in soapy water, then clear water, to prevent the paint from drying on the plastic bristles. Old cast-off remains of bar soap may be dropped in a jar and barely covered with water. This way there is always a supply of "liquid" soap available.

If oil paint is used, a container of turpentine or other solvent may be used to clean stamen brushes as needed. In making contact with the canvas or paper, the brushes are usually touched in color on the palette or

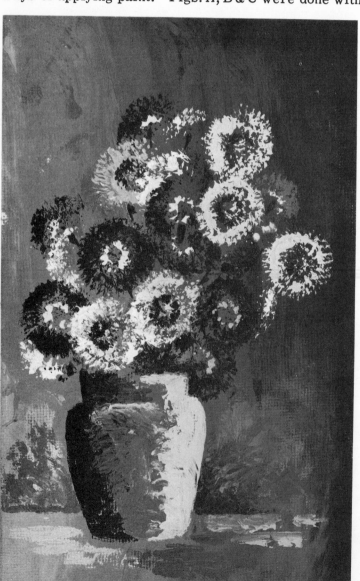

3

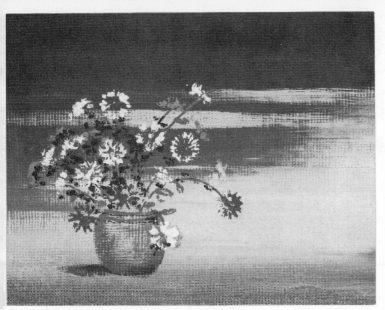

TRY THE UNTRIED!

disposable palette papers, then tried ex-
perimentally on a scrap (that is, if there
is any doubt as to the effect to be obtained).

The still life in fig. 4 has a back-
ground applied with a flat, white bristle
brush. The vase and shadow were then
painted in. After that the flowers were
set in with stamen brushes. Then a few
stems and leaves were added with a fine
red sable brush. Other objects could be
added, like a couple of apples, pears or a
book, or perhaps a fallen flower. Observe the one flower lopped over
the vase (see p. 89, figs. 5, 21 & 28). Sometimes it is advisable to have
dark flowers over a light area and light flowers over a dark area.

Fig. 5 is another example of mist painting. The flowers here are
flattened, unattached stamen centers (or real flowers may be used). The
plain area at the upper left furnishes relief for the rather busy pattern
in the picture.

The still-life artist should not throw narrow limitations around his
or her creative activity. There are always new things to try, new pic-
tures to draw and paint in many different ways with many different media.
Every day holds exciting challenges! Try the untried! Paint the unpainted!

5

INDEX

References are to page numbers which contain particular mention in text or which carry a picture or diagram of subject. For divisional treatment and major still-life topics, consult the Contents.

A

Abstract Expressionism, 77, 86, 87
Abstract still life, 26, 74-88, 90, 113-119
Acrylic & oil painting, 48, 49, 57, 79, 91-93, 115, 118, 119
Action in still life, 52-55, 66, 77, 84, 87
Active and passive planes, 44, 45
Adding pieces in composition, 14 (also see Composition)
Adventure sketching, 8
Anchor piece in still life, 14, 28
Angular lines, 84, 85
Apples, reference to, 20, 32, 33, 60, 61, 84
Arellano, 91
Arrangement of still-life pieces, 3, 28-31, 50, 56
Asymmetrical balance, 26
Atomizer, use of, 98
Availability of still-life material, 2
Awareness of planes, 16 (also see Planes)

B

Backdrops, 47, 59, 91 (also see Recession into space)
Balance in composition, 26, 27, 40, 53, 70, 80, 82, 87
Bananas, abstract treatment, 76, 77
Basic shapes in still life, 4
Basic shapes in flowers, 97
Beckmann, 87
Blocks placed in composition, 14
Bold outlines in still life, 33
Braque, 49, 71, 79, 85
Brueghel, 91
Brush-strokes in painting, 48, 49, 57, 61, 92, 93, 116-119

C

Cards in still life, 39, 40, 41, 44, 45
Cézanne, 49, 66, 85, 90
Chains of value, 12 (also see Value)
Chalk and pastel, 34, 35, 40-43, 94
Charcoal and charcoal papers, 23, 67, 76
Chopping tints and shades, 35 (also see Value 'walk-around')
Circular shapes in still life, 4
Composition, 3, 7, 9, 12-17, 21, 23-27, 29-31, 34-47, 49-56, 58-61, 66, 67, 70-73, 84, 85, 88, 90-93, 97-99, 118, 119
Cone, 18, 19
Container types and arrangement, 6, 28-31
Contrast in dark and light, 20, 21, 24, 25, 71 (see also Dark and Light)
Control of pen and pencil line, 56, 68, 69
Crayon drawing, 21
Crosshatch, 51, 63
Cube, pure, 18, 19
Cubes modified, 11
Cubism, 86, 87
Curtains, 5 (also see Drapes)
Curve in composition, 52, 53 (see also Composition)
Curved shapes, 4, 6
Cylinder, 19

D

Dark and light, 11-14, 20, 21, 46, 47, 50, 58-61, 79, 81, 90, 91
Delaunay, 79
Departure from reality, 76
Depth in still life, 11, 44, 46-48
Diagonals in composition, 26, 66, 80, 81, 84, 85, 115
Directional flows and feelings, 26, 27, 38, 44-47, 50, 53, 66, 69, 70, 76, 80, 85, 87, 105, 114, 115, 118, 119
Distortion, 82, 83, 85-87
Dividing space, 14, 80, 84 (also see Composition)
Divisionism, 63
Drape, 4, 5, 45-47, 52-55, 64-73
Duchamp, 77, 79
Dürer, 88

E

Economy of line, 4
Edge differentiation, 10, 41
Entering point, 50 (also see 26, 44, 46, 47, 61, 70, 85)
Equivocal aspects in abstract still life, 86, 87
Essential shapes in still life, 4
Evergreens in mist painting, 106, 107
Experiments in abstraction, 74, 75, 80-83
Exploratory sketching, 7
Expressionism, 86, 87
Eye containment, 84
Eye cycle, 78
Eye level and composition, 3, 89
Eye track, 45, 53

F

Fantin-Latour, 96
Felt pen, 62, 63, 67
Feininger, 84
Flowers, basic shapes, 97
Flowers in still life, 88-119 (also 7, 9, 27, 44, 45, 60-63, 66, 67, 85)
Folds in fabrics, 64-73
Follow-through for the eye, 50 (also 26, 27, 38, 44-47, 52, 53)
Form and texture, 59, 87
Form observations in fruit, 32
Forms in dark and light, 20, 21, 82, 83, 87
Four basic values, 34, 35
Frame around the still life, 1, 60, 61, 75, 80
Frames, interior use of, 46, 47
Freehand lines, 1 (and pages following)
Fruit in still life, 23, 32, 33, 36-38, 44-49, 52, 66-71, 76, 84, 85

G

Gauguin, 49
Geometrical shapes, 24, 25, 80-84, 86, 87, 114, 115
Globe in still life, 4, 18, 19, 22
Good still-life material, 2 (and continuing examples)
Gorky, 77
Gouache water paint, 24, 58-61, 90
Grasses, use of in mist painting, 98-100, 108, 113, 114
Gris, 49, 71, 79, 85, 87
Guitar, 2, 27, 62

H

Halos in still life, 37, 88
Halted spatial planes, 85
Heavy outlines in still life, 33, 36, 88
Highlights (see Reflections and Reflected light)
Holbein, 88
Horizon line, 47
Horizontal planes, 39, 40-43
Huysum (Jan van), 96

I

Iced-over effect in mist painting, 106, 107
Imaginative experience, 75, 77
Impasto lines, 115
Intense lighting, 20, 21, 46, 60, 61
Interpenetration, 78, 79, 85, 87
Isolating values, 12, 13, 27
Ivy for misting, 105

K

Kandinsky, 77
Kitchenware in still life, 68
Klee, 77

L

Layered surfaces, 20, 61
Léger, 77, 79
Linard, 91
Lights and darks, tints and shades, 19, 20-23, 34, 35, 46, 47, 60, 61, 65, 87, 90, 91
Line-up of still-life containers, 28, 29
Linkage of shades and values, 12, 13
Loose control of pen and pencil, 1, 56, 68, 69

M

Manet, 49, 90
Marker painting, 62, 63, 67
Mass and bulk, 9, 27
Matisse, 66, 85
Mechanical lines, 1
Mergence in values, 24
Metzinger, 79
Middle values, their importance, 12, 13
Mimosas for misting, 106
Mist painting, 98-115, 119 (also 94, 95)
Mondrian, 75
Monet, 90
Mood painting in still life, 92
Moser, 90

N

Napkin, folds in, 64
Negative space, 1, 25, 30, 89, 90
Neo-Impressionists, 63
Nets in mist painting, 95, 111, 119
Newman, 75
Nicholson, 85
Noland, 75
Nonobjective paintings, 77
Nonrepresentational art, 74

O

Objects in front of each other, 7
Oil and acrylic painting, 48, 49, 57, 91-93, 118, 119
Opaque colors, 24, 26, 58-61, 90
Outer confines of components, 17, 29
Overhead viewing of pieces, 3
Overlapping of lines and objects, 7, 10, 11, 66, 73, 77, 83

P

Palette knife, use of, 48, 92, 118
Paper showing through, 35, 43, 62, 63, 70, 71, 98
Pastel and chalk, 34, 35, 40-43, 94
Pattern of simplified planes, 11
Pears in still life, 38, 52
Pen and ink drawing, 38, 50, 51, 56, 65
Pencil, kind and shape, 4
Pencil sketching, 7, 33, 37, 62-64, 66, 68, 69, 72, 73, 88, 89, 94
Perpendicular planes, 39, 44, 45, 60, 61
Petal analysis of the rose, 96
Picasso, 71, 77, 79, 85
Pictorial space, 44, 46, 47, 78, 82
Picture plane, 44, 77, 85
Pissarro, 90
Planes, 11, 14-17, 34, 35, 39, 76, 78, 80-85
Planes and cards, 39
Planes, implied, 46
Planes in fruit, 32, 34, 38, 84, 85
Planes: static, tilting, thrusting, dynamic 44, 78, 84, 85
Plants in mist painting, 98-115
Pointillism, 63
Pollock, 113
Positive space, 1, 25, 30, 89
Prism in purest form, 19, 65
Protrusion from the picture plane, 44, 45
Pure dimensional form, 18, 19
Pure idea, 78
Pure sphere, cube, cone, pyramid, cylinder, prism, 18, 19
Pyramid in purest form, 18
Pyramid shape modified, 5

R

Realism in still life, 21, 23, 32, 37, 46, 47, 52, 68, 69, 90, 105
Receptacles, 6, 28-31
Recession into space, 44-47, 79, 82, 87, 90, 91
Reflected light, 22, 23, 35, 57, 60, 61
Reflections on subjects, 32, 51, 60, 61, 67
Renoir, 90
Rims and lips of containers, 6
Roots of plants in composition, 112, 113
Rose, 94-96
Rothko, 75

Ruben and Beert, 88
Rules of balance, 26, 27

S

Sectional space division, 16, 32
Segmented planes, 84, 85
Sense stimulation, 78
Sensory experience, 58
Seurat, 63
Shadow and design, 13
Shadow and light, 22, 23, 39, 60, 61, 65
Shadow box and planes, 39-41, 60, 61, 76
Shadow patterns, 14, 39, 60, 61, 65
Small fruit compositions, 36
Space divided by containers, 28
Space division, 1, 14-17, 39, 44, 46, 47, 76, 80, 98, 105, 112-115
Spatial stepbacks in still life, 46, 47
Sphere in still life, 4, 18, 19, 22
Splash-over, 33
Spoon as still-life subject, 74, 75
Spray adhesive, 100
Spray painting, 98-115, 119 (first used, 94, 95)
Squeeze-tip painting, 93, 115
Stamen brush painting, 116-119
Stepbacks into space, 46, 47
Stimulators for expanded paintings, 109
Subjective titles, 77
Subjects in still life based on pure form, 19
Subject material, its placement, 3 (also see Composition)
Surrealism, 83
Symmetrical balance, 26

T

Tactile expression, 58, 59
Template finders, 108
Tendency through association, 23
Tension in drapery, 65, 66, 68, 69
Texture drawing and painting, 41-43, 48, 49, 55, 58, 60-63, 67, 77, 111
Thistles in misting, 108
Thought and the non-material, 77
Three-dimensional concepts, 11
Thumbnail sketches, 5
Tight control of pen and pencil, 1, 56, 68, 69
Tint and shade, 59, 24, 26, 34, 35
Transparency in still life, 77-79, 81, 86, 87, 92, 93
Transparent wash and markers, 67, 71, 93
Travel experience in a picture, 44, 46, 47, 53, 73, 85, 105
Treatments of apple surfaces, 33
Triangular containment, 31, 70, 115
Truncone shapes, 4, 19
Two-dimensional concepts, 10

V

Value and color balance, 26, 90
Values and areas, 10, 24, 25, 34, 35, 90, 91
Values, linking and developing, 12, 13, 90, 91
Value 'walk-around,' 19, 20, 34, 35, 90, 91
Velour paper, 94
Van Gogh, 49, 85, 90
Variety in container shapes, 28-31
Vase in light and shadow, 22, 57, 61, 68, 69, 78, 79, 88, 89
Vases, planes of, 34, 35, 78, 79, 91, 118
Visual weight, 26, 27
Volumetric space division, 16, 17, 113

W

Wall plane, 46, 47
Warnings in container arrangement, 29-31
Wash drawing, 70, 71, 93, 94, (marker, 67)
Watercolor, opaque, 24, 26, 58-61, 90
Watercolor, transparent, 70, 71, 93, 94, (marker, 67)
Weeds, use of in mist painting, 100
Weight of values and colors, 26, 27
Wick pen, 62, 63, 67